EVERY OBJECT HAS A STORY

EVERY OBJECT HAS A STORY

EXTRAORDINARY CANADIANS CELEBRATE
THE ROYAL ONTARIO MUSEUM

Published by the Royal Ontario Museum with the generous support of the Louise Hawley Stone Charitable Trust. The Stone Trust generates significant annual funding for the museum, providing a steady stream of support that is used to purchase new acquisitions and to produce publications related to its collections. The Louise Hawley Stone Charitable Trust was established in 1998, when the ROM received a charitable trust of nearly $50 million — the largest cash bequest ever received by the museum — from its long-time friend and supporter Louise Hawley Stone (1904–97).

Royal Ontario Museum
100 Queen's Park
Toronto, Ontario
M5S 2C6
rom.on.ca

Distributed in Canada by
House of Anansi Press through:
HarperCollins Canada Ltd.
1995 Markham Road
Scarborough, ON M1B 5M8
Toll free tel. 1-800-387-0117

Distributed in the United States by
House of Anansi Press through:
Publishers Group West
1700 Fourth Street
Berkeley, CA 94710
Toll free tel. 1-800-788-3123

Library and Archives Canada Cataloguing in Publication

 Every object has a story : Extraordinary Canadians celebrate the Royal Ontario Museum / Royal Ontario Museum.

Issued in print and electronic formats.
ISBN 978-1-77089-486-0 (bound) — ISBN 978-1-77089-487-7 (HTML).

 1. Royal Ontario Museum — Biography. 2. Royal Ontario Museum — History. 3. Museum visitors — Ontario — Toronto — Biography. I. Royal Ontario Museum, editor of compilation.

AM101.T67E84 2014 069.09713'541 C2013-907034-6
 C2013-907035-4
Library of Congress Control Number: 2013922161

Concept: Kelvin Browne
Editor: John Macfarlane

Special thanks to the following people for their contributions to this project:

The ROM
Kathryn Brownlie
Marnie Peters
Sheeza Sarfraz
Tara Winterhalt
Brian Boyle
Dave Garvin
Julia Matthews
Marilynne Friedman
Zak Rogers
Scott Loane
Julia Fenn
Heidi Sobol
Susan Stock
Tracey Forster

The Walrus Foundation
Shelley Ambrose
Kyle Carsten Wyatt
Brian Morgan
David Leonard
Pamela Capraru
Sonia Straface
Michael Strizic

House of Anansi
Sarah MacLachlan
Kelly Joseph
Barbara Howson
Eric Jensen
Laura Repas
Erin Mallory

Printed and bound in Canada.
The Royal Ontario Museum is an agency of the Government of Ontario.

 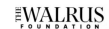

CONTENTS

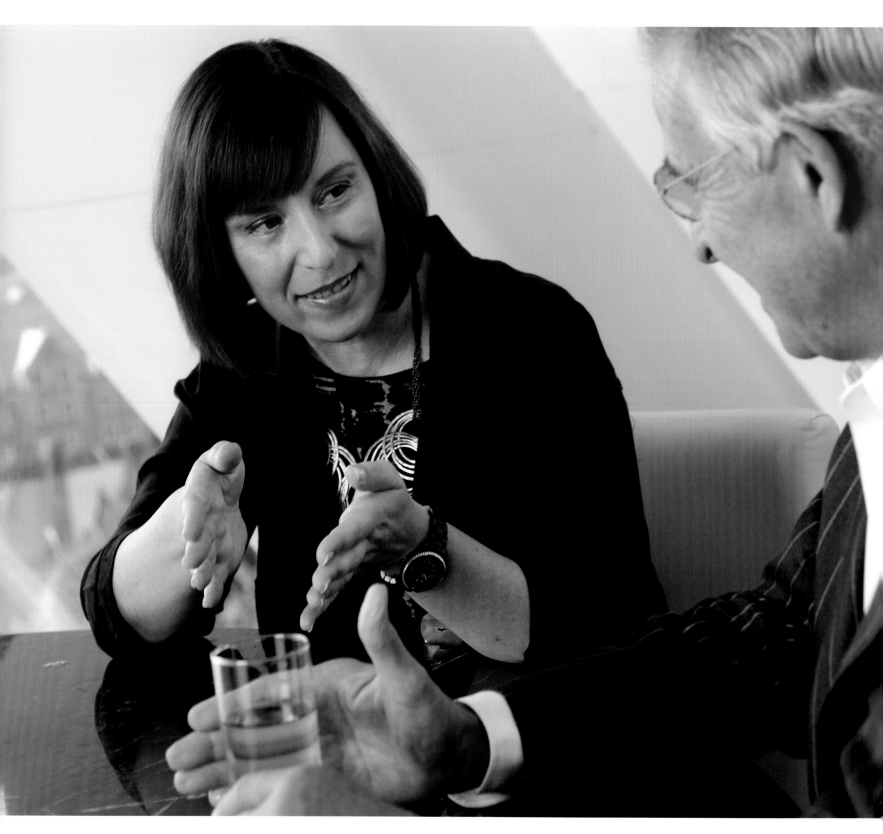

Janet Carding, director and CEO of the Royal Ontario Museum, with John Macfarlane, editor and co-publisher of *The Walrus* magazine. Photography by George Whiteside.

PREFACE

Janet Carding in Conversation with John Macfarlane

John Macfarlane: What is important about the Royal Ontario Museum's centennial, and why is the ROM collaborating with the Walrus Foundation to celebrate it with a book?

Janet Carding: The centennial is a moment to reflect—to compare what we're doing now with the aims of our founders. But I think we should look forward as well. I want to make sure it is not an introspective exercise—that it isn't just us talking to ourselves. The centennial is an opportunity to encourage a whole range of people to think about the ROM—about why it's important now, and about how it might meet their needs in the future.

J.M.: One of the things the book does, through the essays we've commissioned by Canadian writers and artists, is illustrate the impact a museum can have on people's lives. In one of them, for example, painter Robert Bateman writes about the ROM being his second home when he was a boy and visiting every Saturday. Studying the iconic dioramas opened up a whole new world to him; he describes himself in that period of his life as a ROM groupie. In another essay, the journalist and novelist Linden MacIntyre reflects on growing up in a part of the country where there wasn't anything like the ROM, and how that absence affected his childhood.

J.C.: The impact museums have on people is one of the reasons I work in them. And it begs the question: in a changing world, how do we continue to connect with people?

J.M.: Without a ROM to visit on Saturdays, MacIntyre talks about discovering *The Book of Knowledge*—an encyclopedia that I'm old enough to remember. In a sense, the book became his museum, but he wasn't looking at actual artifacts. He was looking at descriptions of them.

J.C.: Museums are still places where people see real things for the first time, because increasingly they get their primary understanding of the world virtually—from its flora and fauna to its many different human cultures. So for us the question becomes, how can we offer a potent experience to a generation of young people who thrive on virtual experiences? And going forward, will people fall in love with the ROM, through its collections, the way that previous generations did?

"We want the ROM to appeal to everybody. The important measures of success are the stories people tell about how the museum affects their lives."

J.M.: How do you measure the success of a museum?

J.C.: It's easy to say that it's all about numbers. And, yes, we want the ROM to be popular; we want it to appeal to more than a select group of people. We want it to appeal to everybody. But in the end, I think the more important measures of success are the stories people tell about how the ROM affects their lives. When people tell us what the museum means to *them*, they're telling us the museum is succeeding.

J.M.: So it's not just numbers?

J.C.: In the end, it's about people and their memories, reflections, and actions.

J.M.: Why did you decide to celebrate the centennial through essays about artifacts from such a massive collection?

J.C.: As I said, one of the most interesting ways to illustrate the ROM's importance is to invite people to say—or in this case to write about—what the museum has meant and continues to mean to them. While it's important for those of us who work here to continue to document what we've achieved, these essays are testaments of the actual users. It was only natural to seek out writers and artists, and a book helps illustrate that the ROM doesn't exist in isolation. It's very much part of the community.

J.M.: With six million objects in the collection (it's difficult to comprehend the scope), how did you go about choosing the objects this book considers?

J.C.: We gave that job to the people who know the collection best—our curators. Not that it was an easy task. You can't be a reductionist, because ours is an encyclopedic museum. Its vast scope is intrinsic to our identity. No single object could ever sum up the ROM. You need many, and I think those we've chosen do that really well.

J.M.: So I guess the next obvious question—and it's one I should answer—is how did we go about choosing the authors?

J.C.: Yes, how did you?

J.M.: We compiled a list of Canada's foremost novelists and non-fiction writers. We added some poets, artists, scientists, and—why not?—an astronaut. We came up with more than fifty names, and then we asked ourselves which items on the object list might interest them. In some cases, it was an easy pairing; in others, it

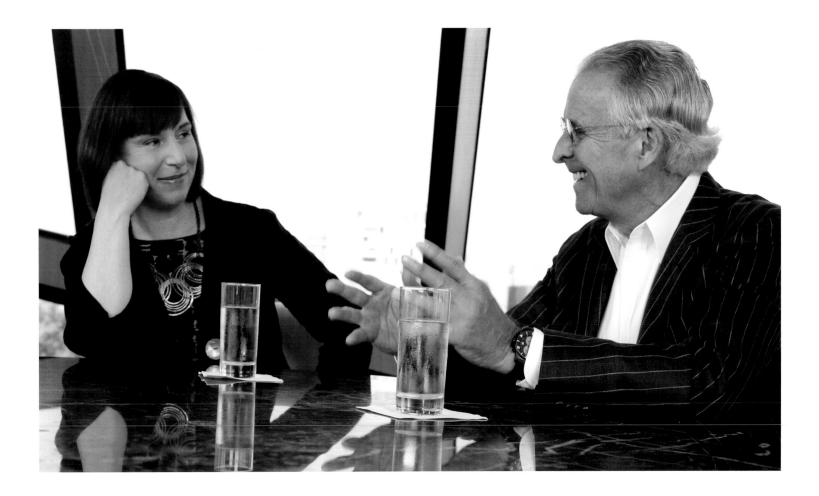

seemed rather arbitrary. Then we began reaching out to writers, and even those who said they couldn't participate, even *they* were excited about the project. They said, You know, if I didn't have this book tour or didn't need to be in New Zealand for the next couple of months, I'd take this assignment on.

Obviously, we're thrilled with the list of people who said yes. We asked them to write about their object and what it, or objects like it, had meant to them. We asked them to be personal. We told them there are no rules. Their pieces could be serious, playful, biographical, humorous...We said anything goes. We all see things differently, because we all see things, as anthropologist David Pilbeam has observed, not as they are but as we are. Neil MacGregor, the director of the British Museum, contends that

history is best told through objects that, as the *Financial Times* recently put it, "slither through different generations, acquiring extra layers of meaning and shades of interpretation." Do you agree?

J.C.: Absolutely. They move through time, and in so doing acquire their own biographies, which are the stories curators tell. But every individual who encounters an object brings something to it as well. An object can resonate for one person differently than for somebody else. The great thing about objects is that they are complicated; they are multi-layered. There is no single way to define or describe them. What's interesting about this book is that we've asked a group of writers and artists to tell *their* stories about objects the ROM's curators identified.

J.M.: American humorist John Hodgman says he doesn't think museums need to engage with popular culture in order to make themselves interesting, because museums are inherently interesting. Engaging with popular culture for its own sake, he argues, is beside the point and suggests insecurity on the part of the institution.

J.C.: There's a debate about allowing objects to speak for themselves, rather than creating narratives or experiences around them. It's another way of thinking about how museums engage with popular culture. In an exhibition, there is no such thing as a neutral space. If you choose to put paintings on white walls, you choose an approach—the gallery as white box—that is typical of modern museums but would have seemed strange a century ago, when artifacts would have been displayed in more colourful salons. Every generation brings something different to the way it interacts with a collection. Museums don't exist outside popular culture.

"Every individual who encounters an object brings something to it. An object can resonate for one person differently than for somebody else."

J.M.: This book is a conversation between curators, artists and writers, and images taken by young photographers. How would the book have been different had it been published a century ago?

J.C.: When the ROM opened, it wasn't clear who it was for beyond the curators and the founders. It really was a grand idea—about civic significance, about creating public space, about Toronto. Our founders believed Toronto was poised to become an important city, in an important province of a young country. One hundred years ago, this book would have been written with a wish to inform and encourage understanding, but it would have been written *by* curators *from* the museum *to* the notional members of the community. That's a perspective that was common for most museums throughout the twentieth century. Only recently have we allowed other voices to join the conversation.

J.M.: What will the ROM look like in the future?

J.C.: In order for the ROM to be relevant for another 100 years—in order for it even to *exist*—we need to continue focusing on the importance of community, because if a community values its museums it will support them. One way or another, we'll find ways to provide the storage, to update the exhibitions, to create the new experiences, and to use whatever media there is 100 years from now to make the collection accessible. But, above all, we need to ensure that the museum is understood to be an important part of the community, because it provides an experience the community savours.

J.M.: That answer is not unlike the one I give when I'm asked whether people will be reading *The Walrus* twenty-five years from now. I say that the way we do what we do may change (in fact, it will change, even if we don't yet know how), but the reason we do it, our mission, will be as valid decades from now as it is today. And isn't that also true for the ROM?

J.C.: I think our centennial will show that while what we do is the same, the way we do it has changed since the beginning—and will inevitably continue to do so.

Janet Carding is director and CEO of the Royal Ontario Museum.

John Macfarlane is editor and co-publisher of The Walrus *magazine.*

THE OBJECTS

KUNTI

Deepali Dewan,
Senior Curator
of South Asian
Visual Culture

There is nothing specifically South Asian about this strange-looking figure, but visitors to the permanent Sir Christopher Ondaatje South Asian Gallery are drawn to her like insects to light. Kids wonder if she is male or female, and teenagers gawk at her ample bosom. There is a DO NOT TOUCH sign on the wall, but people touch her anyway. She is a favourite in photographs: people pose with their arms draped around her shoulders, or mimic her hand gestures. And she is better known by her nickname, Blue Lady.

Kunti is a symbol of the contemporary in a gallery preoccupied with the past. She serves as a visual and intellectual pivot on which viewers can gauge their reaction to the long history of South Asian art. She is like a semicolon that links separate ideas, pulling the present and the past into association.

The present: *Kunti* was created by Navjot Altaf, who worked with Adivasi artists from Kondagaon, a village in Chhattisgrah, India. They carved *Kunti* from several pieces of teak, incorporating their usual metal into a head crest, making the materials equals in the creative process. During her time in Kondagaon, Altaf encountered an educated woman (and the sculpture's namesake) who was accused of witchcraft — symbolized by the figure's transposed thumbs. Because educated women threatened the local patriarchal order, such accusations were not unheard of. For the artist, this raised an ethical dilemma: her feminist politics versus her support of villager rights. *Kunti* is the embodiment of such conflict, commonplace in locations like India that are poised between traditional structures and the global economy. She is also a kind of resolution, breaking down barriers between high and low art, between urban and rural, and between artist and craftsman. This was the focus of Marcel Duchamp, considered the father of modern Western art, in the early twentieth century. Altaf appropriates one of Duchamp's works as the stool on which *Kunti* sits, putting to rest one more dichotomy: that between East and West.

The past: *Kunti*'s shape mirrors the voluptuous shapes of Hindu goddesses created for temple niches. By extension, she evokes their benign and terrifying powers, their association with fertility, and the transformative potential of the feminine divine. Her brilliant blue colouring reminds the viewer of blue-skinned gods, whose unnatural hues signal their divine status. It also references the indigo trade: a historical moment when the Indian subcontinent was forever changed by successive waves of European traders, wooed by its rich natural resources. A rare plant extract that intoxicated the world with its deep-blue tone and seemingly magical colourfastness, indigo is a testament to beauty, as well as to the long and painful history of slavery and colonialism.

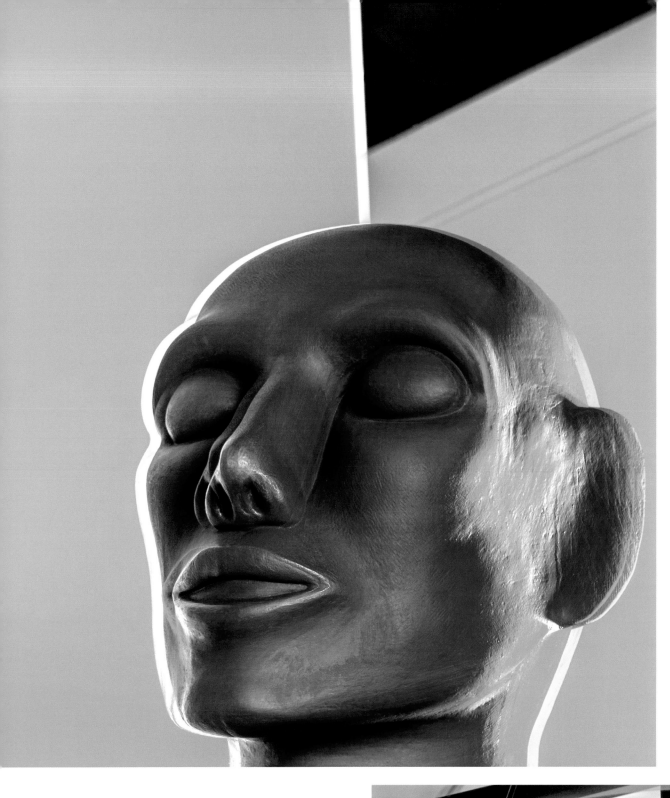

ANITA RAU BADAMI

Photography by Hassan Mohamed

Elemental, larger than life, noisy as a shout in the silent museum room, she sits naked and self-possessed despite her seat — a spiny structure, which I discover later is a vintage bottle rack. Her tongue sticks out slightly between her lips, undercutting her solemnity. She is at once defiant and playful, as if challenging the viewer: *Look, look! All you people, I am who I am and proud of it.* On the back of her round, hairless head, she wears what looks like a knuckle-duster or a stylized cockscomb. Her hands are out on either side of her big-breasted Hindu goddess body, making mudras: One a closed fist hiding secrets, clutching at knowledge. The other open, perhaps dispensing largesse, justice, kindness. Her thumbs are on the outside of her fists, instead of inside, as strange and unsettling as the cockscomb on her head, the cheeky sliver of tongue, or the bottle-rack seat. She is a rich indigo, the same colour as the gods Krishna and Shiva. Blue, the colour of beauty and the infinite sky, is all encompassing and eternal. It is the colour of the sea, from whose depths rose the earth, borne on the back of a giant turtle.

She is named after Kunti, a tribal woman from Kondagaon village, in India's Bastar district, whose story inspired her creator, the artist Navjot Altaf. According to the great epic *Mahabharata*, Kunti was the mother of three of the Pandava princes. When she was a teenager, a sage visited her father's court and granted her an unusual gift — the ability to summon any of a multitude of gods by chanting a secret hymn. Unable to resist the urge to test her new power, she called down the sun god, Surya. By him, she had a son, whom she abandoned because she feared the shame associated with unmarried mothers. Years later, at the request of her infertile husband, King Pandu, Kunti invoked three more gods and had a son with each.

The tribal woman Kunti also possessed knowledge. In the video that accompanies her sculpture, Altaf describes how this power caused the villagers of Kondagaon to declare the woman a witch. There is a photograph of her seated calmly on the ground, surrounded by a large crowd. Although there is no reference to it in the video, I assume she is waiting to be exorcised of her powers, which apparently included swallowing dozens of people.

Standing before the Blue Lady, I remember another woman who had the same earthy dignity and magical powers. Her name was Devi, and she was the cook in my cousin's Delhi home. Tall and heavy, with a smooth moon-shaped face and protruding eyes, she arrived every morning with Anamika, a woman in her mid-twenties, in tow. Devi shuttled around to the various homes where she worked in an auto-rickshaw, driven by a young man who (the chatty helper told me) was a demon subdued after a two-day battle.

"He was very difficult, this *shaitan*. He fought like six tigers," Anamika said, joining her hands in a namaste to indicate awe and respect. "Only a great power like Devi-ji could have tamed him."

The scrawny youth sitting on the steps of my cousin's apartment building, staring vaguely into the middle distance, didn't look as if he had ever possessed an ounce of aggression. I said as much. Anamika shook her head reprovingly at me. Things are not always the way they appear on the surface, she said. Only Devi could see beyond the skin of the world, for she was the goddess Kali incarnate. She cooked during the day, briskly chopping, dicing, mincing, rolling, and stirring up fragrant meals for a dozen families in the area. In the evening, when she went back to her *mohalla*, she answered her true calling — that of a divinity. She was famous for her ability to extract poisons (as Anamika put it) from lives and to cure people of all kinds of emotional, mental, and physical ailments. They queued up for miles outside her home and had to be chased away by Anamika, who I assumed was Devi's daughter or a relative but was actually her acolyte and mouthpiece, literally, for the cook would not speak. I never learned whether she was actually voiceless or had made a conscious decision not to waste her words on us paltry humans. If any of us wished to speak to Devi (there was no question of telling her what to cook; she decided the menu, and we had to like it or lump it), we were to do so through Anamika. She would repeat our queries to Devi. After a few minutes of silence, during which the cook appeared to communicate her thoughts by osmosis, Anamika would present us with an answer. Devi, meanwhile, would stare at us expressionlessly, the enormous red bindi that covered most of her forehead glowing like a third eye.

Another time, Anamika told me that Devi had, just like the Blue Lady, swallowed many people — all evildoers incapable of redemption.

"She ate my husband, too. He used to beat me, he drank, and he nearly killed my daughter. So I went to Devi-ji for help, and then my man disappeared. She ate him, for my sake. She has a big heart."

Devi only consumed those who could not be rescued. The cook's driver, the thin young man with the vacant gaze, had been hauled back from his thuggish ways and was now the recipient of her benevolence. She owned the vehicle he drove, treated him like a son, cooked her marvellous meals for him gratis, and paid him a small wage, which he spent at the cinema on Sundays, his weekly day off. That was when Devi stayed at home and washed her hair, rested, and readied herself for the coming week's battles against demons.

Magic also runs in my own family. My grandmother Mammaji, who recently died aged ninety-three after an energetic battle with life's obstacles and anyone who crossed her (and there were multitudes), claimed to have the power to curse people. She was the first daughter descended from a line of first daughters, and this, according to her, granted her access to potent magic. As a child, I believed her and was terrified of her bright green eyes, her sharp tongue, her intense rages. A product of her time, she was married at thirteen and had her first child at sixteen. None of this stopped her from learning to read and write six languages, including English and German, or from giving her own daughters the thing she most desired — education and with it the power to do anything they wanted with their lives.

I think of her often: A small woman, large with ambition. Raging. Perched uneasily on a spiky seat of other people's expectations and her own unrealized dreams. Her tongue out at the world. My Blue Lady.

Deepali Dewan Responds

The strip of metal on *Kunti*'s head, looking like the proud crest of a rooster, refers to the main handicrafts produced in Kondagaon. These various handicrafts are collectively known as Bastar arts (after the geographic region) or Dhokra arts (after the artistic community itself). They include metal sculptures made from a copper alloy, or bell metal, generally with tin as the additive. Using the lost wax process, Dhokra artists produce images of gods, goddesses, and animals, as well as figurines and decorative objects. *Kunti*'s strip highlights the material: a chunk of pure metal transformed by the artist's hand. In this way, it symbolizes creative potential, self-forging pushing the creative limits of one's mind.

Her tongue sticks out slightly between her lips, undercutting her solemnity. She is at once defiant and playful, as if challenging the viewer: *Look, look!*

PASSENGER PIGEONS

Allan Baker,
Senior Curator
of Ornithology

Passenger pigeons were once so numerous that a flock passing over Cincinnati in 1870 was estimated to be 515 kilometres long by 1.5 kilometres wide, and to contain about two billion birds. Such flocks could darken the skies, and the noise made by their flapping wings or when they landed en masse was likened to the sound of thunder.

Even more amazing, the species was hunted to such an extent that it went extinct in 1914 — when the last living bird, a female called Martha, died in the Cincinnati Zoological Gardens. Prior to that, a single hunter in Kentucky won a prize for killing 30,000 birds, and much larger numbers were caught by professionals using traps and nets.

While the birds were a welcome foodstuff for the early settlers, they were also treated as pests: large flocks could destroy grain crops in spring and summer. One reason passenger pigeons succumbed to human onslaught was their low reproductive rate; they laid only one egg per breeding attempt. Pairs would also abandon the fledged young from one brood and moved to another location to try to raise another.

The ROM has the largest collection of passenger pigeons in the world: 134 stuffed skins, eight skeletons, ten eggs, and one nest.

The ROM has the largest collection of passenger pigeons in the world: 134 stuffed skins, eight skeletons, ten eggs, and one nest. Fortunately, a patron of the museum, Paul Hahn, decided to collect as many mounted birds as he could find and to preserve them for future generations. In 1957, just five years before his death, he was encouraged by James L. Baillie, an assistant curator in ornithology, to request information on passenger pigeons and six other extinct species of birds from other museums and private collections. This resulted in more than a thousand replies and the documentation of 1,532 skins, or mounts, and sixteen skeletons.

What Hahn could never have imagined is that the specimens he acquired and later donated to the museum contain a treasure trove of ancient DNA, preserved in the toe pads that support the foot bones. From a female in the ROM collection, researchers in the United States have obtained samples that will allow her genome to be sequenced in the near future. We might one day have the molecular technology to transfer her DNA into a living relative, and to bring passenger pigeons back from the dead.

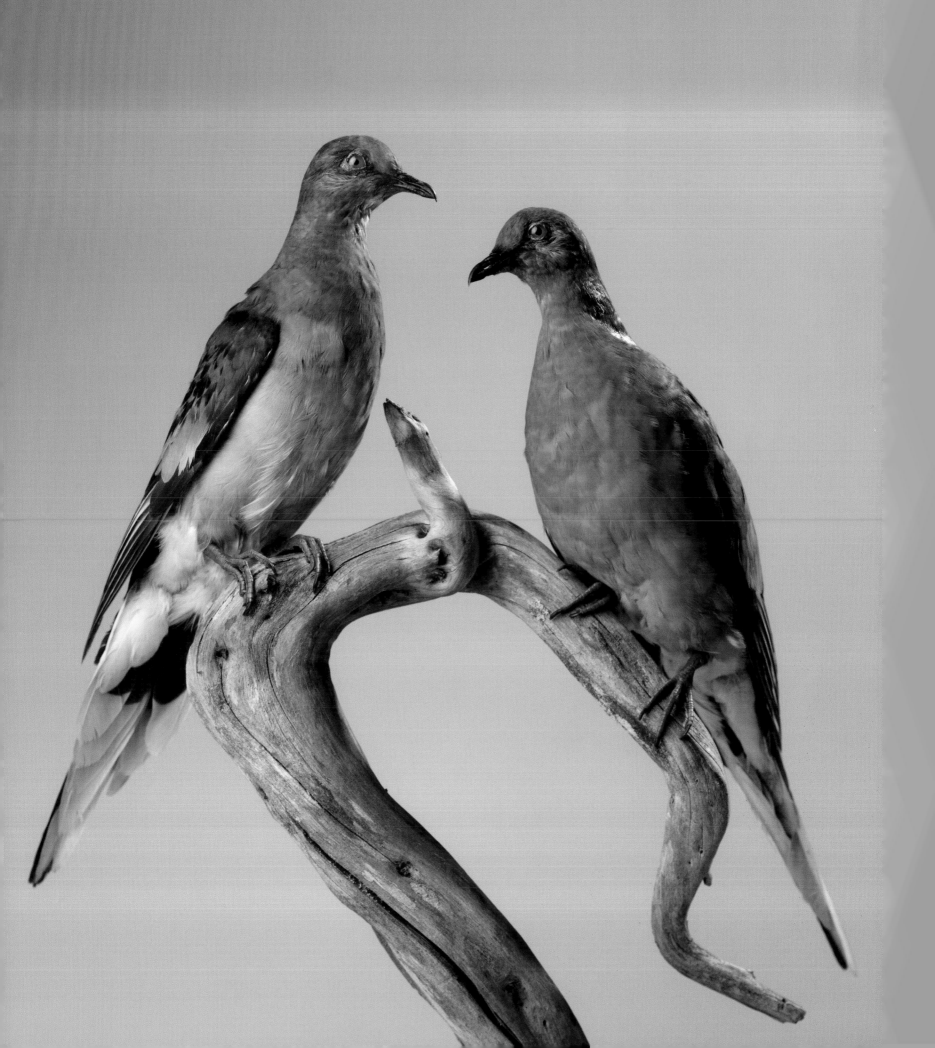

ROBERT BATEMAN

Photography by Genevieve Blais

It may be the time of man or it may be my time of life, but at the age of eighty-three I am sometimes overcome by elegiac feelings (I have been known to mutter, "When I was a boy...."). It is nevertheless true that when I was young, the Royal Ontario Museum was a large part of my life, my home away from home. I actually lived near the Belt Line Railway and its adjacent ravines, a ribbon of nature running around Old Toronto. I could climb over our back fence, jump across the creek with its frogs and minnows, and be in a wild world of giant willows, maples, and beeches. I could squint my eyes and imagine Indians (as we called them then) on moccasined feet, following a woodland trail to the Don River.

My other home, the ROM, found a place in my heart when I was ten and my mother sent me to the Junior Field Naturalists' Club. Each meeting began in the museum's theatre, and we then split up into groups. Mine was the bird-carving group run by Frank Smith. We would take the elevator up to the fourth-floor Brodie room. That's right, the fourth floor. The public space ended at the third floor, and so here I was a kid, already in the inner sanctum — the sacred space where the illustrious Brodie Club met and the collections of mammal species were stored. (Later, when I was in my twenties, my own collections of mice, shrews, and bats, all properly stuffed and labeled, would join the skins prepared by famous Canadian naturalists.)

After the carving class, I would go down to the third floor with its the natural history displays, my real home, and study the cases, the paintings, and especially the dioramas. In my early teens, I transported myself beyond the boundaries of Toronto through books. Every two weeks, I would ride my bike to the Toronto Public Library at St. Clements Avenue and Yonge Street. Each year, I read every book by Ernest

Thompson Seton and Sir Charles G. D. Roberts. Reading a book can be a magic carpet, but the best magic carpets for me were always the dioramas — better than any painting or photograph.

You could stand close to the glass and be immersed in a three-dimensional world of illusion that blended authentic nature and clever painting. My favourite diorama, by far, was the Passenger Pigeon Habitat Group. It took me to another time and place: The time was the nineteenth century (still one of the most interesting periods, for my taste). The place was near the forks of the Credit River, not too far from where I later built my first dream house. The forks are part of the great swath of Ontario landscape known as the Niagara Escarpment. Little did I know that between 1975 and 1985 I would serve on the Niagara Escarpment Commission, tasked with drawing up plans to preserve and protect the region's traditional landscape.

I could get lost in that passenger pigeon diorama. The season was early April, perhaps my favourite time of year. Without the heavy green garments of summer or the monotonous snow coat of winter, we can see the flesh and bones of the land. The colours are gentle and subtle but betray the hints of autumn and the anticipation of spring to come. (At that age, I had not yet heard of Andrew Wyeth, but already the colours and textures of early spring at Chadds Ford, my favourite artist's favourite landscape, were imprinted on me. It is a countryside that sees a gentle interface between nature and the hand of man. Industrial agriculture, in sharp contrast, produces an interface that is monotonous and brutal.) The diorama's ecosystem was that of a beech and sugar maple forest, remnants of which still survived in the ravine behind our old house. Because the deciduous trees are not yet in leaf, the spring sunshine penetrates to the forest floor, rich with decades of leaf litter and moisture from the melting snow. This encourages one of nature's spectacles: the spring forest flowers. Hepaticas, bloodroots, trout lilies and others were reproduced in wax in this habitat group. The real ones were — and still are if they have not been bulldozed — to be seen by the observant eye all around southern Ontario.

The diorama let me I gaze upon my own world, recreated. The great American novelist Willa Cather wrote, "What was any art but an effort to make a sheath, a mould in which to imprison for a moment the shining, elusive element which is life itself — life hurrying past us and running away, too strong to stop, too sweet to lose?" The passenger pigeon display recreated a world that was by any definition a work of art. It was an effort to capture a moment in time, a moment that *could* have happened. And that, I realize, is what I have done throughout my career. In a sense, the artists that made the habitat group were faking nature, contriving it to seem uncontrived. This is what I strive for in my paintings.

It happened that the diorama's lead artist was T. M. "Terry" Shortt. It also happened that he became my mentor. In those days, in the '40s, the exhibit staff worked on Saturday mornings, and I had the privilege of dropping in behind the scenes after my carving class. I was a groupie. I hung out with the ornithology experts, and those museum men became role models who taught me how to observe the natural world. I remember showing Terry a feather I had found in Algonquin Park. I did not know what it was, so I pressed it in my copy of Peterson's *Field Guide to the Birds*. When I showed it to him, he said he was not exactly sure what it was. It was either the third or fourth primary from the left wing of an immature female goshawk. When we compared it to the museum skins, it turned out to be the third primary.

Of course the main point of the diorama was to show the passenger pigeon. When the display was unveiled in January 1935, I was four years old and the last passenger pigeon, a female named Martha, had died at the Cincinnati Zoo twenty-one years earlier, the year my mother turned fourteen. Thirty years before that, passenger pigeons were so abundant that their flocks darkened the skies for hours, even days, as they flew over. They were an important food item, and they were shot by the millions. In 1869, in Hartford, Michigan, three train car loads of pigeons were shipped to market each day for forty days — a total of 11,880,000 birds.

In the nineteenth century, farmers along the Don River advertised how many bushels of Atlantic salmon they expected to harvest in a given year. In Hamilton Harbour, Native fishermen risked sinking their canoes by loading salmon to the gunwales, before they went back for more. The story of the Great Plains bison is legendary. In my own time, I watched the foolish obliteration of the Newfoundland cod fishery. We live in a disappearing world. If you like to say goodbye, now is the time. You can call me sentimental, or perhaps elegiac, but I do not celebrate these disappearances.

It is coincidental that Willa Cather wrote those bright words about art around the time that the last passenger pigeon died. But now even the passenger pigeon diorama has disappeared. On my last visit, I was told that it and all the others had been demolished. These were works of art, and they had the ability to move hearts. I trust that the museum is still winning young hearts and minds, and that the odd teenage groupie is still allowed to feel at home behind the scenes. And yet… The saying goes, "Well, you can't stop progress," and maybe it really is the time of man. All I know is that during my time on earth, I have said goodbye to many precious things, the ROM dioramas among them.

BLACKFOOT ROBE

Arni Brownstone,
Assistant Curator
of Ethnology

Armed conflict between North American Indian tribes featured prominently in nineteenth-century life on the Great Plains, and out of this activity grew the important genre of war painting. Usually, such paintings recorded personal war achievements and were executed in a pictographic or pictorial narrative form that rendered their content readable. They employed highly stylized figures and economical ideograms tailored to quickly convey the essential aspects of the events portrayed. The protagonist usually painted his own war deeds on his animal skin teepee, shirt, or robe — encircling himself with a legible display of his exploits and signalling his elevated status within the community.

Our example is one of nineteen extant pre-1850 war robes. While it came with no cultural documentation, it almost certainly belonged to a Blackfoot warrior, whose people occupied southern Alberta and Montana. It displays a number of features common to Blackfoot paintings: stiffly styled figures, either with rectangular torsos and V-neck shoulders or elongated X-shaped torsos, often rendered with missing limbs; an emphasis on captured trophies, sometimes enumerated in discrete tallies; and a preponderance of scalp and abstract hand motifs.

One can identify twenty-one separate vignettes, depicting more than eighty war deeds, including the capture of some thirty-nine weapons and the injuring or killing of thirty enemies. Fifty-two hand motifs stand in for the robe's protagonist — a short-form device identifying his many exploits.

The robe's previous owner, Deborah Wolton, discovered it in 1958. She was fifteen at the time and rummaging through a jumble of fabrics, hangings, and rugs on a large kitchen table, at a contents sale at Poltalloch House — home to the head of the Malcolm clan in Argyllshire, Scotland. After the ROM acquired it in 2006, a member of the Malcolm family suggested that when he was a child it belonged in the house's "dressing-up room." There, along with other exotic clothing, it was kept under lock and key, until such time as his parents performed skits in costumes for their guests.

> War robes employed highly stylized figures and economical ideograms tailored to quickly convey the essential aspects of the events portrayed.

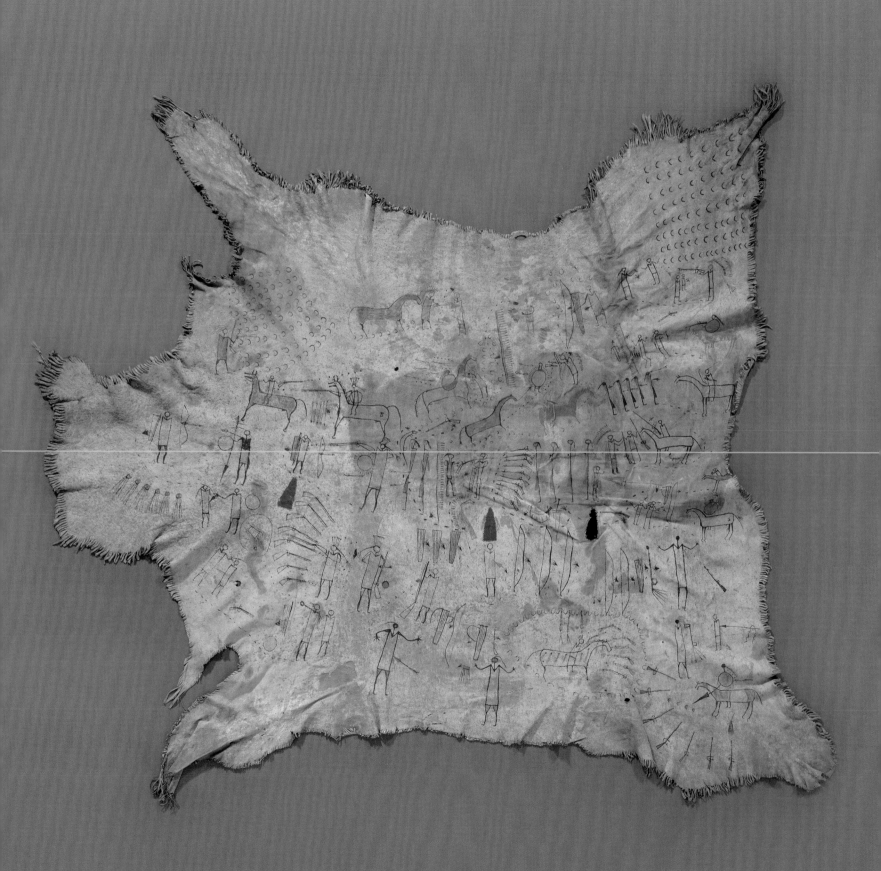

Deborah Wolton discovered the robe in 1958. She was fifteen at the time and rummaging through a jumble of fabrics, hangings, and rugs on a large kitchen table, at a contents sale at Poltalloch House.

Although the robe came with no documentation regarding its Indigenous origins, there is a glimmer of hope that information may yet surface. In a letter written to the ROM in 1960, Letitia Macfarlane noted that Cree or Blackfoot chiefs presented a robe to her great-great-grandfather Governor MacTavish of the Hudson's Bay Company. It left her home when she was a young girl, at about the time of World War I, and she could only recall that it was covered in black marks like a crow's foot. If those marks were one and the same as the hand motifs on the ROM's robe, then it would be certain that ownership had transferred from the Mactavishes to the Malcolms. Should further research confirm this, we would have an opportunity to learn even more about one of the most important and interesting Plains Indian paintings in existence.

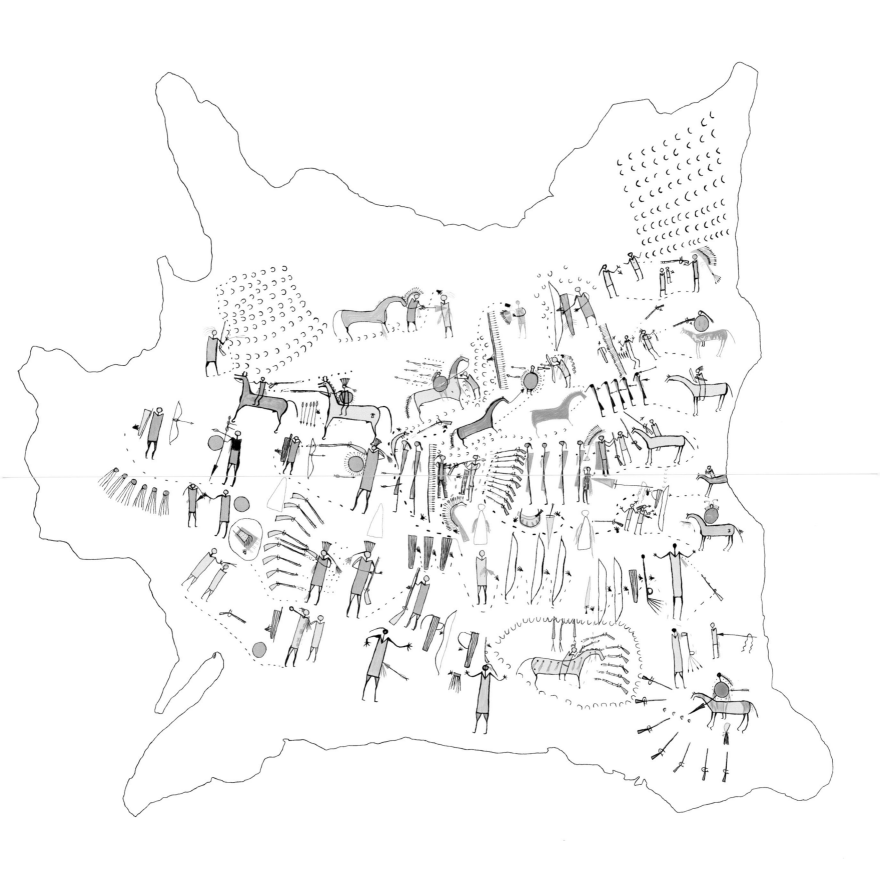

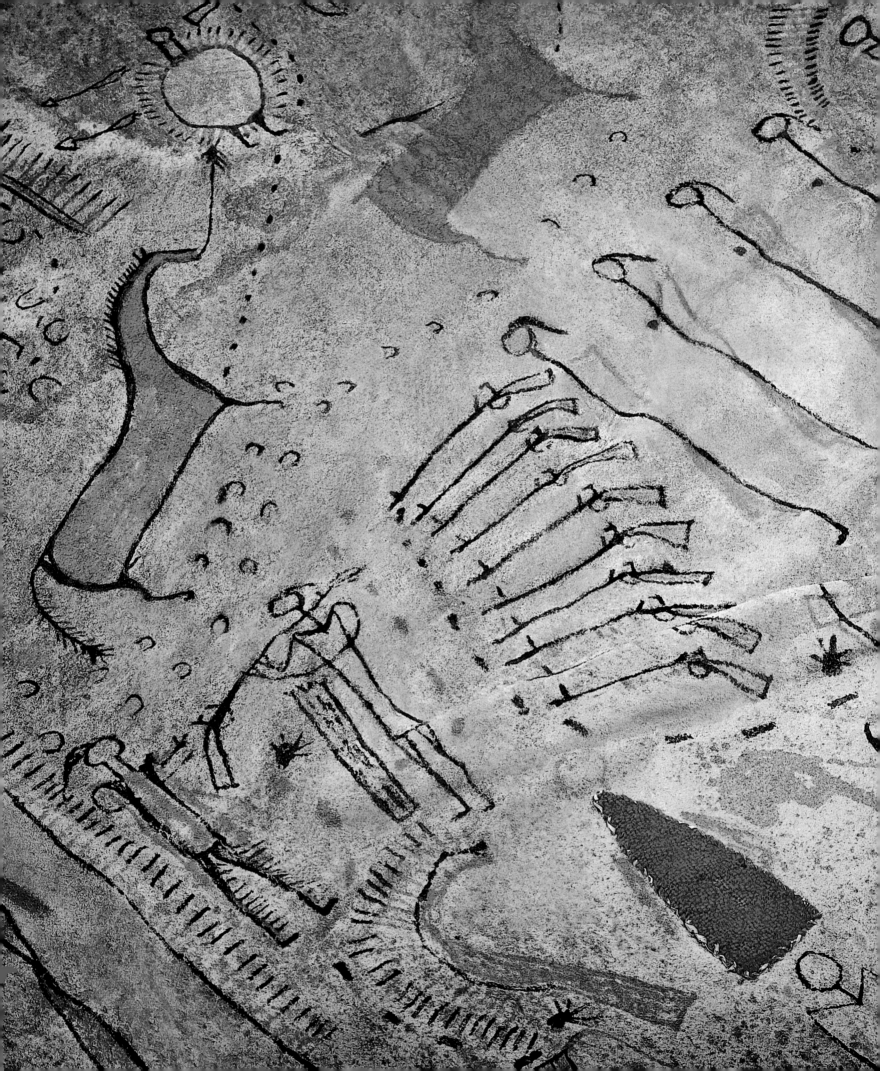

JOSEPH BOYDEN

Photography by Takumi Furuichi

1. Blackfoot

Nobody knows which warrior was honoured with this robe. His name, the one possession that can never be taken away, a name he possibly found on a vision quest during puberty or after he experienced his first military action, is lost to history. But that's him, right there, either wearing his feather bonnet or carrying his painted shield, counting coup or outright killing his enemies, at least thirty of them on the hide.

I'm no Blackfoot expert, but I know they call themselves Niitsitapi and are made up of three lines: the Piikani, Kainai, and Siksika. The Piegan, the Bloods, and the Blackfoot. They possess these names. One of them, a war bearer, once possessed this robe. It was the highest honour to have one, highlighting your bravest achievements, painted for you.

An untrained eye might comment that the robe's illustrations are childlike. But if you look closely, you'll see our protagonist represented by a skilled abstract hand. You'll see single actions or whole sequences of them. You'll see ideographic devices: dashes for footprints and dots for gunshot traces. Don't let this robe's simplicity fool you. It possesses the story of a warrior's life.

This robe was once possessed by a person whose name we do know. A Scottish woman named Deborah Wolton. When I heard that, I asked myself, how did a Scottish woman come to own this unknown Blackfoot man's history?

2. Piegan

When I was a child and enthralled with learning everything I could about the First Peoples of North America, I distinctly remember hearing the phrase "Piegan Indian" and mistaking it for "Pagan Indian." Being an altar boy, I knew that pagans were bad. They didn't believe in Jesus or God or Catholics. Pagans were wild and

I wanted to know more about these Pagan Indians. I wonder if Deborah Wolton, the Scottish woman who once possessed this robe, was as fascinated by them as I was. I bet she was.

drank wine and had things called orgies where everyone got naked and touched one another. I wanted to know more about these Pagan Indians.

I wonder if Deborah Wolton, the Scottish woman who once possessed this robe, was as fascinated by Pagan Indians as I was. I bet she was. I read the story of how she came to the robe, and it to her. She and her three half brothers used to play cowboys and Indians as children on the windswept western shores of Scotland. She liked being the Indian best, making headdresses out of seagull feathers, fashioning bows and arrows from hazel wood, and constructing teepees to live in. Perhaps she had been a pagan in an earlier life.

Deborah's family attended an estate sale of another family downsizing from a sprawling Victorian mansion to a castle. Apparently, castles are actually smaller than sprawling Victorian mansions, and this family had to get rid of some stuff. When Deborah stumbled across the Blackfoot robe in one of the mansion's many rooms, she begged her mother to bid on it. From what she remembers, her mother was the only one to make an offer. They paid little for the pagan artifact.

Deborah loved the robe very much, using it sometimes as a bed cover, sometimes as a floor rug, and sometimes as a thick blanket thrown across the back of her pony. If this sounds like disrespect of a historical artwork to you, I say Deborah was just a kid. And my money's on the spirit of that pagan Blackfoot warrior, who once and still possesses this robe, feeling good and even smiling in the knowledge that his hide was used for its purpose. His art, in some small way, imitated life.

3. Blood

The Blackfoot are known for their practice of corralling wild bison, forcing them into natural funnels created by the knifed-out curvature of certain prairie landscapes, where the animals, herded now and panicked, stampede headlong over cliffs. The most famous of these places is called Head-Smashed-In Buffalo Jump. You might think the name came from the poor creatures that fell to their deaths, but it's supposedly taken from the legend of the boy who was so fascinated by raining bison that he stood below the precipice and had his own head caved in by the tumbling beasts.

I feel more than a little uneasy speaking only about the violent ways of a people — the hurt meted out and the anguish absorbed. This robe, commemorating a warrior's greatest feats, does not only celebrate war but also celebrates a life. Yes, it is complex and ironic, as complex and ironic as how a Scottish woman came to posses this robe because a family had to downsize to a castle, and how now it rests in the Royal Ontario Museum. Because this skin celebrates violent accomplishments, it will always be judged through that lens. But we should never judge a people solely in this way.

Did that young Scottish girl who once used this robe as her blanket and her rug and her saddle understand the importance of her possession? She relates that more than forty years after she'd grown out of playing cowboys and Indians, when she was a full-grown woman, she cleared out the detritus from under her bed and rediscovered a warrior's heart song, folded into a carrying case. I picture the moment: this woman pulling the long lost hide from under the place where she slept and dreamed, the sound of a thousand hooves pounding prairie earth in a great rumble, the greatest pounding you could ever imagine; and how she spreads it out onto her floor and recognizes the bonnet, the shield, the red hand of her old friend, the silent hooves that leave earth and scramble for purchase — a purchase they will not possess until they meet the ground below.

PARADISE OF MAITREYA

Ka Bo Tsang,
Research Associate

Arriving in China from India in the first century CE, Buddhism preaches that life involves suffering because of desire. All beings must undergo successive rebirths, each rebirth conditioned by the deeds of a former life. The only hope of escaping the perpetual cycle is to attain enlightenment by following the teachings and practices of Shakyamuni, the historical Buddha.

In a Buddhist scripture called the Maitreyavyakarana Sutra, Shakyamuni designates Maitreya as his successor. Maitreya is a Bodhisattva, one who forgoes nirvana in order to save people, residing in Tushita heaven. Shakyamuni also predicts the course of events that will take place in a future time: Maitreya's rebirth on earth in the blissful kingdom of Ketumati, his attainment of Buddhahood, and the three assemblies he will hold to save the world from suffering.

This remarkable mural presents an abridged vision of those events: Seated on a throne at the centre, Maitreya, as the future Buddha, delivers his first sermon in the company of major Bodhisattvas, Asanga and Vasubandhu; minor Bodhisattvas; disciples Kasyapa and Ananda; and *kalavinkas*, half-human and half-bird heavenly beings who emit wonderful sounds. At both sides are scenes of the king and queen of Ketumati, each surrounded by a barber, attendants, and divine guardians, and undergoing tonsure, a rite that signifies a devotee's willingness to join a monastic order. They represent the first converts to Buddhism, setting an example for others to follow.

Since the fifth century, Maitreya has been one of the most popular Buddhist deities in China — venerated both as a Bodhisattva and as the future Buddha. Devotees have looked forward to being reborn in his heavenly abode; receiving his teachings; and being reborn with him for the last time in Ketumati, a pure land on earth. Painted and sculpted images of Maitreya — an icon of hope and solace — have been worshipped in believers' homes, in temples, and in mountain grottoes.

The ROM's mural, painted by Zhu Haogu and Zhang Boyuan in 1298, originally belonged to the Xinghua si (Monastery for the Promulgation of the Buddhist Faith), located near Jishan county in southwestern Shanxi province. In 1928, while serving in Kaifeng as the Anglican missionary bishop of Henan, William C. White negotiated its purchase for the museum. It was not on public view, however, until 1934, after our ever-resourceful founding director Charles Trick Currelly procured an expert to conduct conservation treatments and mounting procedures.

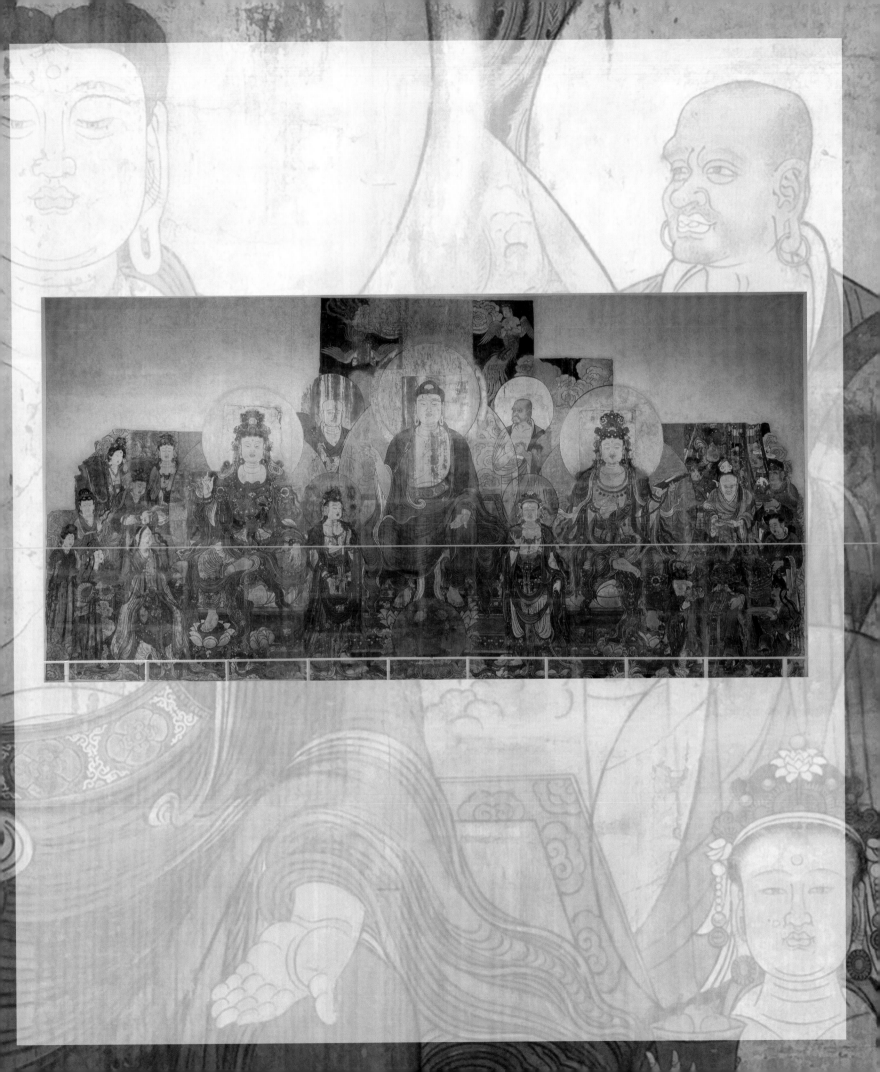

WAYSON CHOY

Photography by Lisa Takkinen

I have always thought of museums as haunted places, their great exhibits imbued with stories waiting to be told.

I must go back fifty years, back to 1963 and the first days of Toronto's Markham Street Village, when a friend introduced me to the portrait artist Stella Grier. I had recently arrived from Vancouver. I wanted to be a writer, and Stella loved to read. We became fast friends.

A member of the Royal Canadian Academy of Arts, Stella had just turned sixty-five and was still active as an artist. "Simply can't afford to stop," she said, and admitted that commissions were scarce. "Photography has taken over."

In the '30s, she had also worked as a restorer in the Royal Ontario Museum's archaeology department. Out of the blue, I asked if she had ever worked on anything Chinese. "So happens that I have. Come with me." She stood me before a mural that same day: *The Paradise of Maitreya*.

I remember being awed by its great figures, so beautifully drawn in black ink and so exquisitely costumed in their robes of red and green. (I'm slightly colour blind, so the greens have always seemed more grey to me.) The central figure depicts the great Buddha of the future, Maitreya, as if he has just lowered his arm and opened his palm, awakening a drift of unearthly powers to stir up his sleeves — the invisible made visible.

A king and queen sit to the right and left. Before Maitreya, their heads are shorn, ready for their conversion to Buddhism. Their faces are tranquil. They have given up all that made them royal, surrendering everything material and inessential, even the locks of their hair.

Stella would be my teacher. She took my shoulder and pushed me toward the painted wall. I protested, "Am I allowed to stand this close?"

Drawn and painted in 1298, during the Yuan dynasty, on Shanxi province clay, the massive mural was eventually sawed into numbered parts, taken down, and brought to the ROM, where it was reassembled and restored to its tallest point of five metres and to a width of nearly eleven metres. Facts and figures noted, Stella continued: "According to the myth, Maitreya never forgets a kindness. He's the Buddha of Kindliness."

How odd. From our very first meeting, the quality I associated most with Stella was kindness. In fact, after we became friends her thoughtfulness towards me (as she was to many others) reminded me of the warmth of my two aunts, Mary and Freda. Whenever I tripped or tumbled as a child, they picked me up. Steadied me. Fed me. Similarly, in the years when I was launching myself as a freelance writer of reports and pamphlets, Stella reminded me there was no need to panic when an assignment fell through. She, too, steadied me. Fed me.

Stella brought me to the ROM because I had told her how, at fifteen, I had longed, not a little desperately, to emulate Françoise Sagan, who wrote the 125-page bestseller *Bonjour Tristesse* at eighteen, and at twenty-one was featured in *Life* magazine, her elegant hand

resting on a fiery red Jaguar. "I'm now six years too late for that kind of success," I said, not quite matter-of-factly.

But Stella took my dreamy disappointment seriously. She'd made up her mind to keep me anchored. "One day you'll write your book," she would say to me. But looking at the credit union report I was polishing, I found that hard to believe. Finally, she led me back inside to stand before *The Paradise of Maitreya*. She would be my teacher. She took my shoulder and pushed me steadily toward the painted wall. I protested, "Am I allowed to stand this close?"

With a nod of her grey head, and a conspirator's wink, she urged me to lean forward. I resisted. Her eyes sparked encouragement — *C'mon, do it*. She pressed until my hair nearly brushed the surface. She put her palm under my chin. "Look up," she said. "See anything?"

What was I supposed to see? All I saw was mural, until I noticed something odd.

"There's a kind of rough-looking patch on that one Buddha's head," I said. She asked me to step back a few feet. Like a shadow, the patch gradually vanished. It was the conservator's rule: make any touch-up visible at six inches, invisible at six feet. Beaming glints of daylight bounced off her thick lenses. "I had to paint that part of the halo and face of Buddha for hours and hours, just in one direction. It was painstaking." During the '30s, this one-directional technique was done to assure future art historians could clearly differentiate a restorer's repairs from the original work.

"Never mind all of the portraits that I've painted before and since," she laughed, eyes sparkling. "Who would ever know I painted on a 700-year-old canvas!? I won't even rate a footnote."

Stella's outburst made the masterpiece even more beautiful to me. The wall had been salvaged from an abandoned monastery, had been broken apart, crated, and delivered across an ocean and a continent. Finally, all the hewn scars were mended, touched up, restored. A team of specialists had, like Stella, dedicated themselves to conserving those sacred faces, labouring anonymously on this wall. Unknown. Unnamed. And, frankly, who would care?

"Wayson, how many pilgrims do you think have bowed and prayed before these painted Buddhas?"

"A million?"

"I counted at least a couple more when I was last here. Imagine how I felt when I saw these two elderly Asian gentlemen close their eyes, actually *bowing*." Her voice fell to a sudden hush. "This wall has to be haunted." She took my hand and fell into a comrade's whisper. "Do you think you and I might close our eyes and bow, just this once?"

"I guess," I said. I kept my eyes half open, in case someone walked in and saw us. I barely tipped my head. Stella took my hand and looked up rather wistfully at Maitreya.

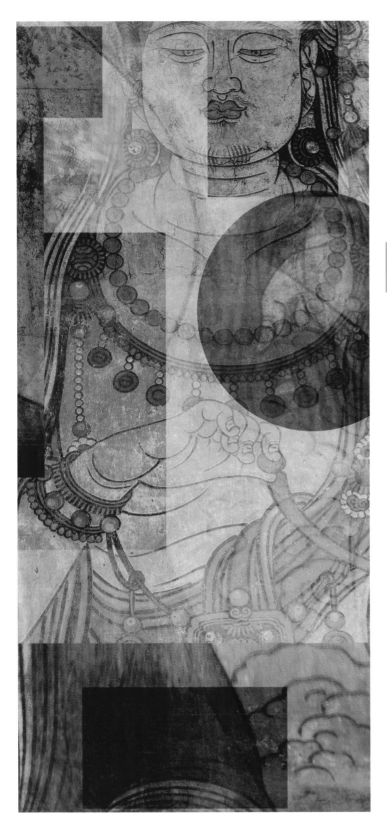

"I can only hope I've done something important during the time I've spent on this earth."

"Even if no one knows your name?"

"Oh, that's not important," she said, and her smile broke into laughter. "Who needs to remember me?"

I'm seventy-four now, and revisiting the mural I realize that Stella's early restoration has disappeared. The rough patch is gone. I'm not surprised. Many others have since worked to conserve it. Still, you might even agree as you take in these last words, the Buddha of Kindliness has not forgotten Stella.

Ka Bo Tsang Responds

The Paradise of Maitreya arrived in 1929 in sixty-three sections. During the summer of 1933, George L. Stout, from the Fogg Art Museum in Boston, travelled to Toronto to reassemble the sections and reconstitute the original mural. He came with two student assistants.

The project involved tedious work: After smoothing out the rough edges of each section, Stout's team cleaned the paint surface, filled losses, and reattached loosened pigments. They then applied a protective layer of polyvinyl acetate (PVA), before scraping away the clay on the back. To consolidate the remaining paint layer, they next applied PVA, kaolin, and putty (made with the detached clay); and removed paper and cloth facings, which had previously been adhered to the paint surface. In the final steps, they attached related sections to Masonite panels, and affixed these larger panels in proper order to a wooden grid frame. Finally, they "inpainted" the mural, making the joints and some larger areas of paint loss less noticeable.

Amazingly, this elaborate process took just three months. Considering the mural's size, I've always wondered if others worked on the project with Stout and his assistants; the archival record has been silent on this point until now. I was delighted to learn that Stella Grier collaborated on the project. Although her contribution — "a kind of rough-looking patch on that one Buddha's head" — was lost during another round of conservation in 2005, she can now be remembered as part of the earlier undertaking.

GEM-QUALITY MOLLUSCS

Dale R. Calder,
Curator Emeritus of
Invertebrate Zoology

Few scientific appellations match the splendour evoked by the Latin name of a rare mollusc called *Conus gloriamaris* (glory-of-the-sea cone). On hearing it, images come to mind of turquoise waters, palm-fringed tropical isles, pristine reefs, and warm sea breezes, all far away from the commotion of city life. Few species have been more sought after and treasured by conchologists, although the shell — pleasing spindle shape, golden brown in colour, with numerous tent-shaped markings — is no more beautiful than hundreds of others.

Historically, its attraction has been its perceived rarity. Found in the Indo-Pacific region, fewer than a handful were known to exist when British shell collector Hugh Cuming travelled to the Philippines in 1837, in hopes of locating a specimen. After a long, fruitless, discouraging search, he turned over rubble on a reef one day and — to his wonder — found two imperfect shells. According to legend, he nearly fainted in ecstasy.

The lure of the species continued to spread. The value and importance of existing specimens were enhanced when the only reef the species supposedly inhabited was believed to have been destroyed; noble *Conus gloriamaris* was feared extinct. Meanwhile, stories circulated about the fate of the few in existing collections. One from the American Museum of Natural History in New York was reported stolen. Another was said to have been dropped and broken while being examined. For nearly two centuries, the glory-of-the-sea cone was the most coveted and valuable of all shell species.

The development of the self-contained underwater breathing apparatus (SCUBA) altered its standing. In 1957, a live specimen was found by a diver in the Philippines; the discovery received widespread media coverage. Shortly after, some seventy specimens were found by a team of divers. Happily, the species is now known to be relatively common in the western Pacific. Yet its appeal has diminished but little. A fine shell collection lacks prestige without this fabled species, and many collectors have been greatly disappointed when shells they hoped might be *Conus gloriamaris* were shown to be similar, more common ones. No longer the most valuable of mollusc shells, gem-quality specimens can now be acquired for a few hundred dollars.

With a half-dozen specimens in its collections, the museum periodically displays *Conus gloriamaris* in exhibits and galleries. Fort Knox is noted for its hidden gold; the ROM's treasures are a store of value visitors actually get to see.

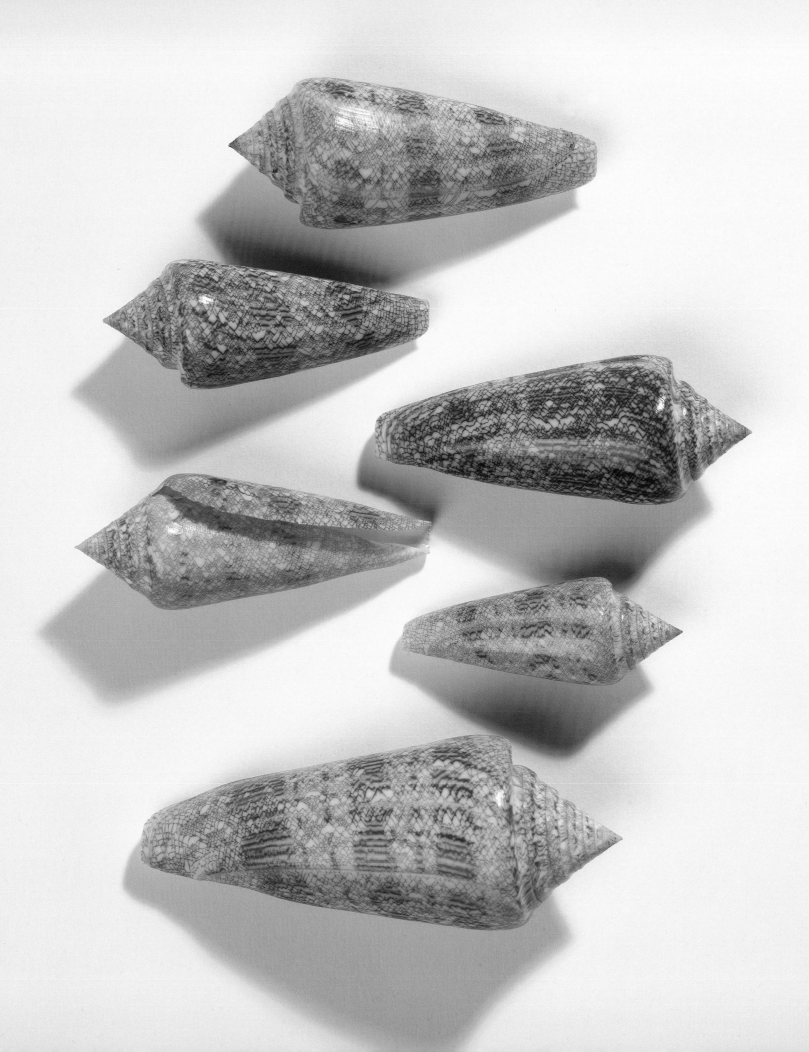

AUSTIN CLARKE

Photography by Tess Goris

Our thoughts, and lips not made to be fashioned by French sophistication,
mouthed the words in the Barbadian native language,
as "mullusses"; and we lived through the years
of hot sun, the blistering heat liked by Englishmen and madmen,
ignoring the slow brawling, deceiving sloth,
for not lacking education and the correct
pronunciation of "molluscs."

Mullusses are the first cousins of sea eggs,
a safe tonic for sex that rises with the waves,
an illegitimate brother of the sea egg
who tears the heart apart.
These eggs of the sea, camouflaged
in the same colour as the sand,
in pearl and pink, smooth as a woman's skin,
molested by hot sun,
the colour almost of milk,
depending almost on the geography of time
and the colour of the time.

Nelson's West Indian Readers, book three,
is the bible of that education,
found like illegal goods
abandoned on the wharf,
like smuggled goods
between the pages of the reader by J. O. Cutteridge.

Cutteridge was a smart man...assuming he was a man.
I never looked him in the face, in a photograph.
But he told me, and all black boys
throughout the British West Indies,
that "Dan is the man in the van;"
and that "Twisty and Twirly are two screws"
...screwing the comma sense out of us!
"Hickory, dickory, dock!
The mouse ran up the clock.
The clock struck two,
The mouse ran down..."

At this time of daydreaming life, I recited the poetry
of Mr. Cutteridge, reading the inflammatory poetry he selected;
and all the while I dreamed of being a British sea captain,
like the Lord Horatio Nelson, Admiral of the Fleet.
Mounted in all of his one-handed glory,
standing erect, in black and black-faced dignity,
lording it over black men
and boys, and black girls too,
walking below him,
below the bowels of his horse,
over them in attitude
and in truth.
To take to heart
his unreasonable plea:
"England expects that every man"...and woman...and child
"will do his"...and her..."duty."

This was the first gathering of mullusses in my life.
I could see myself, now, in thick black uniform —
covered in shroud of shining oilcloth, buffeted
by wave in storm, and wind in the battlements;
battling the waves, those same waves — which later
in the mouth of a different poet
was brought to me through the torment
of the waves, from Africa, to live...
which slave can "live"...on a sugar plantation,
or in a hotel owned by the children of the Lord Horatio Nelson,
Admiral of the Fleet?

In song and in history, those very same waves carried a different
 song and poetry,
a different voice. And music
in the ocean, the Atlantic Ocean, conveyor belt of caught slaves,
now battling the waves, those very same waves, thick like words of
 love and promise,
like a penis of love that was used.

Those very same waves, in the mouth of a different poet,
had brought me through the torment of waves, from Africa, to live
amongst the bramble of broken limbs of crabs and other mullusses,
 to live...
But what slave can "live" amongst the broken limbs of a sea crab
 after he has escaped the treachery,
the black monster? The Cobbler.
Cobblers lie beside the civilized sea egg, or pink-faced sea crab.
 One is white; one is black.
They live in greater harmony, below waves,
pounded by raucous voice and warm urine,
hidden in greater safety from the eyes of fishermen
and of "tourisses" who smash them up, by accident,
against the sturdier bottle of Mount Gay Rum, to take to husband,
 and boyfriend,
to show they have seen the hearts of beauty.

This ambition lies exposed to ridicule,
in proportions equal to the madness
of political ambition seen through the wrong eyes.
But I wanted to be a Sea Scout.
A Scout who rides in the Dunlopillo of soft waves,
the wind like a taste of mother's milk blowing into his face,
sharpening the appetite of love, of mullusses
at the pearly gate, at the bottom of the sea like a carpet of pearls.
I want to be a Sea Scout! Like Lord Nelson!

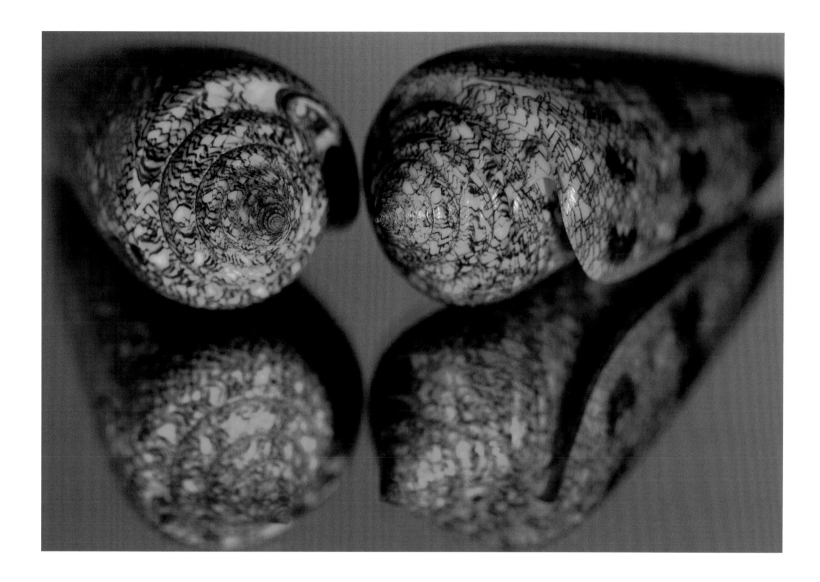

If you wasn't my son, that I borne, in such pain,
I would kill you,
right here and now.

But that weight in my cotton-bag blanket and the top of her
 cotton socks
came from her husband. Deep sleep came cool and heavy.
I slept the sleep of righteousness and of thieves.
Nelson's statue slept heavier than me.

Let us leave the mullusses alone; leave them to the boys,
meddling with the women tourisses up in Toronto

and Buffalo,
and keep to yourself.
And leave the sea alone.
Be a Land Scout; forget the Sea Scout business.
Keep your two foots on land.
Leave the mullusses round here.
I want you to learn to do the crawl and the backstroke.
And to search the bottom of the sea.
And to see real molluscs one of these days
get drown.

HUDSON STRAIT KAYAK

Kenneth Lister,
Assistant Curator
of Ethnology

*"The unique articles are all being put in cases,
and will be on exhibit within a few days."*

The above announcement was published in the Toronto *Globe* on March 31, 1915. It referred to a collection of artifacts amassed by Robert J. Flaherty (1884–1951) and acquired by the newly opened Royal Ontario Museum. Over the previous four years, at the behest of Sir William Mackenzie, president of the Canadian Northern Railway, Flaherty had searched for iron ore deposits along the eastern and northern coasts of Hudson Bay. While doing so, he collected a wide range of artifacts and became interested in filming Inuit life. It was his 1922 silent docudrama, *Nanook of the North*, that garnered him acclaim as a documentary film pioneer.

The skin-on-frame Inuit kayak came from the Hudson Strait region; it displays the characteristics of the eastern Canadian Arctic.

A 6.6-metre skin-on-frame kayak was among the artifacts referred to by the *Globe* announcement. When I first saw it six decades later, in the mid-'70s, it was displayed in a polished wooden case with expansive glass panels. It was cradled in two carefully crafted mounts, and directly above it, in the same case, rested another kayak on horizontal arms. The top craft, from the Bering Strait region of Alaska, had a rounded hull; its decks were sharply raked between the gunwales and raised central deck beams. The lower one, from the eastern Arctic and more than two metres longer, had a flat cross-section and level forward and aft decks. The two showed differences in size, design, and structure, but together they signalled diversity across space and cultural traditions.

The lower kayak captured my attention. Its long length, flat side-to-side bottom, deep bow and upward curve to the stern suggested form for function. The sharp edges of the wide wooden gunwales could be seen against the stretched sealskin cover, suggesting a strong structural frame. The cockpit coaming, symmetrically bent to shape, was burnished from the rub of hands and the polish of a sealskin jacket, which would have surrounded it like a skirt.

The Inuit kayak came from the Hudson Strait region; it displays the design and structural characteristics of the eastern Canadian Arctic. Its maximum

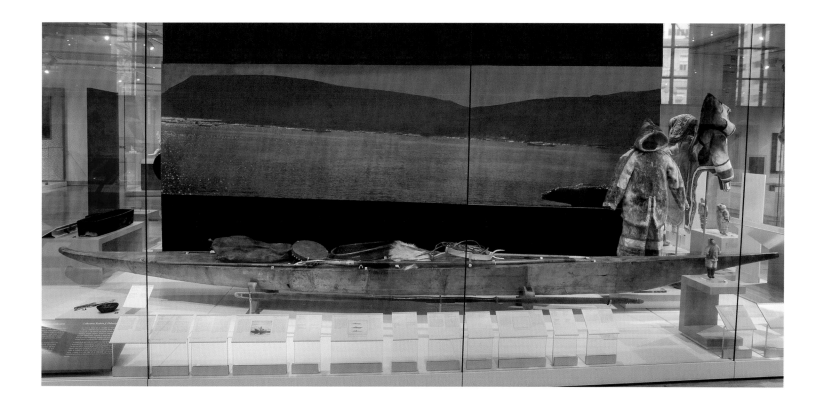

width is located behind the cockpit, giving it a full stern. This element, in combination with its side-to-side flat bottom, provided stability. In addition, the deep forefoot at the bow and the upward sweep of the stern gave it natural directional positioning, allowing it to swing bow first into the waves and giving the hunter a safe boat-to-wave orientation.

For more than 1,000 years, the skin-covered kayak was a vital Inuit technology. With a variety of weapons on its decks, it provided the hunter with an efficient system for capturing sea mammals, birds, and swimming caribou — the food, skins, oil, ivory, and bone necessary to sustain himself, his family, and his community. Here, resting in its case on mounts constructed by the museum's carpenters, was a craft that possessed within its form and materials a narrative intertwining land and water, mortal and spirit.

WADE DAVIS

Photography by Christine McLean

When the British first arrived in the Arctic, the Inuit took them to be gods; the British took the Inuit to be savages. Both were wrong, but one did more to dignify the human race than the other. What the British failed to understand was that there could be no better measure of genius than the ability to survive in the Arctic, with technologies limited to what could be made with ivory and bone, antler and animals skins, soapstone, slate, and small bits of wood that drifted to shore as flotsam.

The Inuit did not fear the cold; they took advantage of it. Three Arctic char placed end to end, wrapped and frozen in hide, the bottom greased with the stomach content of a caribou and coated with a thin film of ice, became the runner of a sled. A knife could be made from human excrement. A moist skin left overnight became a shovel by dawn.

In winter darkness, men left their families to follow the open leads in the new ice; there they knelt motionless over the breathing holes of ringed seals for hours at a time. The slightest shift in weight would betray their presence, so they squatted in perfect stillness, all the while knowing full well that as they hunted they too were being hunted. Polar bear tracks ran away from every breathing hole. If a seal did not appear, an Inuit hunter might roll over and mimic a seal — an attempt to attract a bear, so that predator might become prey.

Patience, stealth, and above all ice — the way it moves, recedes, dissolves, and reforms with the seasons — inform the Inuit heart and spirit. They have no illusions of permanence; they deal with death every day. To live, they must kill the things they

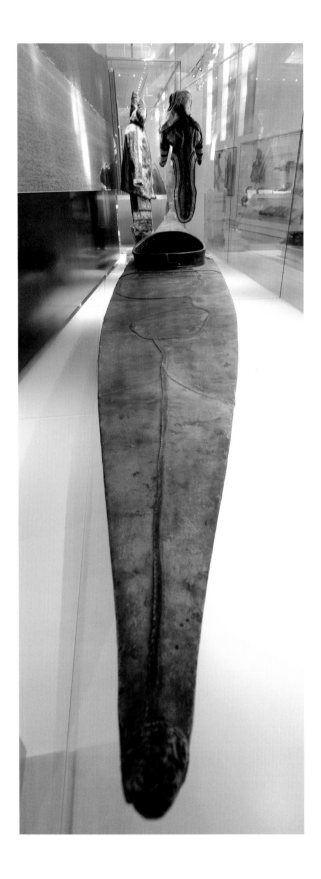

To be an Inuit hunter is to be a master of life, and of ice, water, wind, and sky.

most love. Blood on ice is not a sign of death but an affirmation of life. Eating meat becomes a sacramental experience. To be a hunter is to be a master of life, and of ice, water, wind, and sky. *Sila*, the word for "weather" in the language of the Polar Eskimo of Greenland, is also the word for "consciousness."

If an entire world view, a unique vision of life itself, could be distilled into a single technological achievement, it would surely be the elegant, graceful, efficient, and sophisticated kayak, a mode of transport bequeathed by all polar peoples to the world. And of all its iterations, the one that still fires the hearts and imaginations of all who see it in archival photographs — ghostlike images of small flotillas of hunters slipping over the sea, so distant and so close, shot only in the time of our grandfathers but now gone forever — is that commonly known as the Hudson Strait kayak.

The craft's fundamental design was unique to the eastern Canadian Arctic: a combination of a flat bottom, flared sides, and wide stern, with the maximum width occurring behind the cockpit, made for unsurpassed stability in the open water. The cockpit was located well aft and tilted for ease of access and egress. Covering the frame were hides, tightly drawn and varnished with oil that was derived from harp, ringed, or bearded seals (the third being the preferred source). Among the largest of all kayaks of the north, the Hudson Strait measured up to seven metres in length, with a width almost a metre across at the rear set beam. The longitudinal design was accentuated by its most essential feature — a great rising and overhanging cutwater prow that allowed the craft to ride over the waves, even as it lent grace and elegance to the overall profile.

For a nomadic people who lived by the hunt, and whose prey dwelt largely in the sea, the kayak was both a mode of transport — stable, fast in the water, and easy to propel — and a killing platform that carried the entire arsenal of hunting technologies. The paddles were half the length of the kayak itself, with long and extremely narrow blades that offered minimum wind resistance when out of the water. Drip rings of fibre or sinew-wrapped skin surrounded the handle and kept water from running down onto the paddler's hands. The blade tips were armed with ivory, meaning the paddle could double as a weapon, a tool to enlarge wounds and dig through flesh to pierce the hearts of prey. Secured to the deck were a lance and a two-metre harpoon with an ivory foreshaft of walrus tusk, connected to a coil of line neatly placed just in front of the cockpit and running past it to a sealskin float. A towing hook, a trolling lure for fish, a deck de-icing knife, and plugs to jam into the wounds of prey to staunch the flow of blood (nothing was lost or wasted) were also on hand. The hunter would wear a waterproof anorak, gauntlets of hide, pants of split gut-skin strips — all covered in sealskin, caribou, or polar bear fur.

Gliding past ice floes — separated from the frozen sea by but a layer of skin, stretched over a shell crafted from bone and driftwood, accompanied by a half dozen kinsmen, each alone in a kayak of identical design, all with weapons aligned — the hunter approached his prey, sea mammals for the most part, narwhals and bowhead whales, bearded seals and fierce herds of walruses.

Step back for a moment to imagine what this implied. Think of this kayak not as an artifact, inert and deadened by time, but rather as a dynamic extension of the hunter, a single physical force, lethal in its intent, converging as a pack upon these creatures of the deep. The smallest of the prey — aside from ringed and harp seals, which were readily dispatched with a stiletto to the head or heart — was the bearded seal. It weighed as much as 400 kilograms and grew to three metres in length. Narwhals struck with a harpoon had the capacity to dive to depths of 1,000 metres. Bowheads grew to eighteen metres in length, and yet individual Inuk hunters did not hesitate to go after them, though it might mean being dragged out to sea by an animal that weighed as much as 100 tonnes. To penetrate the tough skin of a walrus, the hunter had no choice but to strike from just a paddle's length away a ferocious animal armed with metre-long tusks, protruding as modified canines from a body of 900 kilograms.

Merely to secure the basic essentials — food, skins, oil, ivory, and bone — the Inuk hunter on a daily basis had to place his life on the line. On top of this, he had to deal with the elements — the impossible cold, storms at sea and on land, the season of darkness and the long Arctic night. Is it any wonder that such an adaptation produced such an ingenious and resilient people, so stoic and patient, unyielding and tough? There is a story from Greenland about a group of men and women who walked a great distance to gather wild grass in one of the island's few verdant valleys. When they arrived, the grass had yet to sprout, so they watched and waited until it grew.

I once joined a small party of hunters from Igloolik, Nunavut, as they set out on the sea ice in search of polar bears. We were perhaps 150 kilometres offshore, with the wind chill hovering around minus 50°, when one of the snowmobiles hit a piece of rogue ice and spun out of control, even as the momentum of a fully loaded komatik carried it up and over both driver and machine. One of the skis twisted like a pretzel; the other was torn completely in half. I watched in astonishment as my Inuk friends pounded out the metal, blasted four holes into it with rifles at close range, improvised clamps with a scrap of iron, scavenged a splint from a hockey stick, and had the entire works bound back together in twenty minutes. We pushed on into the night, and it was only days later that the driver, while cleaning the carburetor of his Ski-Doo with the feather of an Arctic tern, casually mentioned that he had broken his foot in the accident.

Kenneth Lister Responds

Two words from Wade Davis' essay deserve tribute: "patience" and "stealth." They are illustrated in separate Robert J. Flaherty photographs.

The photographer captures the meaning of patience with an Inuit hunter sitting on a snow-block bench, hunched over a seal's breathing hole. A caribou-skin mat protects him from the cold, and he is wearing an eider duck feather parka. His arms are clamped close to his chest, and his feet rest flat on the ice; a harpoon lies lengthwise across his knees. Upright snow blocks shelter him from the prevailing wind and lessen the air that passes over the breathing hole. In this position, for hours on end, he sits. The side of his hood covers his face, but Flaherty captures the concentration — the focus on the feather he has placed in the hole. Silently, he waits for the slightest movement that will mark a seal's rising — and anticipates his own riot of energy.

In another season and photograph, a hunter is poised to thrust his harpoon. Flaherty crops his kayak's ends, emphasizing the cockpit and harpoon, the coaming, and the sealskin float with line. The hunter holds a paddle in his left hand, a counterweight to the harpoon in his right. Through stealth — caution and furtiveness — he stalks his prey. Flaherty captures the apex of tension: the grasped harpoon, swung into position. Here we see the moment of transition, when skill learned through generations of experience is tested, as is the generosity of the hunted.

IKEM HEADDRESS

Silvia Forni,
Curator of
Anthropology

This sculptural headdress, acquired in the Calabar area of Southeastern Nigeria, was donated to the museum in 1935 by the widow of Reverend W. G. Adams. It was purchased six years earlier by her daughter, who was most likely stationed in Calabar as a missionary. According to anthropologist Keith Nicklin, it may have been created by Asikpo Edet Okon, who worked in the Efut village of Ibonda, near Creek Town, and died in the '20s. Many of the headdresses produced in Asikpo's workshop were made for Ikem, a regional entertainment association. Headdresses are just one element of Cross River masked performance. This type was traded extensively in the region and was copied by various ethnic groups and dance societies, who would incorporate it into various performances.

"Horned" headdresses were produced in the Cross River region at least until the '70s. They were carved in wood; covered with soft, untanned stretched antelope skin; painted with natural pigments; and finished with bone and metal detailing. The ROM's example represents a young woman (*moninkim*); its elaborate face painting and coiffure recall the typical appearance of maidens being reintroduced to the community after the period of initiation and seclusion that marked their passage from childhood to marriageable womanhood. While it represents a woman, we do not know if it was danced by a male or a female performer. African men often embody female masquerades, but researchers have also documented a tradition of masquerade performances danced by women among the Ejagham and neighbouring peoples. In fact, the mask could have been used by one of the local women's associations.

At the turn of the twentieth century, women's societies in the Calabar region were vocal and active social agents. The younger Adams may have been aware of their protests, but as a participant in the British colonial enterprise she likely attempted to instill a more subdued, domestic idea of womanhood. We can imagine that she modelled the demeanour of a polite Victorian lady — one who did not take to the streets, engage in politics, or contest male authority. Thus, it is fascinating that she brought back a mask that continues to engage and challenge gender stereotypes, as well as our aesthetic appreciation.

> A missionary brought back a mask that continues to engage and challenge gender stereotypes, as well as our aesthetic appreciation.

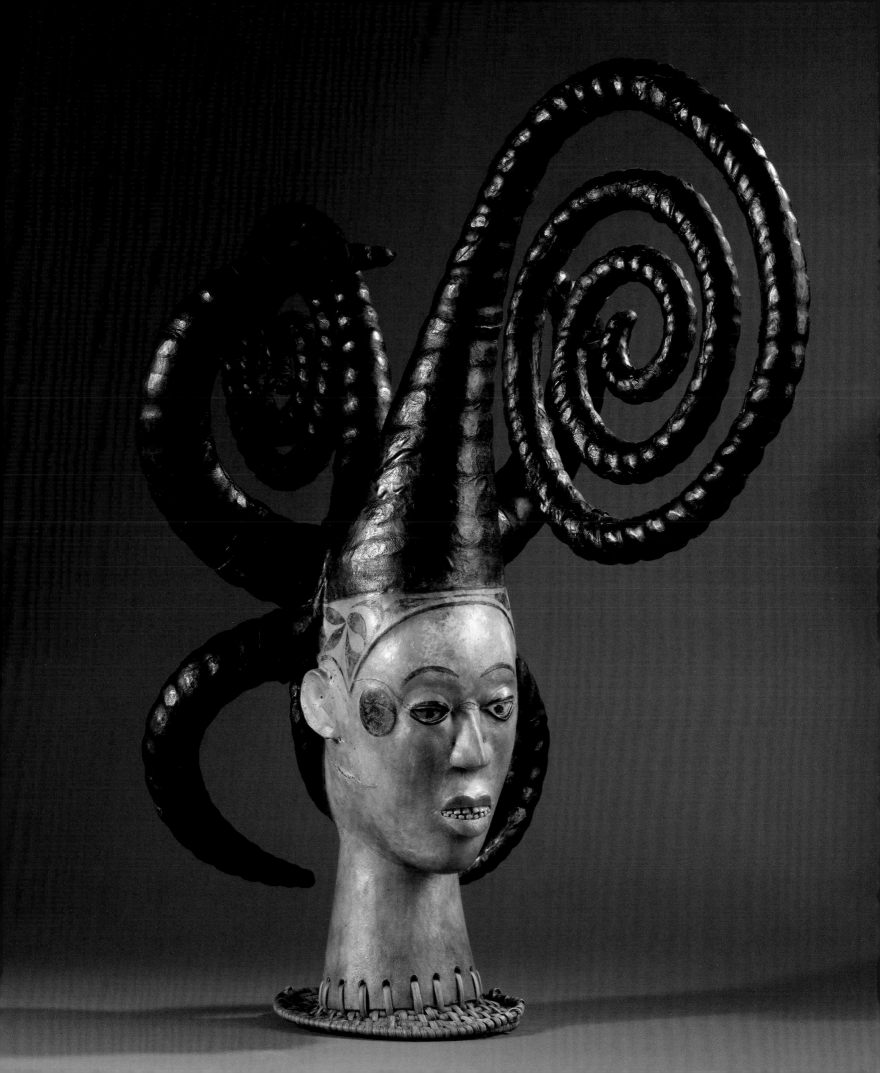

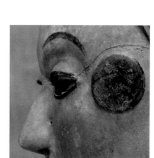

UZOMA ESONWANNE

Photography by Beau Gomez

Lot 2553
 An Efut (Ibibio) dance-crest by Asikpo

 Sold for $30,483 ($27,900 US), including premium
 — *bonhams.com/auctions/15413/lot/2553*

"Ikem headdress, possibly created by Asikpo Edem Okon, circa 1920"
(Royal Ontario Museum, Toronto)

On Display: Ikem Headdress

 Rising from a raffia-mat base,
 her elongated neck soars —
 soars into her head
 palm crest, exfoliates
 two whorls of thick, black braids
 backing each other
 ride the wind over her head

Leaning slightly left into the updraft
of concave braids on the sides
vertical antlers holding all in equipoise.
Brazen? This display of Fertility —
Motion at rest
With itself at rest
Serene.

Slightly parted lips keep counsel
over thought, indelibly etched
on a face in which eyes, demure
yet confident, gaze aslant
on a horizon visible only to her,
our Debutante.

So I ask: Wetin bring you come?

One shilling. A souvenir swaddled
 wooden peak to leathery neck in cottony fabric
 then stacked, prone, alongside kin similarly clad
 in the reverend's daughter's sturdy trunk

Where, courtesy of camphor,
 we evaded the steel jaws of termites
 until months later we disembarked.
 Where? Wish I knew.

When? Same. The others? What others? Oh.
 Heck! How would I know?
 Uncatalogued. Unserenaded. I arrived
 1935: Courtesy of Reverend's Widow.

1935: eight decades, and I, trophy, am atrophied
 Trephein: to fatten.
 Efut now the severed limb.
Efut or Creek Town, the skits was always the same:
 weeks after being cleaned of amniotic shavings,
 varnished against humid Atlantic air,
 whorls burnished black against the evening sky
We ride the celebratory din of a thousand voices
 into the dreams of doughty men
 whose flaccid members, wrapped in puerile cynicism
 we will gently knead into docile hardness

Four decades before

Four decades and four removed,
 and a block Atlantic from the Bight,
 we meet on the third floor in the Crystal.
 Our Debutante and I, safe against Arctic chill
 that, having scaled ambition up to Artifact:
 Ikem headdress, possibly created by Asikpo Edem Okon
 vouchsafes a cadaver's musings.

Four decades ago, by the Cross
 scores of miles north,
 I spied you make stately progress down Raleigh, Ikom,
 in a dust-laden bacchanal that veered right
 to Ekpe Hall, away from the Cross's turgid gut
 that twists past our sodden hillside homes
 into the distant horizon.

That is how we first met, Debutante.
How the boy whose imagination swilled down
that incomprehensible choreography
of elegant steps saw his Debutante —
his, until the Cannon issued an edict
prohibiting willed kinships and
stilled my youthful gaze.

Stilled in my memory that delicate dance
by which you made all around you
privy to the flesh's rhythmic mysteries.
That, in defiance of all edicts,
persists in recounting the ties
forged in play, in song, in cries —
that know neither state nor origin.

Meeting you here where glass displaces Cannon
I ask: How does a doughty man's dream end?
What does it mean?
Here in our new home, more home than home —
here in our Black Atlantic home a sea block
from the Bight that dispersed us —
Dream eludes capture as it does there.

"GORDO" THE BAROSAURUS

David C. Evans,
Curator of Vertebrate
Palaeontology

The huge skeleton of the rare sauropod *Barosaurus lentus* is the centrepiece of the Royal Ontario Museum's James and Louise Temerty Galleries of the Age of Dinosaurs. With an eight-metre-long neck, clearly visible from bustling Bloor Street, it serves as a public ambassador for the ROM's internationally recognized dinosaur collection. The specimen is remarkable in a number ways: it is one of largest dinosaurs on display in Canada (second only to the massive *Futalognkosaurus* in the Hyacinth Gloria Chen Crystal Court); it is the largest skeleton in Canada that contains actual fossil bones; and it was the first relatively complete fossil *Barosaurus* skeleton mounted in the world. It was collected from Dinosaur National Monument in Utah, from rocks that date to the late Jurassic period (about 150 million years ago).

Nicknamed Gordo — in honour of Gordon Edmund, the curator who acquired it in 1962 from the Carnegie Museum of Natural History in Pittsburgh, in exchange for duck-billed dinosaur skeletons — its numbers are impressive: It is three times longer than the reticulated python, the longest reptile alive today. In life, it would have weighed as much as 15,000 kilograms, the equivalent of three adult male African elephants. The skeleton is about half complete; it is unusual for sauropods to survive completely intact because of their size. After such a giant dinosaur died, it would have been easy pickings for carnivores of all kinds, making the chance of its skeleton being completely dismembered quite high.

> For nearly forty-five years, the huge skeleton languished largely undocumented in the storeroom.

I have a special connection to this skeleton. It is my biggest find to date, and an unorthodox one. For nearly forty-five years, it languished largely undocumented in the museum's storeroom. Then, by referencing the work of renowned sauropod expert Jack McIntosh, I discovered that the fossils once thought to be random bones from multiple animals actually belonged to a single specimen — that of the impressive twenty-seven-metre-long *Barosaurus*. Luckily, I made my discovery in time to assemble the skeleton for the new dinosaur galleries, which opened in 2007. Gordo was an instant hit with visitors, and his story, immortalized in the globally syndicated television show *Museum Secrets*, will forever be the ROM's biggest "skeleton in the closet."

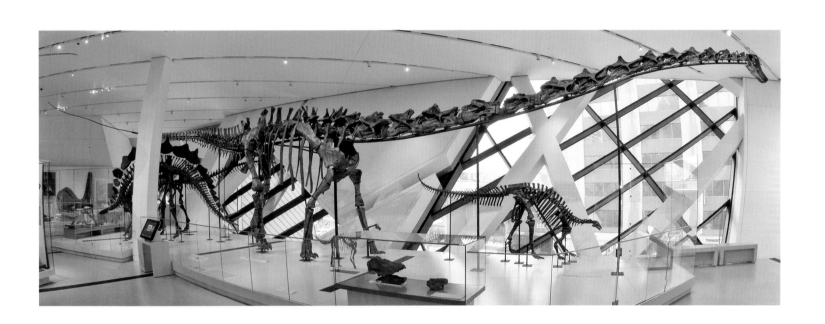

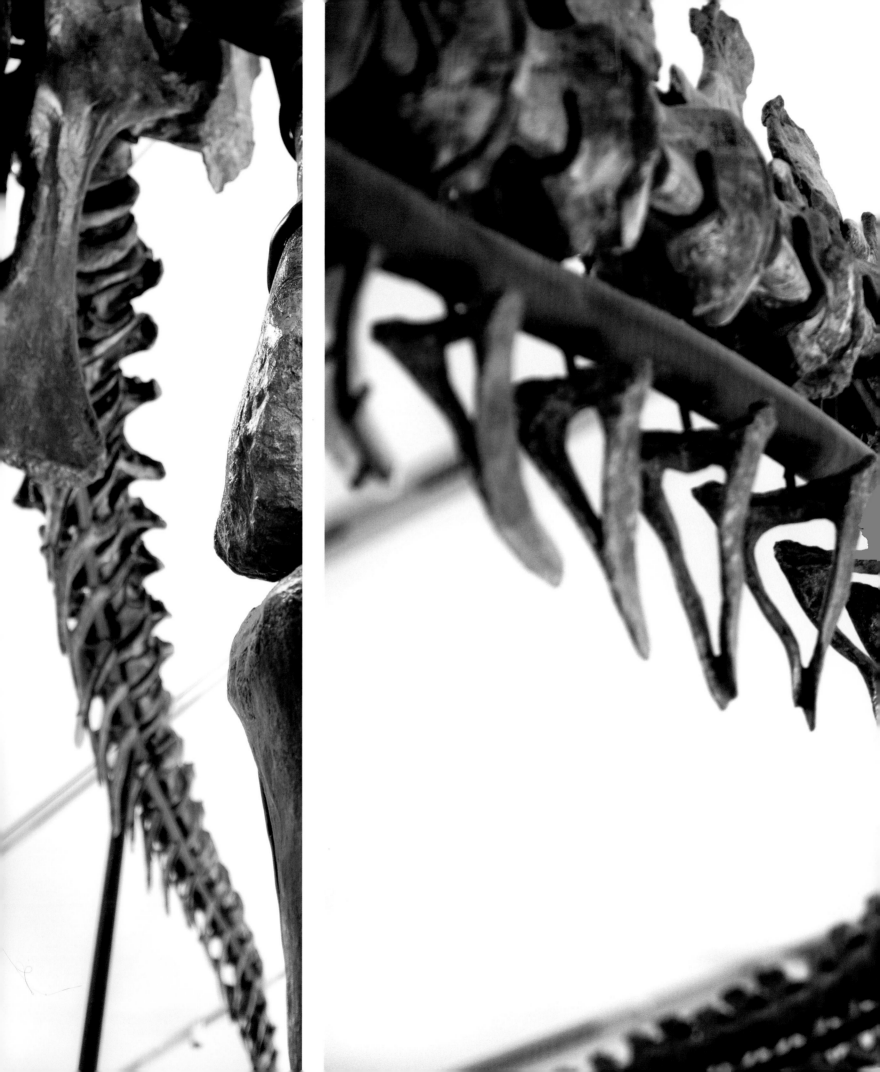

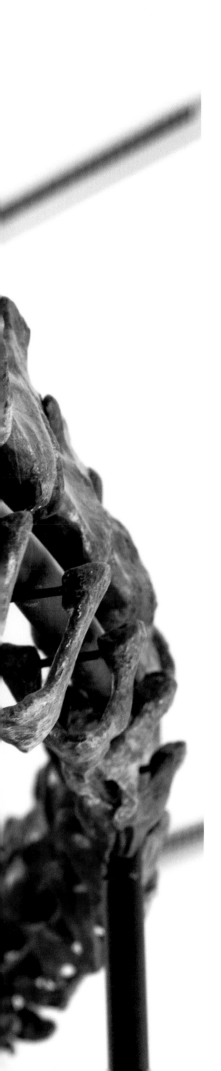

SHEREE FITCH

Photography by Jessica Toczko

Imagine: one galumphing thumping
 something,
 a ginormous herbivorous,
 crashing thrashing
 tail whiplashing
 half-giraffe Jurassic
 creature,
 screeching belching
 stomp chomp-chomping,
 one coniferous
 destroyer
 in a prehistoric forest...
Now:
 fast-forward,
 see before us,
 one saurischian
 Barosaurus,
 one humongous
 dinosaur!

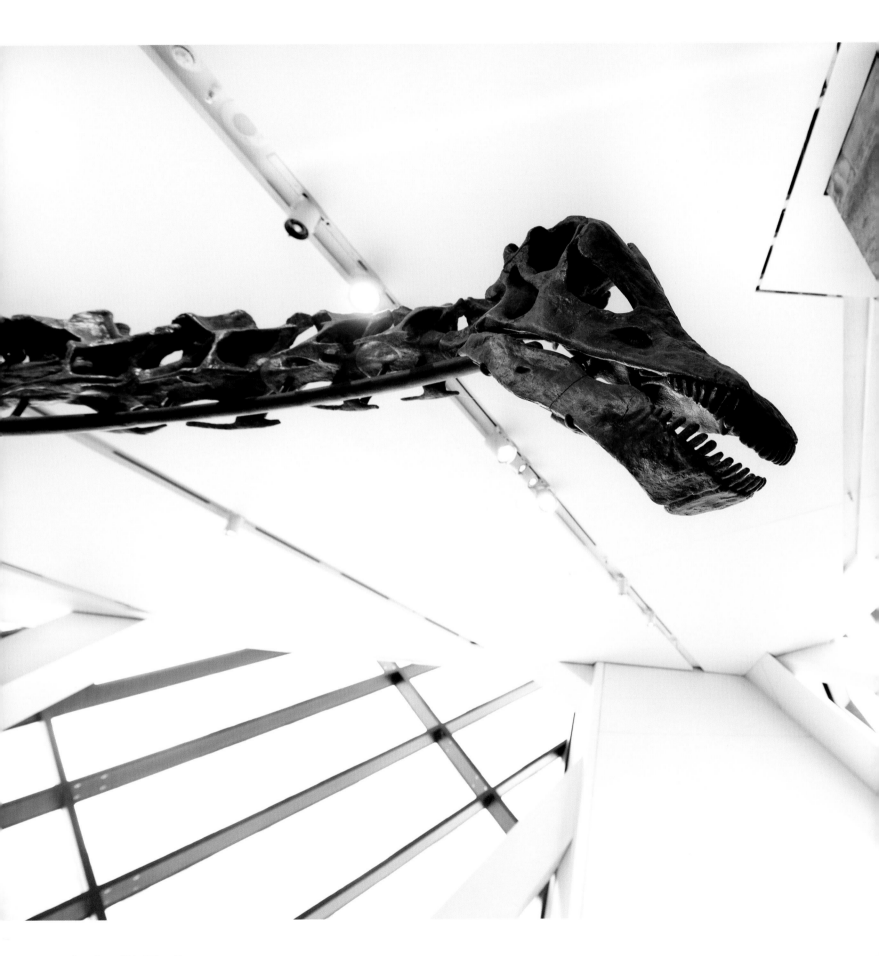

Gordo is his name-o
Yes, Gordo is the dino
whose home's inside the ROM.

Old Gordo's quite a story,
his tale's ridiculously long.
If he could,
I think he would,
tell his history in a song:

I was a species gone to pieces,
forgotten, lost, ignored,
a skeleton in a closet,
my bones long stored in drawers.

I was a mess in the beginning,
I was trouble from the start.
I had eight hearts — all broken.
I was literally torn apart.

I was a paleontologist's puzzle,
Extinct, therefore I was —
Now
I stand before you.
Why? Because
because

They discovered I was scattered
in rooms throughout the ROM.
Here a rib, there a rib —
Hurrah! More vertebrae!
They put me back together,
then they put me on display.
Now here I am
in my home,
Good Gordo of the ROM!
I once was lost — amazing —
lost but now I'm found.

Gordo is his name-o!
Yes, Gordo is the dino
whose home's inside the ROM.

Imagine:

 students, teachers, tourists,
 dino geeks like me exploring
 seeking and adoring
 GOOD GORDO
 of the ROM!

Do you ever wonder if the thunder
 you sometimes hear at night
 is the dino we call Gordo,
 doing a rumba at the ROM?
 Gordo always makes me feel
 another poem's coming on.

Gordo is my name-o!
Yes, Gordo, I'm the dino
whose home's inside the ROM.

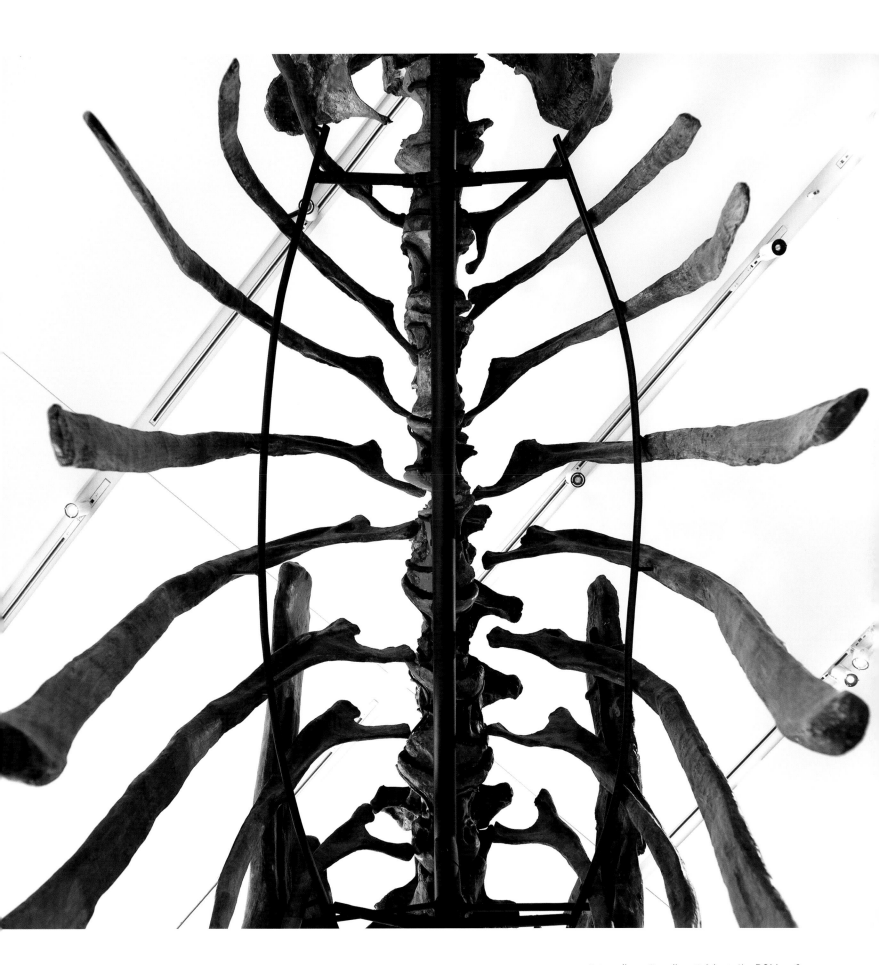

TRAILL SCRAPBOOK HERBARIUM

Deborah Metsger,
Assistant Curator
of Botany

The Green Fern album is one of the museum's two scrapbook herbaria compiled by Catharine Parr Traill, Canadian pioneer and author of *The Backwoods of Canada* (1836), *Canadian Wild Flowers* (1868), and numerous other works. Part of a special collection in the ROM's Green Plant Herbarium, they attest to the Victorian tradition of gathering plants and preserving them as mementoes of natural history. Such scrapbooks were either filled with an individual's own collections or with "traders" from fellow naturalists. The Traill scrapbooks were donated to the herbarium in 1950 by her granddaughter Katherine "Katie" Parr Strickland Heddle, for whom they were compiled.

Catharine Parr Traill loved plants and was a prolific collector. Although a fire destroyed much of her collection, thirty or more of her plant scrapbooks survive in Canadian museums and libraries. While many contain artistically arranged assemblages of pressed plants with little or no documentation, the Green Fern album is mostly scientific in nature. Its sixty-two pages are filled with specimens, gathered between 1875 and 1887, that are individually labelled with both scientific and common names; collector; date; locality; and notes that often indicate flowering time, abundance, or whether or not the plant is native to Ontario. It also has more than forty pages devoted to ferns; its other specimens range from mosses and lichens to flowering plants. Along with her friends and relatives, Traill collected many of these in the vicinity of Stony Lake, near her home in Lakefield, Ontario. The highbush cranberry (*Viburnum opulus*), a subspecies of which Traill knew from the wilds of England and Canada, is from a plant she purchased for her garden. Some specimens, such as the wild bergamot (*Monarda fistulosa*), are useful indicators of the tall grass prairie habitats that were once abundant on the Rice Lake Plains. Finally, the several specimens attributed to John Macoun (Dominion botanist) and James Fletcher (botanist and entomologist at the Central Experimental Farm in Ottawa) tell us that while Catharine Parr Traill was not a botanist herself, she interacted, corresponded, and exchanged specimens with recognized experts of the day.

The Green Fern album is named, in part, for its ornate green and gold fabric binding, with a bold picture of "the farmers daughter" on its inside cover. Unfortunately, much of the paper used in Victorian scrapbooks was of poor quality and became brittle and discoloured with age. Over time, the album's paper became so fragile that it disintegrated when touched. In 2006, the book was dismantled to preserve its content. Each page was mounted on an acid-free board — the original format sacrificed to allow safe handling.

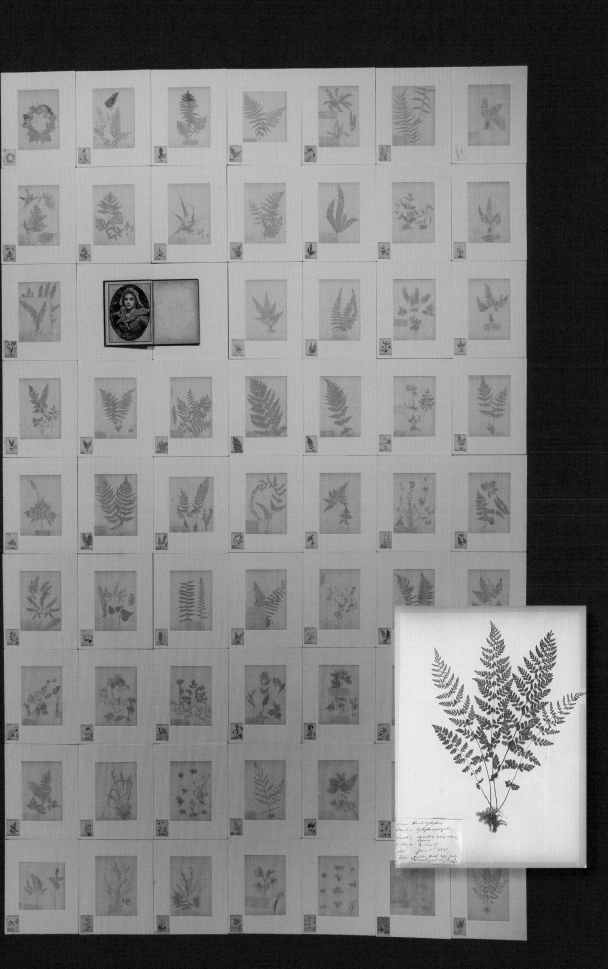

CHARLOTTE GRAY

Photography by Jody L. Rimmer

atharine Parr Traill's motto was "In cases of emergency, it is folly to fold one's hands and sit down to bewail in abject terror: it is better to be up and doing." That's a good axiom for a woman who lurched from crisis to crisis, and who, despite emergencies, managed to leave a legacy of botanical observations and specimens. Traill's journals, publications, and scrapbooks allow us to glimpse the virgin forests and untamed waterways she discovered when she arrived in Canada in 1832.

I encountered Traill and her books, particularly *The Backwoods of Canada* (1836), soon after I arrived here in 1978. Like her, I was English-born, already a published writer in London, and entirely ignorant of the land to which I had immigrated (I had married a Canadian; she had married a Scottish widower, Thomas Traill, who hoped to make his fortune across the Atlantic.) The place that I discovered was very different from Traill's Canada: I landed in one of the wealthiest, most comfortable countries in the world, while she stepped ashore into a threadbare and under-populated colony. But we were both British immigrants battling homesickness and facing an unfamiliar terrain. I tried to grasp my new home through its literature, which is how I met her. But there was no Canadian literature when the Traills crossed the ocean. In the forested wilderness where they settled, there was a babble of locally printed scandal sheets, plus a few private shelves of dog-eared British books. For Traill, aged thirty, the route to understanding North America was through its landscape.

Traill's interest in botany began in her East Anglian childhood, when her father, a London merchant named Thomas Strickland, would take little blue-eyed Katie

on long rambles through the woods and introduce her to mysteries of plants and wildlife. For the rest of her life, she would rely on botany to distract her from setbacks and confirm her simple Christian faith. "It is fortunate for me that my love of natural history enables me to draw amusement from objects that are deemed by many unworthy of attention," she wrote years after her father's death, when she was far from Suffolk. "The simplest weed that grows in my path, or the fly that flutters about me, are subjects for reflection, admiration and delight."

Those idyllic walks along Suffolk hedgerows don't tell the whole story about Catharine's childhood. When she was fifteen, her father died, leaving his widow Elizabeth with six unmarried daughters and two young sons in an isolated and drafty Elizabethan manor house. Elizabeth Strickland struggled to maintain a genteel lifestyle on a pittance. Five of her six daughters became published authors, in a valiant attempt to supplement the family income. Catharine's specialty was children's books. In 1830, when she was twenty-eight, she was paid more than £12 (a considerable sum) for a slim volume entitled *Sketchbook of a Young Naturalist*.

Catharine Parr Traill would rely on the mysteries of plants and wildlife to distract her from setbacks and confirm her simple Christian faith.

This was not a happy period for Catharine, as her marital prospects dwindled and her mother grew more irascible. Then her favourite sister, Susanna (one year younger, and the sixth of the eight young Stricklands), announced she was leaving for British North America with her husband, John Moodie. Susanna had already introduced Catharine to Thomas Traill, a friend of John's and, like John, an Orkneyman and half-pay officer who had served in the Napoleonic Wars. Their mother and older sisters did not think much of Catharine's suitor, who was several years her senior, with two young sons and poor prospects. To her family's dismay, Catharine accepted Traill's proposal of marriage. Worse still, the Traills announced that they were going to cross the Atlantic too.

And so the next stage of Catherine's life, and a new chapter in the story of the young naturalist, opened. Over the years I've lived here, I've come to realize that, emotional ties apart, perhaps it wasn't such a painful wrench for her to leave Suffolk. She had experienced hardship and biting cold long before she left home. The Stricklands subsisted on a diet of butcher's scraps, stale bread, and mouldy vegetables. Moreover, East Anglia, the rounded bulge of land north of London that juts eastward, may be bucolic in summer, but in winter the icy wind that blows over its flat reaches roars straight from the Russian steppes. I have stood on a shingle beach there and felt colder than I have ever felt in Ontario.

I also suspect that Mrs. Strickland's insistence on "maintaining standards" within the rigid British class system was an invaluable asset to Traill in Canada, because in reaction to her snobbish mother she took everyone as they came. In England, she had hated the obligation to look ladylike, which involved whalebone corsets, six or seven petticoats, bonnets, lace boots, heavy wool shawls, and gloves. What use was such a cumbersome wardrobe for a woman who wanted to get down on her knees and coo over young buds and baby birds? Once in Upper Canada, she delighted in pioneer society's indifference to accents, dress codes, and deference to "betters." Her outfit was dictated by the need for warmth alone. She noted in a letter home, "We do what we like; we dress as we find most suitable and most convenient; we are totally without the fear of any...Mrs. Grundy [a fictional British character who embodies excessive and judgmental priggishness],...we laugh at the absurdity of those who voluntarily forge afresh and hug their chains." North America offered Traill, as it has offered so many subsequent immigrants, liberation from suffocating tribal conventions.

Nonetheless, emigration has always required courage, and the Traills were guilelessly ignorant about the British colony towards which they sailed. Thomas, an Oxford graduate, proved a hopeless pioneer; lacking practical skills and inclined to melancholia, he didn't share his wife's sturdy "up and doing" spirit. He would much rather

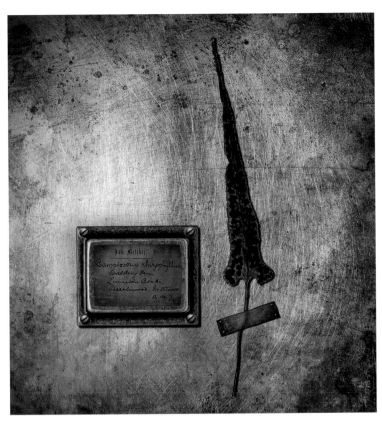

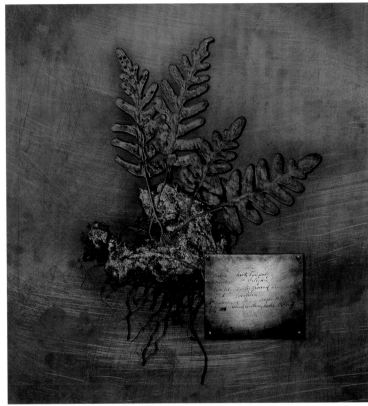

settle down with a book than clear woods, burn bush, sow grain, weed, harvest, thresh, build, or hunt. Yet I've always had a soft spot for hopeless Thomas. He was a thoughtful man, who knew what his wife loved. When the Traills' ship anchored in the St. Lawrence south of Quebec City, he was allowed on shore but she was not. When Thomas returned, he brought along a bouquet of wildflowers for her. She recorded with pleasure that she recognized sweet peas, lungwort, wild orchid, and "several small white and yellow flowers, with which I was totally unacquainted." The challenge of identification and preservation would become a large part of her life's work.

In her first years on Canadian soil, there was little time to pick flowers. The Traills hurried west, to a modest settlement north of Peterborough, Upper Canada, where her younger brother Sam Strickland had already established himself. During the next two decades, nine children were born (seven survived infancy), Thomas sank into chronic depression and Catharine struggled to feed and clothe her family. But even in the darkest hours — when harvests failed, babies died, bailiffs came knocking — she found succour in the changing seasons and the promise of new growth. She always knew

that spring would come: "The sight of green things is life to me," she wrote to her friend and neighbour Frances Stewart.

Dublin-born Stewart was Traill's mentor, and shared her passion for collecting. The Stewarts' log house must have looked like my summer cottage, with every shelf laden with antlers, fossils, dried flowers and ferns, feathers, squirrel skulls, and rock specimens. Stewart lent Traill two guidebooks to North American flora: *Frederick Pursh's Flora Americae Septentrionalis* (London, 1814) and J. E. Burton's *Essay on Comparative Agriculture; Or a Brief Examination into the State of Agriculture As It Now Exists in Great Britain and Canada* (Montreal, 1828). Traill learned to use the Linnaean classification system of plant species from Pursh. She gathered ferns and flowers, and carefully pressed them between the leaves of her husband's precious books. At the same time, she tried to put bread on the table by writing, as she had done back in Suffolk.

In early nineteenth-century Canada, there were few readers and even fewer publishers: Traill's best hope of publication was in England. The long, gushing letters that she wrote home ("brevity in epistolary correspondence is not one of my excellences") became the basis for her

first Canadian book. Her Suffolk sisters edited and sold to a London publisher eighteen of Catharine's letters, describing her voyage across the Atlantic and her early years in the little settlement of Lakefield. *The Backwoods of Canada: Being Letters from the Wife of an Emigrant Officer, Illustrative of the Domestic Economy of British North America* appeared in London four years after her arrival. Packed with handy hints and relentless good humour, it sold well. The author spent only two pages describing outbreaks of cholera, and forty pages rhapsodizing about the country's plant life — blue asters, orange day lilies, scarlet cardinal flowers, purple phlox, lilies of the valley. "I consider this country opens a wide and fruitful field to the inquiries of the botanist."

Traill realized that there was a market for a manual of sisterly advice to other British immigrants, and she tried again with *The Canadian Settler's Guide*. A Toronto publisher produced this book in 1855: despite good sales, few of the proceeds reached her purse. The Traills' fortunes spiralled down into a morass of debt and deprivation. The last straw came in August 1857, when their decrepit log cabin on Rice Lake went up in flames, and all their furniture, clothing, winter preserves, handworked quilts, and books were destroyed. The only possessions she managed to rescue were those most precious to her — botanical notes on flowers, ferns, trees, and shrubs.

Traill's life followed a pattern that I've noticed often characterizes gritty, long-living women, then and now. Devastated by the loss of his library, poor Thomas was dead within two years. In contrast, Catharine embarked on the third, and perhaps happiest, stage of her life, although she struggled with poverty, rheumatism, and gout. A cheerful widow, she moved to a pretty clapboard cottage in Lakefield, near her brother Sam, with her eldest daughter, Kate, to look after her. She planted a garden of violets, scarlet geraniums, primroses, and dahlias. She filled album after album with dried specimens of plant life, noting their names in her spidery script. And with her niece Agnes FitzGibbon (daughter of her sister Susanna), she produced one of the most touching examples of the new Canadian nationalism sparked by the declaration of the Dominion of Canada in 1867: the first field guide to wild flowers for the Canadian general public.

Canadian Wild Flowers, by Catharine Parr Traill with ten lithographs by Agnes FitzGibbon, appeared in 1868. Some of FitzGibbon's hand-coloured lithographs focused on a single specimen, such as the purple pitcher plant, but most featured an unrelated group of three or four flowers, such as lady's slipper, blue iris, and small cranberry. Traill's chatty text included the Latin name of each plant and a detailed description of it and its medicinal qualities, plus a smattering of romantic verse. Her model was the popular eighteenth-century naturalist Gilbert White, the country parson who wrote *The Natural History and Antiquities of Selborne*. Catharine did not stint on personal opinion: "Very lovely are the Water Lilies of England, but

their fair sisters of the New World excel them in size and fragrance."

I can picture Traill in her little Lakefield cottage, wanting to build on the success of *Canadian Wild Flowers* but knowing that her approach was increasingly old fashioned. By the late nineteenth century, botany had evolved from a genteel pastime for ladies into a serious branch of science. As she sat by her window, carefully sorting a half-century's worth of notes and pressed flowers, and placing them into scrapbooks, she must have known that the Gilbert White approach was passé. Canadian scientists with academic qualifications — including George Lawson at Dalhousie University in Halifax, William Hincks at the University of Toronto, and John Macoun at Albert College in Belleville, Ontario — discussed stamens, pistils, and plant reproduction: they did not mention God or Longfellow. There was little room for female amateurs.

But Traill had an important message for the waves of newcomers still arriving in Canada, a warning note sounded in her introduction to *Canadian Wild Flowers*. Indigenous species, such as pyrola and slipper plant, were disappearing, she wrote, "as the onward march of civilization clears away the primeval forest" and turns swamps and prairies into agricultural land. "Oh wail for the forest, its glories are o'er," she ended her plea. She wanted native plants to be catalogued in a proper herbarium before it was too late.

Luckily, Traill — now almost as old as the century, and with well-known titles to her credit — had become that Canadian rarity: a celebrity. Her collecting method and writing style were archaic, but her enthusiasm and renown meant that even the most meticulous post-Darwin botanist regarded her with affection. Naturalists like James Fletcher, a botanist and entomologist who ran Ottawa's new experimental farm, exchanged specimens and seeds with her, and quietly corrected her errors of identification. Partly thanks to his support, when Traill was eighty-three years old, the manuscript on which she had worked for decades was finally published in 1885, under the title of *Studies of Plant Life in Canada*. Fletcher told her, "I wish a fraction of one percent of the students of plants who call themselves botanists could use their eyes half as well as you have done."

I'll admit that when I was writing *Sisters in the Wilderness*, about Traill and her sister Susanna Moodie, I preferred sharp-tongued Susanna to warm-hearted Catharine. I found Traill's relentless optimism irritating. In the hundreds of surviving letters she wrote to relatives and friends, she goes on and on in an unpunctuated ramble about children's illnesses, deep snowdrifts, and local gossip. She would mention her problems in passing (her sons' lack of shoes, her empty larder, Thomas's low spirits), and in the next paragraph extol God's goodness or the beauty of the sunset. When does stoicism become denial? I grew tired of her stiff upper lip, her determination to make

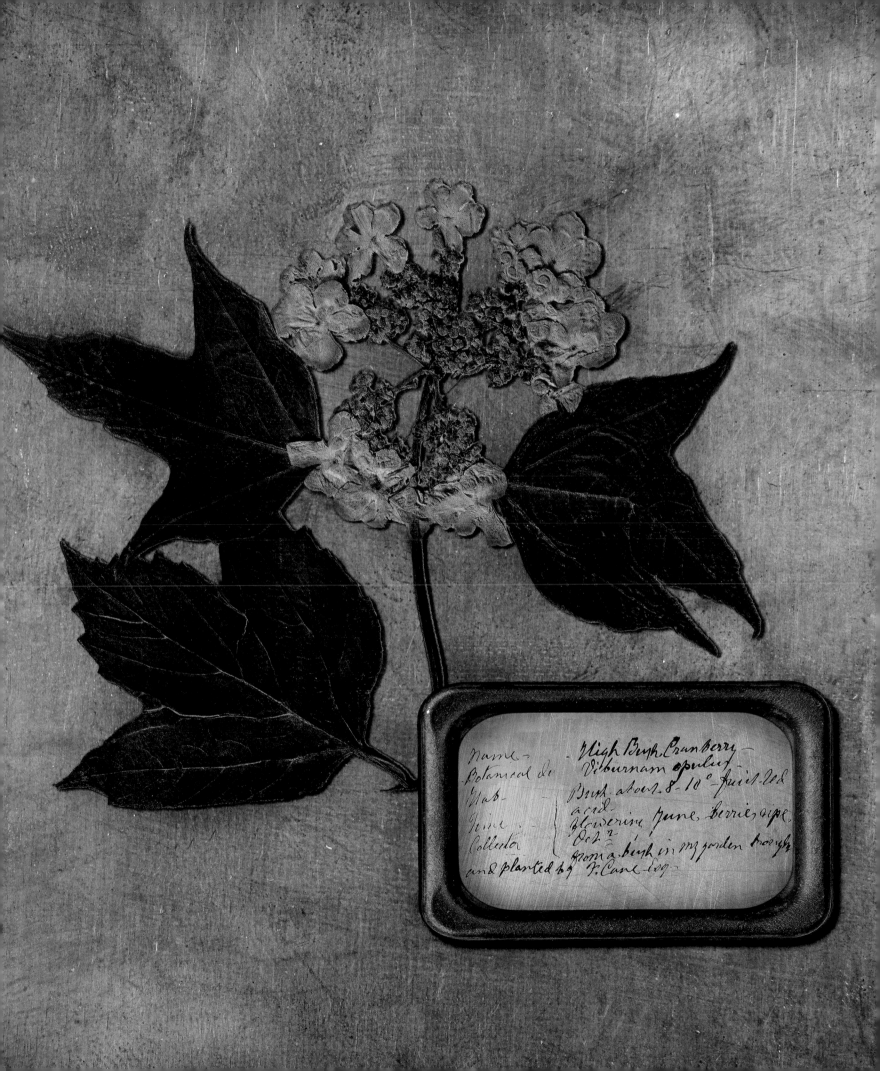

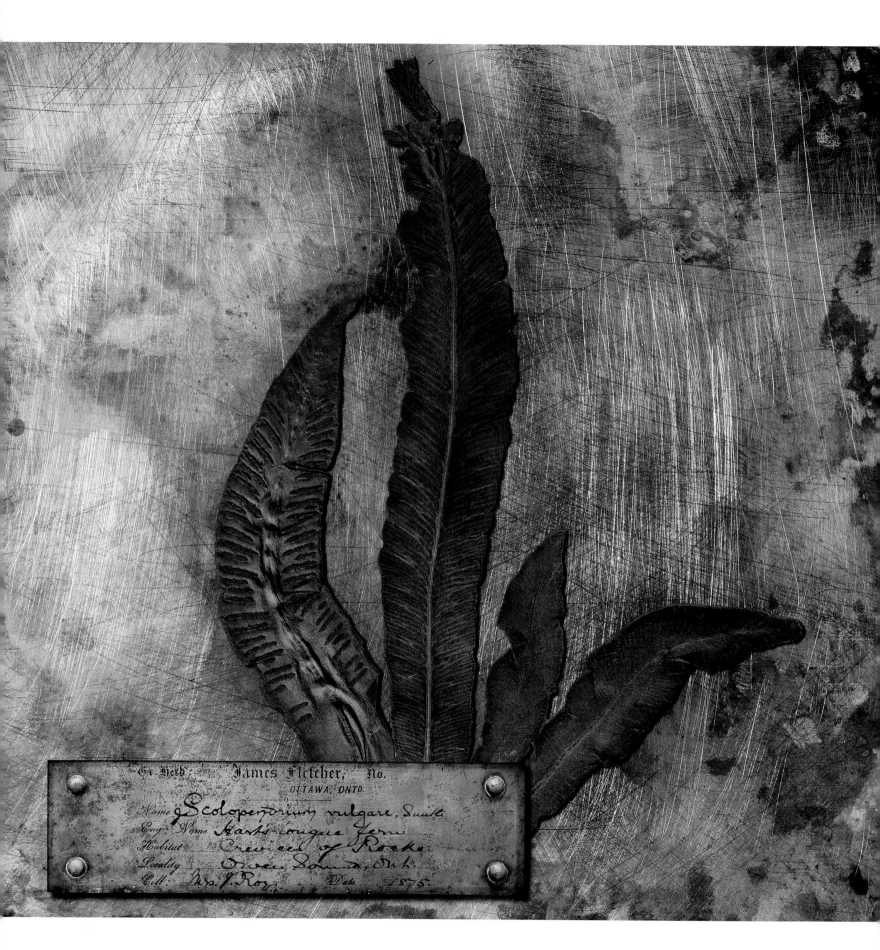

The label on the specimen reads:

Gr. Herb. James Fletcher, No.
OTTAWA, ONTO.

Name Scolopendrium vulgare, Smith
Eng. Name Hart's-tongue Fern
Habitat Crevices of Rocks
Locality Owen Sound, Ont.
Coll. Mrs. J. Roy Date 1875.

the best of things. I wanted to say to her, "Catharine, you are allowed to complain. You are having a really tough time!"

In contrast, her sister was exquisitely attuned to social nuance and human foibles, and focused all her attention on the people she met. Moodie was a better writer than her sister, even if she complained a lot, sneered at her neighbours, and proved as big a snob as her mother. She had no time for prattle about old growth forests. Her reaction to the Canadian landscape was summed up in her line: "Oh! land of waters, how my spirit tires / In the dark prison of thy boundless woods…" Moodie's letters and the classic *Roughing It in the Bush* give an unvarnished but witty account of a pioneer society emerging in the backwoods. In my early years as an immigrant, I enjoyed watching her try and make sense of all the different peoples she met; I was trying to do the same thing myself. I was not alone in my preference: many of the contemporary Canadian novelists I read (Carol Shields, Margaret Atwood) had embraced Moodie but ignored Traill.

Today, however, I am impressed by Traill's prescience, and her relevance to our preoccupations. Her life was eco-exemplary: she was on the 100-mile diet long before there was any alternative, and she ate only organic food because there was no choice. Her concerns about environmental degradation and the loss of indigenous species have

far more resonance than Moodie's disdain for her fellow immigrants. Traill was correct to predict that we would lose boreal woods, prairie grasslands, indigenous species of flora and fauna. She does not have the scientific credentials of the other botanists whose scrapbooks are in the Royal Ontario Museum, but she has a folk-hero status that was acknowledged in her own lifetime (when she was officially recognized as "the oldest living author in Her Majesty's Dominion"), and that the curators today happily acknowledge.

And I've come to realize that optimism is an armour against life's mishaps. I'm sure that Catharine Parr Traill's determination to be "up and doing" was a large factor in the astonishing longevity of this sweet-tempered woman, who was ninety-seven when she died in 1899.

Deborah Metsger Responds

Catharine Parr Traill's penchant for collecting and preserving plants was more than just a pastime: it improved her livelihood; informed her writing; and fostered interactions with family, friends, and scholars. In a biographical sketch that accompanied Traill's *Pearls and Pebbles* (1894), her niece Agnes FitzGibbon recounts how the entrepreneurial author regularly sent pressed ferns and mosses back to England for sale. Britain was smitten by pteridomania, or fern fever, and the plant's motif dominated the decorative arts, while fern collecting and propagation were popular pastimes. Shortly after Traill's husband died in 1859, one of her collections attracted the attention of Lady Charlotte Greville, who supplied Traill with a proper plant press and "succeeded in so interesting Lord Palmerston in Catharine's literary work as to obtain for her a grant of £100 from a special fund." With this unexpected support, Traill bought the Westove cottage in Lakefield, where she lived out her life.

James Pringle, in "History of the Exploration of the Vascular Flora of Canada," published in *The Canadian Field-Naturalist* in 1995, counts Catharine Parr Traill among an emerging number of nineteenth-century amateur botanists who interacted regularly with the scholars. Though, as Charlotte Gray suggests, scientists considered her writing to be popular, they were nonetheless impressed by her observational skills, record-keeping, and careful preservation — and referenced her in their own work.

Traill frequently forecast the impending destruction of the forests and their plants, and saw this loss as almost inevitable. One can't help but wonder what, if transported to the twenty-first century, her message would be. Would she still simply want to encourage observation before the flora disappeared — or would she join the movement to protect and preserve it?

Indigenous plants were disappearing, and Traill wanted to catalogue them in a proper herbarium before it was too late.

SPRINGWATER PALLASITE

Ian Nicklin,
Earth Science
Technician

At 52 kilograms, this is by far the largest known specimen of the Springwater pallasite — a rare type of meteorite. In 1931, Springwater samples were uncovered on a farm near Biggar, Saskatchewan. In 2009, acting on a hunch, a team of professional meteorite hunters returned and made new discoveries, including this remarkable specimen.

Of the approximately 50,000 known meteorites, only ninety-seven are pallasites. They are as beautiful as they are rare — an intriguing mixture of olivine (a green-to-amber silicate mineral) set in a brilliant alloy matrix of iron and nickel. We never see this combination on the earth's surface, although pallasite-like materials may exist on the planet, or rather in it.

Scientists disagree about how pallasites form. In one of the most widely held theories, they are a core-mantle boundary mixture. The earth's inner core is solid — iron combined with some nickel — and the surrounding outer core is a layer of liquid iron and nickel. The earth's crust is largely made up of silicate minerals — quartz, feldspar, mica, et cetera — and the bulk of its mass is between the crust and the core, in the mantle. This region is made up of silicate minerals, including olivine, that are heavier than those typically found in the crust. The planet's rotation, along with the intense heat between the core and mantle, combine the outer core's liquid metal with the lower mantle's olivine crystals, forming a mixture like the one we see in pallasites. Something similar may have happened on asteroids that were forming at the same time as Earth, more than 4.5 billion years ago. When they were torn apart in enormous collisions with other asteroidal bodies, core-mantle materials could have been exposed, creating pallasite meteoroids in the process.

Rare, beautiful, and scientifically fascinating, pallasites tell tales about the formation of our solar system, and of our planet, in the distant past. Like other meteorites, they are a source of constant wonder.

> Pallasites tell tales about the formation of our solar system, and of our planet, in the distant past. Like other meteorites, they are a source of constant wonder.

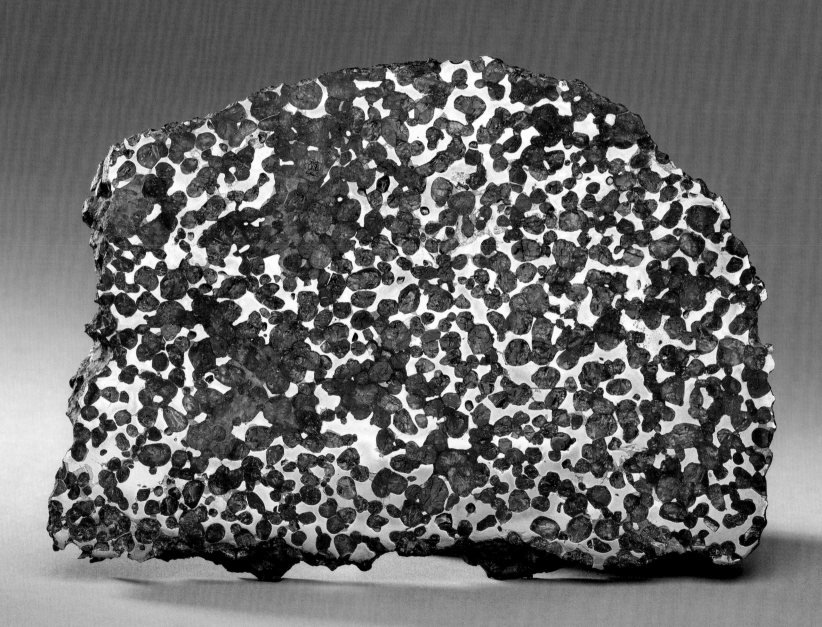

CHRIS
HADFIELD

Photography by Arianna Perricone

Orbiting Earth on the International Space Station offers an incomparable perspective. Of the many billions who have lived on the planet, just over 500 of us have seen it from that height — the globe perfectly round, blue, improbable, and precious from an altitude of 350 kilometres. Astronauts have come from many countries, cultures, and faiths, but we all share a common reaction when first reaching orbit: the undeniable need to look out the window and see our home, directly, for ourselves.

It is a world of wonder. The sudden richness of colour and texture is startling, gasp inducing. What once was just a place on a map or a remote destination, only to read about, turns into an explosion of reality. A simple sideways glance reveals a whole country, the five Great Lakes, the entire length of the Nile River. The rush of exploration and human history, the wildness of geology and nature, all of everything inexorably rolling by. It's like standing at the prow of an immense ship, plowing through all that exists.

And these ships go fast. It's a by-product of basic physics, but spaceships need to travel eight kilometres per second just to stay in orbit. Any slower and they would drift down into the atmosphere; any faster and their orbit would climb, possibly taking us away from Earth forever. Our launch rockets are surgical, steering and accelerating us to the perfect combination of height and velocity. We are glad for speed: it takes us around the planet every ninety-two minutes, twenty-five times faster than the speed of sound, immeasurably faster than Ferdinand Magellan. An effortless around-the-world tour sixteen times a day, as the globe spins below, lets us

see, literally, everything. Who could ignore it? We can't, and we have to wipe our nose prints off the windows regularly.

Earth is a visibly dangerous place. Despite the best efforts of vegetation and erosion to cover up the scars, it is pockmarked with the acne of a troubled and difficult past. Giant rings glint mutely out of the bedrock, ancient reminders of a forgotten violence. A crater sits bizarrely in the Arizona plain, like a bullet hole left after a cosmic shootout. The great sweep of an entire sea shore is the artifact of a pre-historic cataclysm. Our world has been pummelled, blasted, attacked. One night, in orbit over Australia, I watched a meteor burning across the sky below me. Of all my spaceflight experiences, that one scared me the most — a random lump of rock from the heavens, caught by the pull of Earth's gravity, that could have just as easily smashed into our spaceship and killed us instantly. I remember the shiver that ran up my back.

Now that I'm on the ground again, I can watch meteors from a much safer vantage point. All I have to do is lie on my back in a field at night, stare at the sky, and wait a bit; I regularly see hints of the same space invaders that caused the earth's scars. Quick shooting stars streak across the black sky, each a pretty extraterrestrial falling to the earth. Pulled here against their will, most burn up completely, and the vespers of that cosmic firework only later drift down to the surface as cindery dust, the motes you see floating in a bright sunbeam.

But some tenacious pieces of rock — the heaviest, densest ones — survive the fiery plunge and slam into the surface with gravity's sado-masochistic force. They careen into Earth's protective atmosphere with immense speed, up to seventy kilometres per second. Their outer layers heat up and melt with the air pressure and the shock wave. Their insides are stone cold after endless eons in deep space, but their grey-black skin suddenly starts to scorch and peel off, heated in the instant blast furnace of atmospheric entry.

If you had been lying in a field in Springwater, Saskatchewan, around 4,000 years ago, you would have seen and heard one — the sudden fiery trail and supersonic thunderclap of a boulder tearing through the air, the palpable shock as it hit the earth and bounced to a halt in pieces. Most of the fragments were tiny, but a few hunks landed there, wedged in the dirt of the Canadian Prairies. You could have bravely walked up and nudged one with your toe. You would have seen that it was glinting with frost — amazingly ice cold, even after the external heat of entry. The main outer skin would have been rough and dark, like coarse, dirty lava. But the newly split inner parts would have revealed the shining heart of the stone itself — something resembling petrified nougat, a mottled admixture called pallasite that is part iron–nickel, part olivine.

And part magic. How did this strange rock, this complex collection of minerals, arrive here at all? Simply looking at it, you can see that it could have only formed under heat and pressure, melting those elements together. Was it the primeval heart of another planet or asteroid that was broken apart by a violent, ancient impact? Or was it the chance offspring of a cosmic collision, the child of two asteroids that randomly slammed into each other with enough energy to melt the parent rocks themselves? Regardless, looking at this stone is like looking deep into the earth itself. It shows us what conditions must be like near the planet's core-mantle boundary, thousands of kilometres beneath the cool surface under our feet — Jules Verne's *Journey to the Centre of the Earth* come to life, like a scientist showing us something unexpected through a microscope.

Or better, showing a child in a museum. An innocuous stone that found its way to the Royal Ontario Museum, letting visitors see our solar system first-hand. A sample from the deep beyond, from the edges of our understanding, that helps us know our history and ourselves better.

Every time we wish upon a star.

Ian Nicklin Responds

I can imagine no job more technically challenging than commanding the International Space Station. The crucial attention to detail and the focus on every decision are the very definition of no-nonsense. Though Chris Hadfield is no-nonsense when it comes to his job, he still manages to step back and reflect on the wonder of it all. In my day-to-day work, I do not face the life-and-death decisions of an astronaut, but I do focus on details. Focus allows me to accurately describe and understand the objects in my collection, but it also constrains the five-year-old inside who's dancing around shouting, Look at how cool this thing is! In his essay, Hadfield turns his five-year-old self loose.

From a coldly descriptive, analytical perspective, the Springwater pallasite is just a rock. So, why do we care about it? We care because, as Hadfield reminds us, Springwater is a portal, a marvellous object. It is from another world — one that formed at the same time ours did, billions of years ago. Torn apart in some monumental cataclysm, its fragments wandered the solar system until some of them were caught in our gravitational net and brought fiery to the ground. If we pay attention to every detail, and take a step back, we can learn facts that transport us to wider worlds, that give our past more richness and depth, and that better orient us in the order of things. When seen with open eyes, such as Hadfield's, objects like Springwater invoke curiosity and evoke wonder.

Pulled here against their will,
most quick shooting stars burn up
completely, and the vespers of that
cosmic firework only later drift down
to the surface as cindery dust.

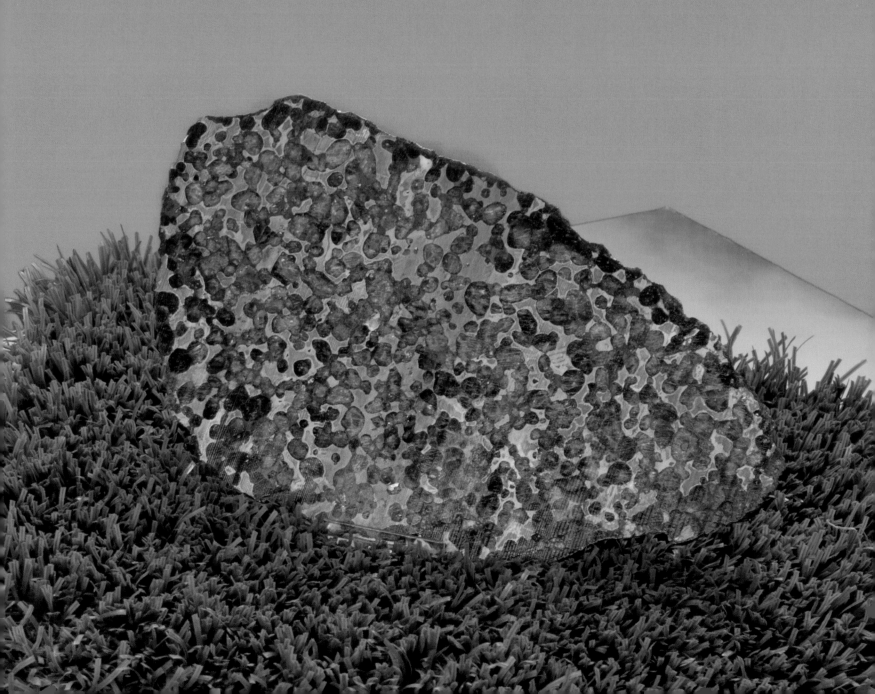

EDO PLAQUE

Silvia Forni,
Curator of
Anthropology

This figurative plaque was one of hundreds produced by brass casters working for the court of Benin, in present-day Nigeria, to decorate the royal palace's pillars. Sixteenth- and seventeenth-century travelogues described these plaques, and Olfert Dapper referenced them in *Description of Africa* (1668). Dapper's book provided the first published visual depiction of the palace's aesthetic splendour, along with the court's sophisticated architecture and decor. Despite this early acknowledgement, the art of Benin — which was reserved for the king and the political hierarchy — remained mostly unknown to Europeans until 1897, when the British attacked and looted the capital and sent thousands of artworks as official spoils of war back to England. Some of the pieces were also distributed — based on rank — to the officers who participated in the expedition.

Founding director Charles Trick Currelly purchased this plaque in 1908, from S. G. Fenton, a London dealer who specialized in decorative arts, weapons, and curios from all over the world. It was one of thousands of Benin artworks sold by British auction houses and dealers to museums and private collectors in Europe and North America.

According to estimates by Kathryn Wysocki Gunsch, a curator at the Baltimore Museum of Art, the plaque dates to the mid-sixteenth century, during the reign of Oba Esigie, whose military and economic successes were often expressed in courtly artworks with iconographic references to Olokun, the god of water. While the crocodile and the floral designs (*ebe-amen* and river leaves) refer to the water kingdom of Olokun, the central figure represents a young warrior. His attire and sword — not in a style restricted to the court — suggest that he is of relatively low rank, and probably from a vassal state. His hairstyle is somewhat peculiar, and the markings on his nose and left arm are atypical of Benin body markings identified in other plaques. The flying braid at the top of his head is perhaps a stylistic touch that suggests movement, despite the apparent firmness of his legs and arms. In life, this young warrior was probably present at court as an ally or as a tribute bearer. His image is just one element of a complex visual narrative that celebrates the king's military power and spiritual authority.

> The British attacked and looted the capital of Benin and sent thousands of artworks as official spoils of war back to England.

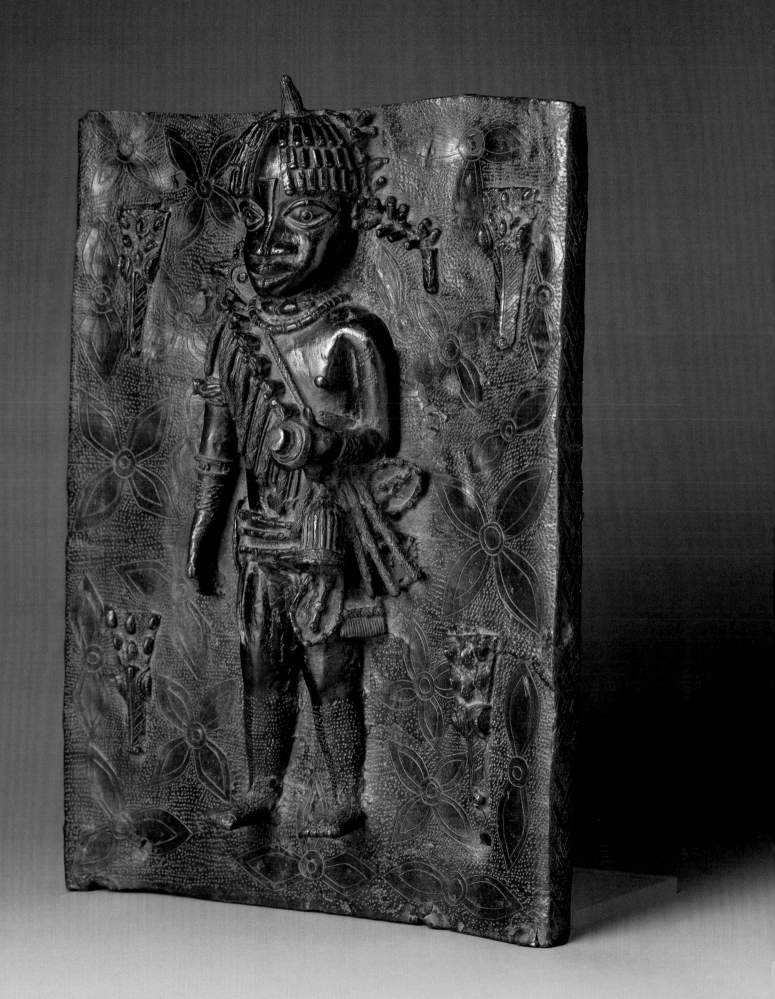

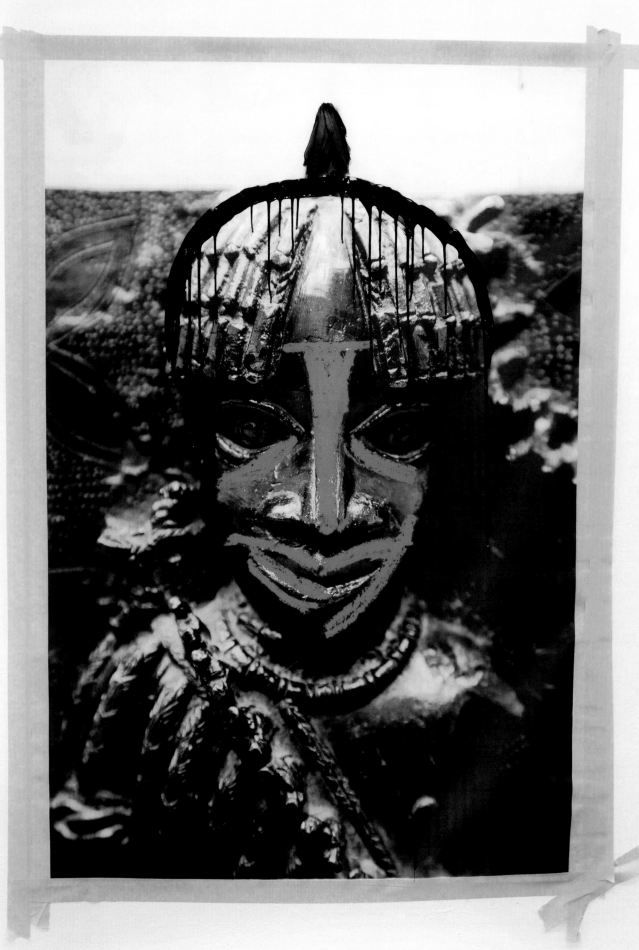

LAWRENCE HILL

Photography by Marvin Luvualu Antonio

To the undiscriminating eye — perhaps yours, and certainly mine before curator Silvia Forni led me to the backstory — the Edo plaque might not warrant more than a passing glance. A sixteenth-century bronze plaque, it depicts a watchman or soldier. He is an ordinary man. He is not royalty. He is *serving* royalty, in the Kingdom of Benin, now located in southwest Nigeria. He has a beaded headdress and wears a loincloth.

A sash, holding a bell, falls diagonally across his chest. He carries a sword. Immobile, he stares forward, eyes wide, frozen in time. His facial features are clear and simple. He offers up a clear, bold representational image of a guardsman in a palace.

The Royal Ontario Museum acquired the plaque in 1908. Charles Trick Currelly purchased it from a London art dealer named S. G. Fenton for £11 (the equivalent of £3,800 today). A full century before, in 1807, the British had issued a parliamentary decree to abolish the slave trade, but they continued to pursue their other economic interests in West Africa with barbaric zeal. Let me tell you a story:

In January 1897, a delegation of nine British emissaries and 250 African "carriers" (I imagine porters carrying food, water, clothing, bedding, alcohol, and gifts) set off for Benin, where the local king (or *oba*) was refusing to go along with the British trade monopoly. Led by vice-consul James Phillips, the delegation's mission, presumably, was to set the king straight. He had made it known that he did not wish to receive the European visitors, but they undertook the two-week trek anyway — a mistake, as it turned out. Before they reached the royal palace, they were ambushed and all but two of them were killed.

The king and his people had fled.
The British sacked the palace
and, in the process, came upon an
unexpected and astonishing
discovery: thousands of pieces of
art, including hundreds of plaques
cast in bronze, sculpted lions, and
ivory carvings.

The massacre provided the British with the excuse they needed to counterattack. Within a month, they sent a "Punitive Expedition," consisting of 1,200 well-armed marines and 1,700 carriers, on the same journey to attack the Kingdom of Benin. They met with some resistance and experienced light casualties along the way, but they succeeded in reaching the royal palace only to find that it had been abandoned. The king and his people had fled. The British sacked the palace and, in the process, came upon an unexpected discovery. Previous European visitors had told stories of human sacrifice, calling the area the "City of Blood" and painting a picture of a land rich in resources but devoid of cultured civilization. But the invaders were astonished to discover thousands of pieces of art, including hundreds of plaques cast in bronze, sculpted lions, and ivory carvings.

The works had been created over centuries and surpassed, in quality, any African art Europeans had yet seen. It was so good, in fact, that for some time many observers speculated that it could not possibly have been created by Africans. Who could believe that they had the knowledge and the skill to cast bronze as early as the sixteenth and seventeenth centuries? (This, of course, calls to mind the other abilities Africans possessed before they were brought in chains to the Americas: knowledge of rice and indigo cultivation, literacy in Arabic, midwifery, herbalism, and musicianship, among others. But let me return to the story.)

The British were delighted by the treasures they found, so they took them. A few valuable pieces were given to military officers. A certain Admiral Egerton, for example, received a dozen special items. Others got ceremonial swords. In the name of the entire troop of invaders, the commander of the Punitive Expedition sent two leopards carved from ivory and two large ivory tusks to Queen Victoria. The rest they took themselves. Let me drop that euphemism. Let me employ instead the verb that would sit on prosecutors tongues if, say, you and I were to break into a house and take the works of art. The verb is *steal*.

They gave some away. The rest they took themselves. Let me drop that euphemism. The verb is *steal*.

The members of the Punitive Expedition stole some 4,000 pieces, brought them to London, and sold them to museums and dealers. This constituted what may well have been Europe's biggest pillage of such works. It was not considered theft, however. On the contrary, as they were selling their haul in Europe, the British claimed the proceeds would help defray the costs of the expedition that allowed them to seize trade routes in the Kingdom of Benin. With very few exceptions, the collection has not been returned. Indeed, the bronze plaques are now among the most valuable works of African art circulating in the West. In 2007 and 2008, four of the world's most prestigious museums in Vienna, Berlin, Paris, and Chicago teamed up with the National Commission for Museum and Monuments of Nigeria to curate an exhibition of art from the Kingdom of Benin. They produced *Benin: Kings and Rituals; Court Arts from Nigeria*, edited by Barbara Plankensteiner, a rich and complex anthology from which I have drawn in researching this essay.

While the Africans did not have much choice in the matter, we in the West have been enriched profoundly by the people and the art of Africa.

When thousands of pieces flooded into Europe at the outset of the twentieth century, they influenced Pablo Picasso, Henri Matisse, Wassily Kandinsky, and other masters. This is the history of the world. Intercultural and interracial contact has produced some of our most vital economic growth, our richest cultural innovations, and our most unforgettable art.

In the Americas, we have evolved and grown as a result of our contact with Africa over half a millennium. But we do well to remember the stories behind African works of art — stories which are occasionally, but not always, footnoted in our museums and galleries. Edo is a story of blood and theft in one world, and of new life in another. To gaze at Edo is to recall all that we in the West have borrowed or stolen from Africa. It is to imagine all the ways we have been enriched by African peoples, and all that we owe them. It is to see not just the object, but ourselves.

Silvia Forni Responds
The looting of Benin City and the dispersion of its treasures is an infamous chapter in the history of spoliation and domination that has shaped European-African relations for centuries. Lawrence Hill's piece is thought provoking for a number of reasons, but I would like stress two points.

First, this is a well-documented confrontation between enemies. Regardless of the propaganda that portrayed Benin as the tyranical "City of Blood," the events suggest a rather straightforward military confrontation, with losses on both sides and a winning army taking away the spoils. This story reveals that the British faced a complex hierarchical state, with regional economic power, and not some "savage" or "primitive" tribe that could be swept away or forced into submission. The unexpected plot twist was the discovery of royal treasures and shrines full astounding artwork. If the British victory and the dispersion of loot brought cash to the army coffers, it also revealed in striking visual terms the contradictions and fictiveness of colonial propaganda. Something was wrong in this picture; art this refined could not be the work of primitive savages.

Second, because of the media attention and the prestige of the booty, the art and the looting have been linked ever since. African art, in Western scholarship and museums, is commonly studied and appreciated as a material testimony of specific cultural and religious practices. For some important collections, we have field documentation and histories, but for many pieces in private collections and institutions we do not know the stories behind their acquisition. If we are lucky, we know the first European to own them, but how did they get out of Africa? Were they stolen? Purchased? Gifted? Many of these details were never recorded or were simply erased. But for most of the Benin pieces, the background is well known and unforgettable. Indeed, as Hill points out, these objects are at once mementos of ancient splendour and of colonial violence.

ICE CRAWLERS

Douglas Currie,
Senior Curator
of Entomology

By the end of his career, Edmund Murton Walker, the museum's first curator of entomology, had published more than 130 scientific papers and several books, including his monumental three-volume *Odonata of Canada and Alaska*. But perhaps his greatest claim to fame was the discovery of the most recent incontrovertible new order of insects, the ice crawlers (Grylloblattodea).

Orders are a major unit of classification, and their discovery is a rare event. For example, beetles (Coleoptera), flies (Diptera), and bees and wasps (Hymenoptera) are all examples of insect orders. Walker's finding was held in such high esteem that ice crawlers were adopted as the official symbol of the Entomological Society of Canada. Coincidentally, his publication on ice crawlers corresponded with the opening of the ROM in 1914, and specimens that formed the basis of his original study are among the most prized holdings of the museum's entomology collection.

The fossil record reveals that ice crawlers have been with us since the Permian period — a span of more than 250 million years. They evolved at a time when the world was radically different, and eventually diversified into forty-four families distributed throughout the world. They persisted stoically through the major extinction events at the ends of the Triassic and Cretaceous periods — episodes that devastated great swathes of organismal diversity that included the dinosaurs. Today, only one family and twenty-eight species remain, persisting in the colder regions of North America and Far East Asia. Unlike their ancestors, modern-day ice crawlers lack wings and are confined to cold and inhospitable habitats, such as caves, deep soil, and the edges of glaciers. Their optimal temperature of activity is around the freezing point, and you can easily kill one by holding it in the warmth of your hand. Ironically, they are also intolerant of extreme cold, succumbing at temperatures below minus 9°.

The dependence of modern ice crawlers on such a very narrow spectrum of low temperatures, combined with their inability to fly (which compromises their ability to quickly colonize new habitats), makes them particularly susceptible to environmental change. With glaciers melting at an unprecedented rate, their preferred habitat is starting to disappear. According to specialists, some populations in the Sierra Nevada mountains of California — perhaps even entire species — may already be extinct.

Today, climate change threatens the very existence of ice crawlers. This would be an ignominious end for a once grand, quarter-billion-year-old lineage, and a sad footnote to Walker's legacy.

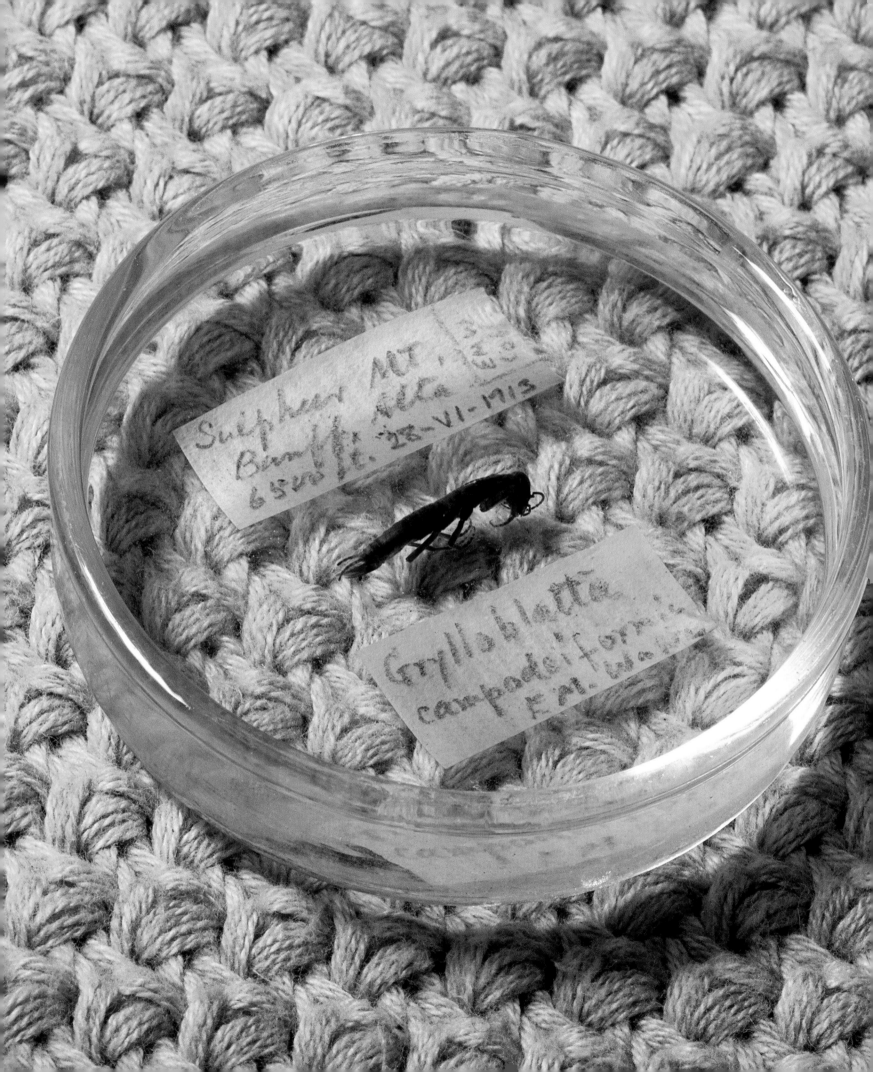

ALEX HUTCHINSON

Photography by Raymond Salaber

In the evening, after tents had been set up, dinner cooked and eaten, and the day's haul of *Somatochlora cingulata* and *Gomphus furcifer* carefully catalogued and preserved, Edmund Murton Walker was an entertaining man around the campfire. The Royal Ontario Museum's first curator of entomology would play the mouth organ, recite Lewis Carroll, and demonstrate his ability to whistle and hum simultaneously in harmony. "Around the fire at night his monologues in full Cockney accent were always in demand," a colleague later recalled. "Towards the end of the evening, if coaxed a bit, he would beat out a few xylophone solos by tapping on a lead pencil held against his teeth, varying the pitch by changing the volume of his mouth cavity." Such was life in the field for the gentleman adventurers charged with the daunting task of filling in the blank spots on Canada's entomological map.

It's hard not to be a little envious of Walker and his generation, for whom *terra incognita* often began literally across the street. Born in 1877, he lived on Toronto's St. George Street during his high school years, just a block from Bloor Street, which at the time marked the city's northern boundary. Young Edmund was already devoted to collecting insects (a friend of his father's having given him a copy of his "well-known treatise" *Insects Injurious to Fruits*), and he could stroll up the unpaved paths north of Bloor to wooded ravines where creatures unknown awaited. By the time he entered university, he was already in correspondence with several eminent figures in the nascent field of entomology, and after a year at university he published descriptions of his first new species — a pair of grasshoppers.

These days, Walker is best remembered for his discovery of Grylloblattodea, a group of ultra-rare glacier-dwelling extremophiles — better and more descriptively known as "ice crawlers" — on Sulphur Mountain near Banff, Alberta, on June 29, 1913.

"This was a big, big deal," entomology technician Antonia Guidotti explained to me when I came to see the original sample, carefully preserved in a vial of 80 percent alcohol and housed in a second-floor collection room. It wasn't just a new species of insect, of which there are somewhere between six and 30 million; nor was it a new genus, or a new family. *Grylloblatta campodeiformis* Walker, a living fossil named for its puzzling resemblance to both cockroaches and grasshoppers, turned out to be the first example of a completely new order of insects — the last of thirty or so orders to be recognized. Walker saw something that no one had ever seen before, and brought it back to the soon-to-be-opened ROM.

On a canoe trip down the remote Snake River in Yukon a few summers ago, we rounded a bend to see what appeared to be a river of thick, creamy milk pouring into the turquoise waters of the main channel. The incoming creek was coloured by limestone sediment, and the patterns created as the merged flows reminded me of high-end cappuccino froth. A thin line of black spruce clung to the tops of the rugged cliffs on both sides of the river, with the Mackenzie Mountains rising behind them, and the combined effect was one of the most arresting sights I've ever seen. There was a flat clearing by the mouth of the creek, and we pulled over and made camp. I spent the rest of the afternoon with my camera, trying to somehow capture and preserve that moment when we'd rounded the corner and my jaw had dropped.

I like to think that wilderness trips like this have something in common with Walker's expeditions, which criss-crossed Canada from Newfoundland to Vancouver Island — a desire to explore the country, to see something new and unfamiliar. It's easy to mock the tourism-as-status-builder mentality in which destinations acquire value in inverse proportion to the number of people at a cocktail party who've been there. But the urge to explore is hardwired in us, a trait that distinguishes us from other species who generally move to new habitats only when forced to by a shortage of resources. About one person in every five carries a gene variant called DRD4-7R — sometimes dubbed the "explorer's gene" — that is associated with curiosity, restlessness, and a desire to see new things and new places.

Our campfire that night was unusually quiet, as we watched the milky water flow past and the low Arctic sun dance along the cliffs. (None of us could remember any Cockney monologues.) I pulled out our guidebook, its pages thick and still glued wetly together after an unsuccessful attempt to run some rapids a few days earlier, and gingerly peeled it open to the short section on the Snake. My heart sank: there, in grainy black and white, was the exact view that had thrilled me, captured from the same spot. It reminded me of a trip to Ayers Rock in the Australian outback, where every tourist in the region converges twice daily at one of two massive parking lots ideally situated to view and photograph the sandstone monolith at sunrise or sunset from the "right" place.

The next morning, I rose early, grabbed my bear spray, and hiked inland along the creek's path. After fifteen minutes, I turned to climb the spur of a ridge leading into the mountains, and fought my way through dense willow shrub and boggy tundra until I reached a modest plateau. It wasn't a great viewpoint, and didn't lead anywhere in particular — perfect, I figured. Of the thousands of ridges, peaks and outcrops along this rarely travelled river, who would ever have had a reason to climb this one before me? As we continued down the river in the days that followed, I tried to find places of my own — little streams, mossy clearings, forgettable outcrops that would appear in no guidebook. Venturing just a few hundred metres off the trail, I found, brought a greater sense of adventure and discovery than the thousands of kilometres I'd travelled by jet, van, and float plane to get here in the first place — an insight with arresting possibilities closer to home.

For all his travels, Walker remained in explorer mode even in the most mundane circumstances, making discoveries by seeing what others didn't see rather than going where they didn't go. He began his career as a doctor, his father having convinced him that medicine offered better career prospects than insects:

"Late in the fall of 1903," he reported in the journal *The Canadian Entomologist*, "I heard the chirp of a cricket in the basement of the Toronto General Hospital, but paid little heed to it, thinking it was that of a common field cricket which had entered the building. My attention was again drawn to the sound, however, as it persisted night after night, and I began to notice that it was higher pitched and of less volume than that of the field cricket. I traced the sound to the

A living fossil named for its resemblance to both cockroaches and grasshoppers.

Walker remained in explorer mode even in the most mundane circumstances, making discoveries by seeing what others didn't see rather than going where they didn't go.

boiler-room and found, as I had expected, the European house cricket, which I had never before met with in this country."

He practised medicine for a year before, inevitably, returning to the University of Toronto's biology department, then heading to Berlin for postgraduate work in entomology.

Other journal papers from the years that followed record a rare cockroach "taken at Toronto from a bunch of bananas," and a faunal list of land snails found in the vicinity of his summer cottage. When he heard of two infants infested by subcutaneous myiasis, he managed to procure a few of the live maggots and nurture them on raw beef until they became flies, which he identified as the flesh fly species *Wohlfahrtia vigil*. "It was the first time anything had been known of the habits of *Wohlfahrtia* in America," he noted, "although a European species (*W. magnifica*) was well known to infest wounds or enter the natural passages of persons sleeping in the open." Even on grand cross-country voyages, like the one that yielded Grylloblattodea, he

was collecting along the way: his 1906 description of the grasshoppers and crickets of the Canadian Northwest includes forty-nine species gathered during whistle stops ranging from a few minutes to half an hour as he crossed the Prairies.

Back in Toronto, green spots such as High Park and the Credit River continued to yield finds for decades (Walker was still cheerfully working away on the third volume of his definitive tome on the dragonflies of Canada in the '60s, when he was in his mid-eighties). These days, you'd think that the age of urban discovery has long since been paved into submission, but the ROM's Guidotti set me straight. Only about 900,000 of the millions of insect species have been identified and described; she herself has described four new species of parasitic wasps from Vietnam. And in 2012, she took part in a one-day "BioBlitz" in Rouge Park in Toronto's east end, in which more than 200 volunteers collected or noted 1,450 different species of living things. Rare finds among the 500 arthropods included *Sphodros niger*,

or black purse-web spider (never before seen in Toronto), and perhaps others still to be determined. "We now have 'Species 1,' 'Species 2,' and so on, just waiting for experts to ID them," Guidotti said.

As it happened, a few days before meeting Guidotti, I had my own opportunity to see Toronto through fresh eyes. As a runner, I'm quite familiar with the trails along such rivers as the Don and, particularly, the Humber, which passes within a few blocks of my childhood home, where my parents still live. My mother had asked for a canoe excursion down the Humber as a birthday gift, so on a sunny day in July I found myself paddling south from Bloor Street West along the route followed 400 years earlier by Étienne Brûlé, the first European to see Lake Ontario. With steep, wooded slopes on either side of the us, the city quickly receded from our minds. We were soon nosing into quiet lagoons that were invisible and inaccessible from the riverside trails, hidden by islands and protected by reedy marshes. Egrets and herons eyed us warily and turtles sunning themselves on logs jumped into the water as we drifted past — sights I'd never seen in three decades of playing, walking, biking, and running there.

I'd only agreed to go on the excursion as a favour: the Humber was too tame and too familiar to interest me, and I was wrapped up in my own frustration that, due to scheduling conflicts, this would be the first summer in almost a decade that I wouldn't get deep into the wilderness for a hiking or canoeing trip. But as we explored yet another hidden inlet, I realized that the trip was awakening some of the same wonder that I'd felt in venturing off the usual path in Yukon. Not that the two experiences are interchangeable — far from it. But it can't be good for a sense of wonder to lie dormant for forty-eight weeks a year and be dusted off only on vacation.

Even Walker's famous expedition up Sulphur Mountain in 1913 required no crampons. He and his colleague, T. B. Kurata, were actually on their way to a month at the Pacific Biological Station on Vancouver Island, where their mission was to assemble a collection of plaster fish casts to stock the ROM's galleries. Kurata would take the moulds and later make the casts, while Walker, a gifted artist, would make the watercolours from which the casts would be painted. As they rode the train across the country, as usual, they collected whatever insects they could at every stop, including a stay in Banff. There they were greeted at the train station by drivers from various hotels yelling for their business; by pure fluke, they ended up getting into a bus that unexpectedly carried them away from the town itself to a now-defunct hotel by the Upper Hot Springs, halfway up Sulphur Mountain. It was a stroke of luck, as Walker later recounted:

"On one of our trips to the top of Sulphur Mountain, when about 6,500 feet above sea-level, Kurata called to me to see an insect he had found under a stone....I knew at once that this creature was something new — unlike anything ever found before. Soon we had another. Both were adult females and both had ovipositors like those of the long-horned grasshoppers. But they ran like cockroaches and had the general shape of earwigs or stonefly nymphs. I knew that this was a real discovery yet I could hardly believe it."

I've been there. In 2007, I was in Banff for the summer, and one morning a friend and I decided to try running to the top of Sulphur Mountain. Above the Upper Hot Springs where Walker and Kurata stayed, the trail climbs in long, steady switchbacks. About three-quarters of the way up, my friend stopped to throw up, so we walked the rest of the way. The summit seemed underwhelming — a gift shop, a pair of restaurants, and a gondola that brought hordes of tourists up to swarm around the observation decks. We didn't linger long. But looking back, I see that the fault was mine. The mountain itself was scarcely different in Walker's day; the difference is that I never once thought to look under a stone.

Douglas Currie Responds

Taxonomists attain a measure of immortality, because their names are forever associated with the species they describe. For example, the first discovered ice crawler is formally known as *Grylloblatta campodeiformis* Walker, signifying that Edmund Murton Walker authored that particular species name. While most organisms continue to persist long after they are revealed to science, what do we remember of the taxonomists who christened them?

Walker had an unrivalled reputation among twentieth-century Canadian entomologists; he received numerous national and international awards and honours. And each time I visit the ROM's entomology collection (now held in the Edmund M. Walker room), I see his portrait hanging near the entrance — a fitting tribute to this entomological giant.

I have always viewed Walker through the lens of his academic achievements, but never contemplated who he was as a person. Alex Hutchinson turned a stone I never thought to look under: by exploring *who* Walker was, as opposed to *what* he accomplished, he put a human face to the man. To my surprise, Walker wasn't the imposing figure I always imagined him to be. Hutchinson revealed a kindred spirit, someone who revelled in exploration and discovery. What's more, Walker was evidently a character — the kind of person I would have enjoyed spending time with in the field. As we mark the ROM's centennial, and the discovery of the last new order of insects, I will personally reflect as much on Walker, the man, as I will on his accomplishments.

FISHING BY TORCH LIGHT

Kenneth Lister,
Assistant Curator
of Ethnology

As Paul Kane paddled up the Fox River toward Lake Poygan, Wisconsin, where the Menominee nation was to receive treaty payments, he entered a region that had already been significantly encroached upon by the United States government. In 1836, with the Treaty of the Cedars, the Menominee people had ceded 1.6 million hectares; nine years later, when Kane stopped to sketch Indians spearing fish, he rested on the southern boundary waters of that territory.

In mid-to-late September 1845, Kane sketched two canoes, each with Menominee spearmen wielding leisters beneath the glow of burning jacklights. The oil-on-paper sketch portrays the immediacy of the scene; with bold strokes, he captures the anticipation and readiness of the fishermen, poised to strike fish attracted to their lights as the evening darkness of the wood-lined river bears over them.

Painted on the river, the *plein-air* sketch exemplifies Kane's enterprise in recording Native cultures and their environments. During the latter half of the 1840s — a time when it was generally thought that Indigenous groups were destined to disappear — Kane set out to visually record what remained of traditional customs and virgin landscapes. After reaching the Pacific Ocean, he returned to Toronto with more than 600 sketches and then dedicated the next seven years to studio work. Commissioned by his patron, the Honourable George William Allan, he developed a cycle of 100 oil paintings to illustrate, in his words, "the characteristics, habits, and scenery of the country and its occupants."

The oil-on-canvas *Fishing by Torch Light* is one of that cycle, and represents a scene Kane witnessed during his journey through the Great Lakes region. Inspired by his original oil-on-paper sketch, the studio painting mimics the general scene: two canoes, the blazing jacklights, the spearmen, and the atmosphere of the evening dusk. But its more formal, romanticized treatment loses the *plein-air* character. Its brightened riverscape and details wash away the damp cool of the night, the black river melting into the dark shoreline, and our imagining of frog croaks. In it, Kane also adds an encampment on the far shore, alters the canoeists' clothing to appear more "Native," and gives the jacklight poles more sinuous lines. These alterations, known only through a side-by-side comparison with the sketch, caution against a literal interpretation of the oil painting. But here is the value of Kane's project: The two works live together. The devoted observer — the ethnographer — gifted the moment he witnessed; the studio artist — the romantic painter — leaves a visual legacy inspired by the doctrine of his age.

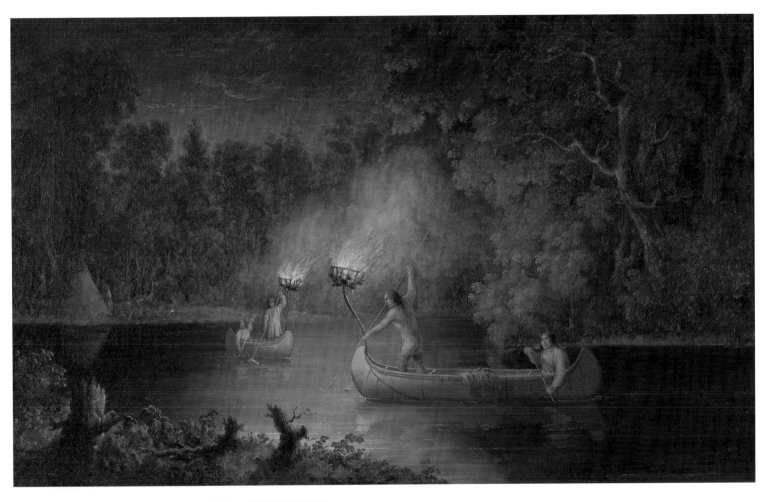

ROSS KING
Photography by David Clark

On Wellesley Street in downtown Toronto, a block east of Yonge Street, stands an unexpected architectural anomaly, a clear holdout from the horse-and-carriage days. Somehow spared the wrecking ball that must have ruthlessly claimed its neighbours, the house features wheat-coloured bricks and a proud little peaked roofline. It's set back from the street, separated from the traffic by an elegant park, and overlooked on one side by a looming '70s high-rise and on the other by an orthopaedic medical centre.

A plaque on the brick cairn out front reports that this was the home of Paul Kane, the painter. I came across the house by accident, soon after moving to Toronto in the mid-'80s, and with the discovery came a slight whiff of disillusionment. I hadn't associated Kane with handsome front porches and perky rooflines. He was someone who lived in tents or slept under starry skies on beds of pine branches. My imagination did not place him in the vicinity of Maple Leaf Gardens and Sam the Record Man.

Growing up in rural Saskatchewan, I discovered Kane not via his paintings but through his words. I was twelve or thirteen when I read *Wanderings of an Artist among the Indians of North America*. Buffalo hunts, scalp dances, the Flatheads, the bleached bones of prairie inhabitants wiped out by smallpox and those of a bison herd that fell through the ice — all of these images are still vividly with me. Kane's travel stories made Canada, and especially Western Canada, seem wild, colourful, dangerous, and outlandish, and in doing so they nicely enhanced my youthful feelings of Western alienation (for these were the Trudeau years). For Kane, Toronto was a "muddy and dirty" place that he rarely wrote about or painted. The West, on

the other hand, was an astonishing land of ancient legends and endless horizons. His book even begins with an evocation of "the valley of Sascatchawan [*sic*], and its boundless prairies," which I took to be a hearty endorsement of the robust charms of my home province.

There are other reasons why I came to admire Kane. Few Canadians today — even in this era of motorhomes, Air Canada, and Via Rail — have seen as much of the country as he did. His two-and-a-half-year expedition from Toronto to the west coast and back is, quite rightly, the stuff of legend. He was one of Canada's original painter/voyageurs, paddling by day and then painting at night by the flickering light of a camp fire. Travelling with the Hudson's Bay Company's fur trade fleet in the late 1840s — decades before the transcontinental railroad permitted the westward expansion of A.Y. Jackson and his cohorts — Kane racked up more miles by canoe, horse, snowshoe, and dogsled than the entire Group of Seven combined. As he crossed the Rockies, his feet were sliced to ribbons by ice that formed in his moccasins, and one of his dogs burned to death in scorching heat along the Columbia River. Tom Thomson's fatal exertions in cottage country seem, by comparison, mere child's play.

Kane wrote that his purpose was to illustrate the "manners and customs" of the Indigenous peoples of North America. By his own account, then, he might appear to have had principally an ethnological interest in those whose landscapes he crossed. However, many of his paintings (executed in final form only when he was safely back in his Toronto studio) reveal themselves as self-consciously and often beautifully staged works of art. The Royal Ontario Museum's *Fishing by Torch Light* shows just how alive he was to dramatic and aesthetic considerations. The glowing jacklight, the still and reflective waters, the *repoussoir* stumps silhouetted in the foreground, the ready-to-strike attitude of the Menominee fisherman whose pose is echoed by the toiling figure beside the fire in the background — all of these careful artistic touches must make us suspicious of Kane's claim that his oil-on-paper sketch, recently acquired by the ROM, was done as a verbatim transcription of the actual scene, while his fish dinner sizzled on the grill and his hands were weary from a hard day's paddling on the Fox River.

Make no mistake: Kane was an artist, not merely an adventurer or ethnologist. He showed the same energy and determination in his Toronto studio as he did while shooting rapids or traversing mountain passes. *Fishing by Torch Light* is part of one of the most ambitious projects ever conceived by a Canadian artist, a cycle of no fewer than a hundred oil paintings illustrating scenes from the lives of Indigenous people. The complete set, painted in only six years, was purchased for $20,000 by George William Allan, for his personal collection, when he was mayor of Toronto in the 1850s; later it was among the museum's earliest acquisitions, thanks to another Toronto plutocrat, Sir Edmund Boyd Osler. These 100 works made Kane's fortune and

reputation — yet another thing to like about him, accustomed as we are to the struggles and sufferings of Canadian artists. He became the country's first celebrity artist, feted in polite society, exhibited in Paris and at Buckingham Palace, and respected by many of his subjects. One of them, an Assiniboine chief, offered him a bear-claw necklace as a tribute for a job well done.

Disappointingly, Kane never went out West again. He married at the ripe old age of forty-three and settled down in the lovely little house on Wellesley Street, which, in memory of his frontier days, he dubbed Miss-qua-Kany Lodge. He relinquished his studio as his eyesight gradually faded, the result, he claimed, of the glare from the snow — something of an occupational hazard, presumably, for a Canadian landscapist. I imagine him being unperturbed by his prematurely curtailed profession. After all, what could there have been to paint in Toronto that came close to the wild grandeur he had seen out West?

Kenneth Lister Responds

In June 1845, Paul Kane headed toward Georgian Bay, north of Toronto, on his first journey to sketch Indigenous peoples. He carried pencils, paints, and paper. A year earlier, the American journalist Margaret Fuller wrote that assimilation was the only true means of civilizing Native communities. But, she opined, they are "fated to perish." Kane shared this widespread belief, and his mission was to record their portraits and cultural practices before they no longer existed — to reproduce "what is proper to them," in Fuller's words, "ere too late."

The sketches he made were praised by Toronto newspapers as "well executed," "perfectly accurate," and "highly valuable." This was the beginning of his popular reputation; as Ross King notes, he was feted upon his return and enjoyed the status of a "celebrity painter." The diarist Caroline Wells Healey Dall writes about taking notables to "see Mr. Kane's pictures," and that his paintings were applauded for their "beauty of colouring," "accuracy of detail," and "great merit." Unlike the sketches — what we can consider the witness record — his studio paintings are indeed "staged works of art." Despite differences in execution, his audience admired their "truthfulness." Thirty-three years after Kane's death, David Boyle, curator and archaeologist with the Ontario Provincial Museum, summed up the popular sentiment by referring to the oil paintings as "excellent ethnographical studies."

"BULL" THE WHITE RHINO

Burton Lim,
Assistant Curator
of Mammalogy

The ROM has a long-standing arrangement with the Toronto Zoo. When animals die, the zoo contacts us — which is why we got a call in February 2008 informing us that Bull, their forty-five-year-old white rhino, was suffering so badly from arthritis that he was having difficulty standing. Clearly, the end was near, and nowadays this is one of the few ways the museum can acquire exotic and endangered species.

The ROM has many magnificent and important specimens of natural history, but we felt something was missing — something big enough to grab the attention of visitors as they arrived at the top of the second-floor stairs. Bull seemed perfect for the job. A white rhino would embody the two main themes of the new Schad Gallery of Biodiversity: the threat of species extinction and the success of conservation initiatives.

If the deceased Bull was going to continue his life's work — informing an inquisitive public — there was much to be done. It fell to Judith Eger, then senior curator of mammalogy, to bring together the zoo's veterinarians, a taxidermist specializing in large animals, the gallery's development team, and the museum's governors (who would have to provide the funding). But preparing a taxidermy mount of an animal that weighs more than two metric tons takes time, and the gallery was opening the following year. (In fact, Bull's skeleton is still buried in the ground, so that nature can clean the bones.)

The gallery opened in May 2009, with approximately 2,500 specimens in more than 900 square metres of exhibition space. The taxidermists worked through the night to deliver Bull on time — just a day before the official opening. As she watched over Bull following his arrival, Eger noticed an infection. The papier mâché inside the mount was still drying, and mould had started to grow in the huge folds of skin on the outside of his body. Waiting for the museum to close, she opened the display case and disinfected the specimen with ethanol. Over the next few days, a fan and dehumidifier dried the rhino out.

The public was none the wiser. Standing guard at the gallery's entrance, it was as if Bull were back at the zoo. Hoards of people gathered around him, awestruck that such a majestic beast had made its way here from the museum's receiving dock. No doubt, he will continue to make his case for conservation for many years to come.

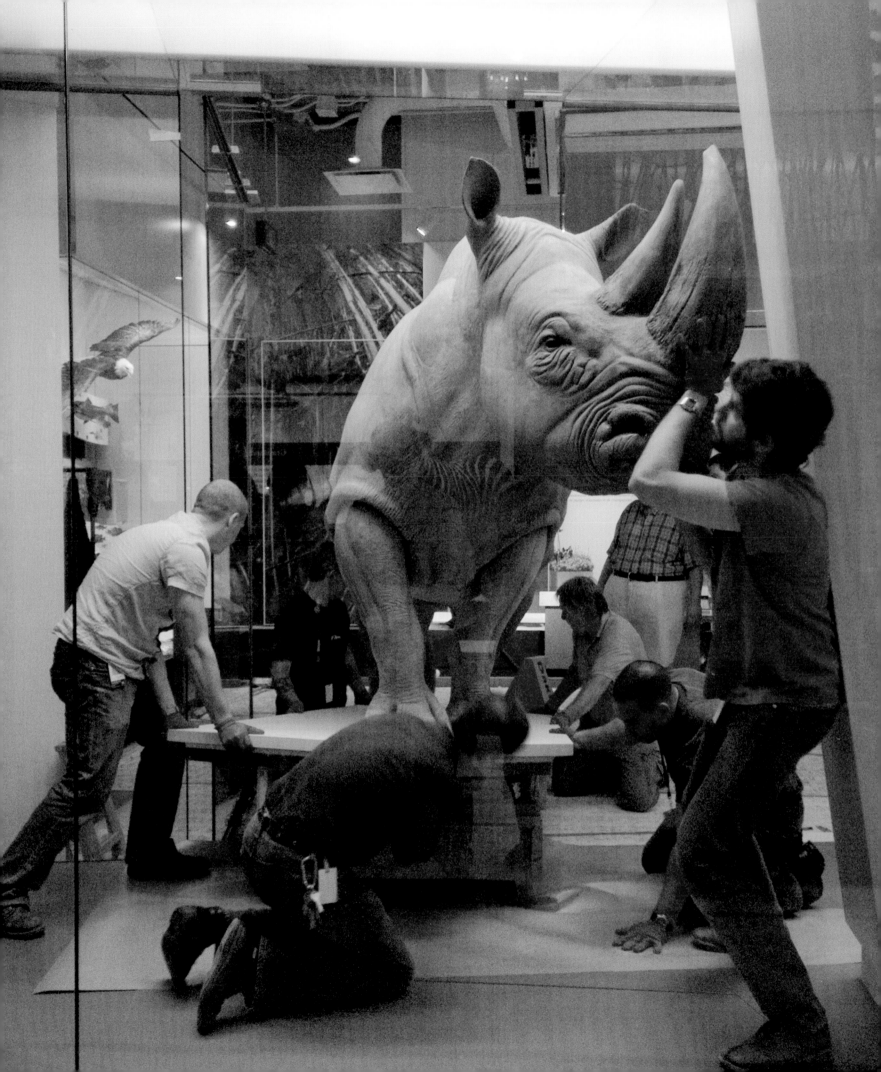

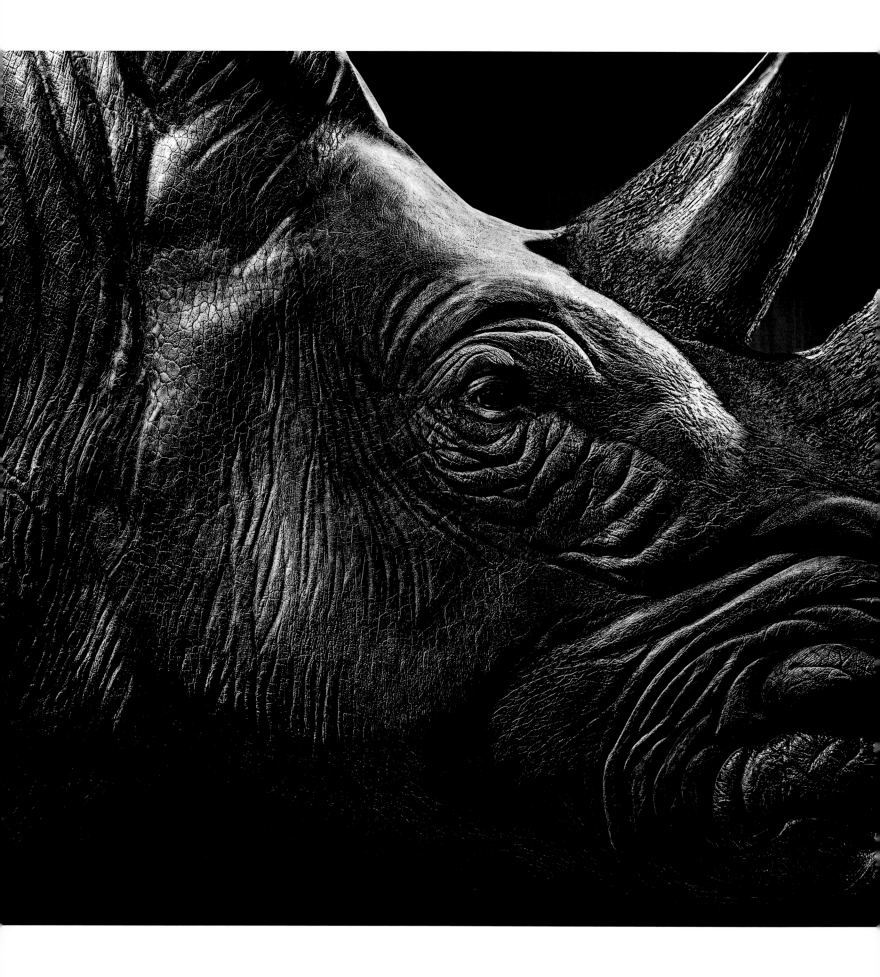

DAVID MACFARLANE

Photography by Takumi Furuichi

Y ou don't often see a really serious face anymore. That's because ours is not a serious age. I'm not sure why. It's not as if we don't have a lot to be serious about.

There was a time when people who were serious looked serious. W. H. Auden, for example. It's hard to imagine the leathery, crevasse-faced author of "As I Walked Out One Evening" and "In Memory of W. B. Yeats" being interviewed on the red carpet by Ben Mulroney about the designer of his tux. Similarly, by sight alone, you would never have mistaken Lillian Hellman or Isaiah Berlin for frivolous people. Igor Stravinsky looked much the way you'd have expected Igor Stravinsky to look had you never laid eyes on him but had heard a composition as grand and seriously ambitious as *The Rite of Spring*.

Charles Mingus? He looked almost as serious as he actually was. I know this for a fact. I once peed beside the great jazz bassist in the men's room of a Toronto club where he was playing. Small talk was not an option.

Not convinced? Let us compare the faces of Raymond Massey and Alan Thicke.

Smoking helped. Poetry didn't deepen the lines in Auden's face anymore than playing tough guys made Humphrey Bogart look like Humphrey Bogart. They were both serious smokers, and in the end their smoking killed them. So do not misunderstand me. If anyone discovers where the tobacco industry sleeps during the daylight hours, I'd happily drive a spike through what passes for its heart. Still, there was a time when lighting a cigarette was what you did when you were doing something serious — whether it was writing "Lay your sleeping head, my love / Human on my faithless arm" or waiting for Ingrid Bergman. You smoked when you were thinking about serious things — such as why, of all the gin joints in the

You don't often see a really serious face anymore. That steady, weathered gaze of world-weary experience and circumspection—the time-carved aspect of someone who has seen it all and then some—is not a look that's much in vogue today.

world, she had to walk into yours. The meditative drift of carcinogens etched *gravitas* on a face as deeply as it carved the slow, steady creep of chronic illness into a respiratory system.

But that steady, weathered gaze of world-weary experience and circumspection — the time-carved aspect of someone who has seen it all and then some — is not a look that's much in vogue. Sadly. If you had to choose a face that would best exemplify the preoccupations of the Western world, with its relentlessly bright and upbeat popular culture, I'm afraid it would be Justin Bieber's. Not Carl Sandburg's. We may not have been born yesterday, but the wide-eyed blankness that is so often the unchangeable expression of the lifted face is now so iconic it makes us look as if we wish we were. A furrowed brow is no longer the sign of thoughtfulness or grave concern. It's the sign of someone who can't afford to have any work done.

No politician today can look like Winston Churchill. Any hope of winning an election would involve giving up the cigar and confessing that a stint in rehab got you off the half bottle of brandy you were nursing on your light drinking days.

No TV news anchor can look like Edward R. Murrow. In fact, news anchors and their attendant plastic surgeons often seem devoted to populating newsrooms with the very opposite of Edward R. Murrow.

And not all that surprisingly, movie stars show the same propensities toward distancing themselves from evidence of personal experience. Once there was Marlene Dietrich. Now there's Natalie Portman.

For some reason our age has decided that instead of listening to our elders, we should listen to our press agents — all of whom look like they are seventeen. And what publicists, marketers, and media consultants inform us is that anybody who is worth asking for an autograph is somebody who, thanks to their personal trainer and the highlights in their youthfully ruffled hair, looks the way the first gulp of a cold soda pop tastes. Forget Greta Garbo's "give me a whisky…and don't be stingy, baby." Forget Bette Davis's "Fasten your seat belts, it's going to be a bumpy night." You can even forget Robert Frost and J. K. Galbraith. As a result of the widely accepted notion that anybody who looks really serious needs a new Facebook picture, people who appear to be wise are almost as rare as people who actually are.

The evidence is everywhere. But let this one example stand for all. For eight years, George W. Bush was the most powerful man on earth. Not Alexander the Great, not Elizabeth I, not Julius Caesar, not Genghis Khan — not one of history's heaviest heavies had anything like the power Dubya had. He could have stopped Napoleon in his tracks without turning off *Monday Night Football* on

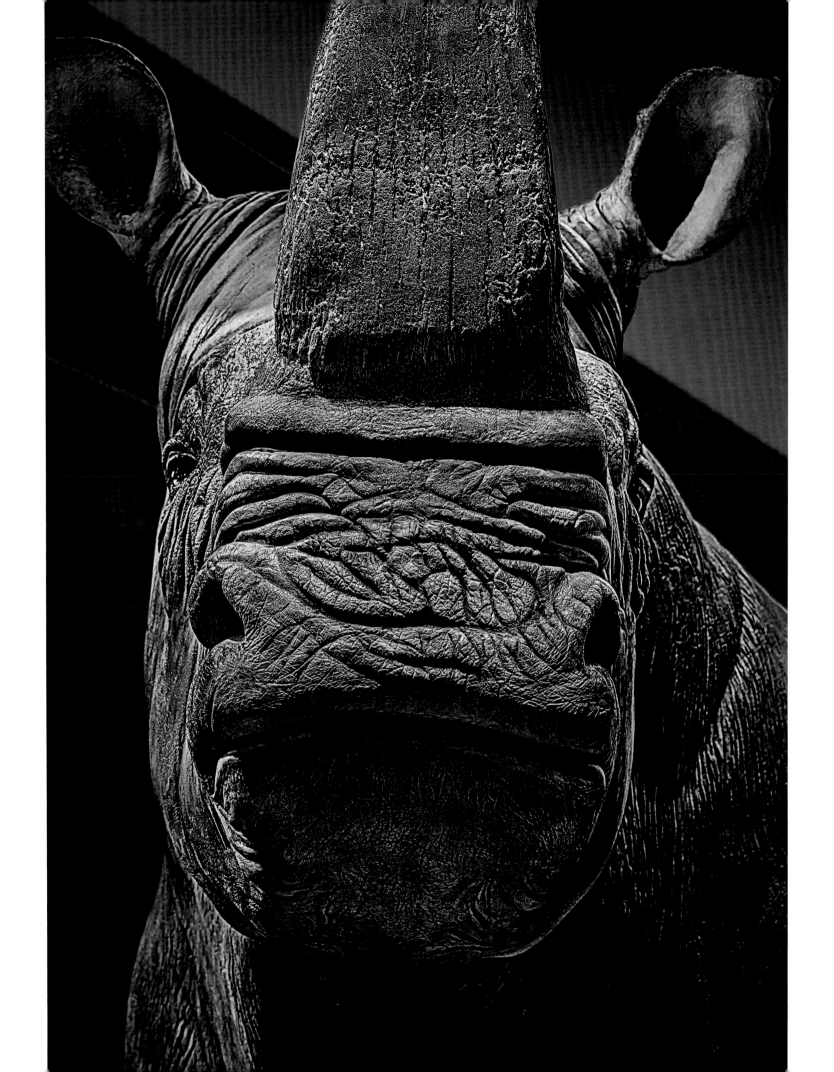

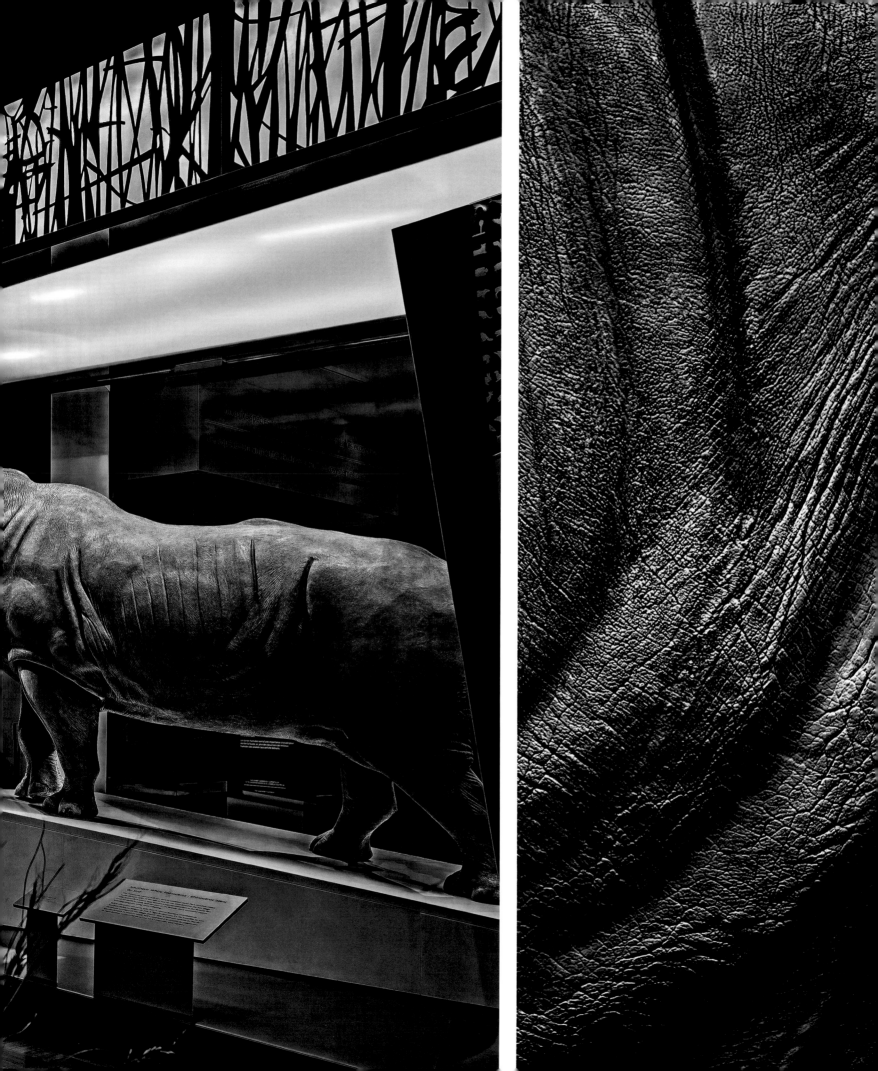

the Oval Office television. And yet, not once did George W. Bush look serious. There were occasions when he tried to, but that's a different matter. A serious face doesn't have to try to do anything. Least of all look serious.

In marked contrast to the forty-third president of the United States, the Royal Ontario Museum's white rhinoceros looks very serious, indeed. The world seems to sit heavily on its broad, muscular shoulders as it trudges heavily along the second floor toward Queen's Park. Buster Keaton had a more carefree expression.

It's easy to imagine that the fate of the planet is on the white rhino's mind. Easier still to think that he's not going to be surprised if the situation gets worse before it gets better. If, that is, it ever does get better. Deep in the collective consciousness, which he guards with his movable fortress of an exterior, is the memory of millennia. Mountains come, mountains go. The stars turn. Seas rise and fall. He knows the howl of the winds of change, and he takes the eternal unfolding of the universe in his slow, lumbering stride. As a result, he's not going to be shocked by anything — and certainly not by environmental calamity. He could see that one coming a long way off. He looks like he's been around the block once or twice.

The white rhino acts as a kind of bowsprit to the Schad Gallery of Biodiversity, and despite his massively elegiac solemnity he's an optimistic figurehead to have on what is turning out to be an

A serious face doesn't have to try to do anything. Least of all look serious. And Bull looks as old and as serious as the hills.

unseaworthy ship. The most casual stroll through the gallery makes it clear that, on the whole, things are not going well for earth's wildlife. Snow leopards, wolverines, giant anteaters, kakapos, leatherback sea turtles, marble murrelets, and spotted owls are only a few of the animals under serious threat. Visitors are informed that by 2100 half of the world's animal species may well be lost forever. "Humans" — so one sign announces in the red and white lettering that is usually reserved for Danger! — "are causing both the extinction of individual species and the destruction of whole ecosystems."

But the story of the white rhino is a happier one. Slightly. Like the American bison, the white rhino was hunted to near extinction in the nineteenth and twentieth centuries. The population of the southern subspecies came perilously close to the point of no return. But in more recent years, thanks to conservation efforts, numbers have been increasing. So it's not all gloom and doom — or so the ROM informs the humans who are making their chastened, guilty way to the building's exit.

The ROM's white rhino looks eastward, between the Nisga'a and Haida memorial crest poles that most people have incorrectly called totems since their first childhood visit to the museum. Bull — for such, inevitably, is this male white rhino's name — was born in Hluhluwe-Umfolozi (now Hluhluwe-Imfolozi) Game Reserve in KwaZulu-Natal, South Africa, in 1963. This information came as a surprise to me. Rhinos in general do not have a youthful aspect. Bull does not have the demeanour, the expression, or the dermatology of an animal that was born twenty years after Keith Richards. He looks a thousand years old if he's a day. The rhinoceros, I mean.

Bull belongs to the genus *Ceratotherium* and the species *simum*. *Ceratotherium simum* is not a name that trips easily from the tongue, but the Latin for "flat-nosed horned beast" is a good deal more accurate and a lot less confusing than "white rhino," which turns out to have nothing to do with being white. *Wijd* is Dutch for wide, and it is Bull's wide jaw and square lips — useful masticators for this more-or-less toothless herbivore — that distinguish him from the other species of the *Rhinocerotidae* family. To make things even more difficult, the black rhino — which remains seriously threatened by hunters and environmental degradation — doesn't have much to do with being black. That, I suppose, hardly matters. If you were out gathering fruits and berries in the savannah and you happened upon a 3,600-kilogram male rhino whose territorial markings of urine and feces you had somehow missed, its colour would be the last thing on your mind. Rhinos charge with unnerving suddenness and can run as fast as 50 kilometres per hour. They may be vegetarian grazers, but don't imagine they're pacific as a result of a calming diet. You don't want to get on their bad side.

Bull is ashen in his colouring, a quality that adds considerably to his air of prehistoric antiquity. The smoke of massive forest fires, the dust of volcanoes and meteorites, the blown sand of deserts and the frost of advancing glaciers — these are the elements that seem to enshroud his hulk in the mottled browns and greys of a camouflaged tank. His taxidermist chose to show him in mid-stride — the three toes of his right foot poised almost daintily en pointe, his rear legs astride with the kind of solid, jaunty confidence you sometimes see in excessively fit elderly hikers.

Bull was born four years after Buddy Holly died, but there's something about his positioning in his glass box that makes him look as if his journey started eons before that plane crashed in Iowa. The only natural surface I can think of that carries anything like the look of distressed age — embedded in Bull's tough, wrinkled hide — is the igneous rock of Ontario's Lake Temagami, which is pocked with lichen that is thousands of years old, and lined with the crevasses and faults left by the planet's distant molten past.

In other words, Bull looks as old and as serious as the hills. In the same way that Charles de Gaulle didn't look like an eighty-year-old man so much as the physical embodiment of centuries of French history, French food, French culture, French military disasters, and French wine, Bull looks as you would expect a species to look that's been around for seven million years. Shelley's "Ozymandias" would have had nothing on Bull's long, sad gaze.

All this is fiction, of course. Ridiculous, anthropomorphic fiction. Almost as much of a fiction as the commercially successful, ecologically disastrous idea that consuming ground rhinoceros horn will make a man's cock as hard as, wouldn't you know it, a rhinoceros horn. It's a suspiciously obvious association, although there's lots of evidence that ground rhinoceros horn makes those same men dumb as streetcars. So there may be something in it.

Because the truth is rhinos aren't the sharpest knives in the drawer. Their lives are not exactly rich in event. They spend half their days eating, a third of their days resting, and the rest of the time they'd probably spend watching daytime television if they could. Avoiding crocodiles is their most advanced intellectual activity. And wallowing in mud is about the most fun they ever get to have — more fun, one can only guess, than having sex with another rhinoceros. But even by rhinoceros standards, Bull's life was a little on the dull side. He passed most of his time standing around doing not much in the San Diego and Toronto zoos. All things considered, there's not a huge difference between what Bull did when he was alive and what he's doing now that he's dead. There's just less cleaning up to be done.

And yet. That saddened face, those bagged, weary eyes, those furrows and wrinkles and deeply creased lines, that stubborn strength are characteristics that — on the busy second floor when we stop amid racing schoolchildren to peer through the glass display case at Bull — speak eloquently to the absence of such forthright seriousness in contemporary life. Who allows themselves to look as saddened by the state of the world as anyone should rightly be? Who appears as grave as the truth? Who'd go out looking like Bull?

Where is the municipal politician who, wise and brave enough to be cognizant of reality and inclined to think that voters are not idiots, solemnly promises to raise taxes in order to build necessary public transit? Where are the federal ministers who, more concerned for the future of mankind than their future re-election, turn gravely to their constituents and tell them (in the full understanding that this might not be what the taxpayer wants to hear) that our way of life is unsustainable — and although it will be expensive to change things, changing things is what, for the sake of our children and our grandchildren, we must dedicate ourselves to do? Where are the leaders who, ignoring the distractions of power and selfishness and parochialism, take the weight of the world on their shoulders and trudge slowly and steadily into the harrowing difficulties that always attend justice and peace?

They are not among us, it seems. They are only vestiges now, of old wisdom, long abandoned. They are only the ghost of a sensibility that is now so out of fashion it can only be found in Bull, the white rhino, as he steps eternally toward a future he won't be at all surprised to find.

Burton Lim Responds

Gentle but serious, indeed. Bull, the white rhino, had a truculent reputation with others of his kind, but a placid disposition with children and keepers at the zoo.

Etched into his wrinkled face is not the blankness of celebrity but the wisdom of majesty, stoically expressed over millions of years of evolution and more recently over decades of human exploitation.

The black-market rate for rhino horn rivals the price of gold; its use in traditional medicine and dagger handles is serious business. And just as desperate anti-poaching tactics have incorporated controversial dehorning methods, Bull's horns have been removed. The museum keeps them behind locked doors in the curatorial centre, safeguarded against theft.

So whether you think he is here for the right reason or not, his species has come back from the brink of extinction. He may appear poised to go crashing through his plate-glass display case, but he is staying to teach us a life lesson. He doesn't have to be politically correct, just in your face enough to grab your attention for a bit of serious reflection. Bull's story is worth a listen.

ANOMALOCARIS

Jean-Bernard Caron,
Curator of Invertebrate
Palaeontology

The "strange shrimp of Canada," as its scientific name translates, was once one of the fiercest predators to prowl the planet's seas. *Anomalocaris* lived at a time of profound transformation — the so-called Cambrian explosion. The appearance of animals, starting about 540 million years ago, followed billions of years of mostly simple bacterial life and predator-free environments. For the first time, many of the earliest Cambrian species evolved hardened skeletal elements, such as plates, spines, or shells. *Anomalocaris* and similar hunters would have played a key role in this initial evolutionary arms race, with prey evolving protective structures in response to predatory threats.

Anomalocaris belonged to a primitive branch of the arthropods — the incredibly diverse group that includes shrimps, spiders, and centipedes. Equipped with large swimming flaps, bulging eyes, menacing pairs of barbed claws, and a circular mouth opening with many sharp "teeth," *Anomalocaris* dwarfed any known Cambrian creature unfortunate enough to cross its path. It was undoubtedly a top predator; like sharks, wolves, and lions today, it played a critical biological role in the control of prey populations and the structure of ecological communities.

Joseph Frederick Whiteaves, from the Geological Survey of Canada in Ottawa, first described it in 1892, from just an isolated claw. It was the discovery of more complete specimens a century later that revealed the fierce animal's true nature. The ROM's *Anomalocaris* — collected in 1993 by a field expedition at the renowned Burgess Shale in British Columbia's Yoho National Park — is the most complete specimen known to exist. While adults might have reached a metre in length, this individual is the size of a small lobster and probably represents a juvenile.

> *Anomalocaris* and similar hunters played a key role in the evolutionary arms race of the Cambrian explosion.

JOE MACINNIS

Photography by Sebastián Benitez

I have spent a lifetime communicating with creatures in the wordless silence beneath the sea. I've had dialogues with hawksbill turtles in the Caribbean, hammerhead sharks in the Pacific, and a forty-five-tonne bowhead whale in the Arctic. In 1973, while filming white belugas off the north coast of Alaska, one rose up in front of me — a mountain emerging from the ice-rimmed ocean, glistening black with a cave-sized mouth. She made the water hum. As she swam toward me, her body curved into a magnificent arc and she exhaled a mist that stank of stale sushi. I froze. When I could hold my breath no longer, the air that left my lungs reeked of fear and astonishment.

The second swoooooosh from her blowhole carried a message: *These are my waters. Why are you here?* She was the animate earth itself, and I a two-legged creature trembling in head-to-toe neoprene. For two centuries, my species had tried to hunt her kin out of existence. The only thing I could do was hum a long, low note of peace through the barrel of my snorkel. For slow-motion seconds, we transferred awareness and intentions. Such carnal language between free-swimming creatures is one of the things I love most about the ocean.

It is also the reason I'm standing in front of *Anomalocaris canadensis* at the Royal Ontario Museum. A half billion years ago, she swam through the dark heart of the world's oldest animal ecosystem, and I'm hoping this great-great-great-ancestor of mine can tell me something about the ancient ocean. What can I learn from her?

I look down at the compressed outline of her body. For decades, I've explored the current version of the primal waters that held her. In 2012, for example, I spent two months in the western Pacific as the journalist/physician on the James Cameron–National Geographic Deepsea Challenge expedition. We made extreme-depth dives

in the New Britain and Mariana Trenches, two of the deepest places on earth. One of our scientists, Patricia Fryer, a marine geologist from the University of Hawai'i, believes that deep-sea trenches — which form a submerged continent as big as Australia — may be where life began. So our pilot, James Cameron, took 3-D images and brought back biological and geological samples, and collected sediments that contained microbes similar to the first living things.

I lean in for a closer look at *Anomalocaris*. The creature locked in rock is a biological celebrity. After the very first microbes, life remained generally small and simple for two billion years. Then, some 540 million years ago, in a geological eyeblink called the Cambrian explosion, *Anomalocaris* and her relatives rapidly evolved into existence. She's a splendid example of one the earliest complex life forms.

She has a wide, fan-shaped tail and segmented body. Two arms reach out on both sides of her disc-like mouth. A pair of compound eyes with thousands of individual lenses jut up from her fearsome head. *Anomalocaris* could be the monster in your worst childhood nightmare.

When she hunted her prey in the Cambrian ocean, North America sprawled across the equator. There was no life on land; the only living things were marine plants and invertebrates. She and countless

A pair of compound eyes jut up from her fearsome head. *Anomalocaris* could be the monster in your worst childhood nightmare.

other arthropod-like creatures prowled through the global waters. Her own habitat was near a massive carbonate cliff known as the Cathedral Escarpment, on the edge of a warm sea in what is now British Columbia. Over the years, periodic mudslides entombed her and trillions of other animals in a thick cloud of clay. In time, buried beneath the heat and pressure of ten kilometres of rock, their bodies were transformed into fossils. About 175 million years ago, tectonic forces transported their enormous marine burial ground — now known as the Burgess Shale — westward and skyward to its current position, on a Rocky Mountain ridge more than 2,000 metres high.

Like all the world's mountain ranges, the Canadian Rockies are losing their glaciers to the warming winds of climate change. As we pump more carbon into the global weather machine, ice caps shrink and arid zones spread. The greenhouse gases causing the change are climbing fast; MIT scientists now predict a rise of nine degrees by the end of the century.

Anomalocaris's flattened body speaks of geological time and forces that are beyond comprehension. Since the ocean delivered the unforeseen backhand that buried her, the planet has made more than half a billion orbits around the sun. During that time, there have been uncounted numbers of subduction-zone earthquakes, sky-darkening volcanoes, submarine avalanches, and giant tsunamis triggered by those events. Some tsunamis were dozens of metres high and raced across the water with jet-plane speed.

Over one-third of the total human population — 2.4 billion people — lives within 100 kilometres of a coastline, many in such megacities as New York, Los Angeles, London, and Singapore. Lost in the gleaming seduction of our hand-held smart phones, most of us think of the climate crisis as an abstraction. We've forgotten a geological past that includes dramatic changes in sea level.

During the last century, the carbon dioxide produced by the human family has caused the oceans to rise almost seventeen centimetres. Estimates for this century range from an additional thirty centimetres to almost two metres. If the Greenland ice sheet dissolves, the rise could be closer to six metres.

So in a way, *Anomalocaris* is a postcard from the future. She is a reminder that Mother Nature can be violent and punches far above her weight. The fossil warns us that an overheated ocean, melting glaciers, and thawing ice caps are a recipe for mayhem.

The ocean acts in random and unpredictable ways, she informs me. *Adding the weight of melting glaciers and thawing ice caps to hundreds of thousands of square kilometres of sea may bend the earth's crust and generate a perfect snake ball of earthquakes, submarine landslides, and tsunamis. It happened at the end of the last ice age. It can happen again.*

She seems to be smiling. She knows she's in the company of a lifelong carbon addict. She knows that I'm complicit.

STRIDING LION

Clemens Reichel,
Associate Curator of
Ancient Near Eastern
Archaeology

The museum's terracotta lion comes from Babylon, which became the largest city in the world during the reign of Nebuchadnezzar II (604–562 BCE). Best known for conquering Jerusalem, and for initiating the Babylonian Captivity of the Jews, he was also an active builder. As king, he oversaw the construction of Etemenanki, the imposing ziggurat popularly called the Tower of Babel, as well as massive outer and inner city walls with numerous gates. In the north, the Ishtar Gate and its monumental Processional Way were decorated with moulded reliefs of striding lions, bulls, and snake dragons — a setting that the Pergamon Museum has reconstructed in Berlin.

Unlike most Babylonian striding lions, the ROM's came from the facade of Nebuchadnezzar's throne room in the Southern Palace, located to the west of the Ishtar Gate. This type of relief required considerable effort, since it was made of bricks that were individually moulded and baked. Each brick was then painted (white for the lion's body, ochre for its mane, black for outlines, and blue for the background), glazed, and re-fired. Unlike lions on the Processional Way, which had their tails lowered, those in the throne room displayed royal status with raised tails.

The lion played a role in both the rituals and the mythology of ancient Mesopotamia. As the king of the wild, it represented the natural antithesis to the Babylonian ruler, who exemplified and defended the established order of civilization.

> The king of the wild represented the natural antithesis to the Babylonian ruler.

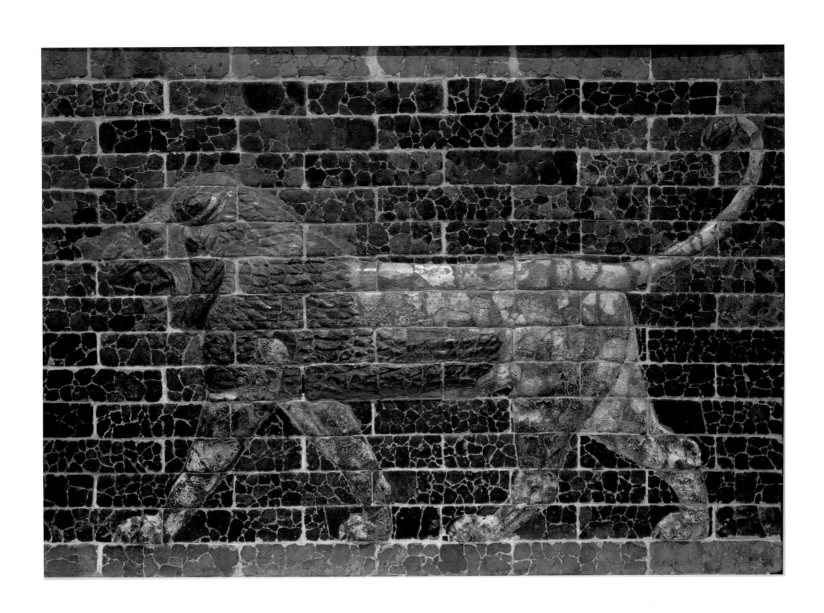

LINDEN MACINTYRE

Photography by John-Charles Pinheiro

I t was the only school I knew, so to my eyes it was as remarkable in its final years as it was when, many decades earlier, it was a jewel in the middle of my Cape Breton village. Two rooms, two teachers, and every day a critical mass of childhood from all around the area — maybe as many as forty-five when the place was booming.

There was a tower with an ancient bell, which overly enthused kids on the other end of the rope frequently dislocated. At that point, some nimble volunteer would climb up to fix the bell. The tower was also a refuge for every pigeon in the county, or so it seemed from the evidence of their excretions, and its bell was coated along with all accessible surfaces. Similarly, the hands, hair, and clothing of the volunteer when he or she returned — so he or she would be sent home for rehabilitation, which was always an incentive to volunteer for what was otherwise a nasty, thankless job.

Only years later did I find it unusual that for all its academic trappings (teachers, textbooks, blackboard, water cooler, and a strap), the school was devoid of what we would now consider essential learning opportunities. There was no gym, no lab, no library. Who knew that such places could be aspects of an education? Our basic texts were sternly focused on the fundamentals of reading, writing, calculating. In the elementary years, there was rudimentary history — dully written, dutifully taught — and geography as revealed through maps, which we would laboriously copy from an atlas (I loved to draw Saskatchewan). When my mother was the teacher, there was an insistence on Latin and grammar. And in one awful year, when I was the only pupil in my grade, she opted to maximize her time with other grades by teaching me at home.

School offered few joys. It was confinement, while the larger environment seemed to impose few restrictions on childhood freedom and curiosity. The nearby sea glittered with its endless possibilities, the woods pressed in close, loud with nature and the constant call to wander and explore and — now that I have the advantage of a retrospective overview — to learn. The school, because of our confinement, was a rambunctious place when the bonds of discipline were briefly loosened, say at recess or dinnertime (a.k.a. lunch). All the pent-up energy would explode in the momentary liberation on the small yard out front, the nearby gravel roads suddenly shrill and busy with excitement.

In the shrill environment where I now spend my time, I'm often reminded that the character of any school is defined by primal elements of human nature. And human nature, the protoplasm of consciousness, does not change.

They squirm and jostle, little backpacks bumping other subway travellers who are invariably sullen and impatient and bemused, and bound for less interesting destinations. Their energy is overwhelming. They are ecstatic in their liberation from routine. It doesn't matter where they're going, just that they are briefly free from the structures of the classroom and well aware that the authority of supervisors — mostly teachers, sometimes parents — has been compromised by the transparency of this public space. There can be no adult shouting, sanctions, or threatening while they are here.

When we think of school as joyless, we most likely refer to what goes on there in the academic sense. The social aspect, from childhood play to adolescent sexual awakening, is rich. Important education happens outside the structures and the dreary rooms. That was my experience. And, yes, at some point — possibly around the age of ten — the learning process became dull and burdensome. The ringing of that bell was a call to tedium.

This was when many of my peers (I skipped some grades, so they were older) would speculate about life after school, ending formal education altogether. Many did so, and I might have too had it not been for occasional discoveries within the limited resources of the place. One such revelation came when I realized that while there was no library, there was a bookshelf in our classroom and on it a dozen formidable dark red volumes called, collectively, *The Book of Knowledge*. From the moment I first opened one of those heavy tomes, the encyclopedia became an excursion to anywhere I fancied.

They could be going anywhere, these squirming, jabbering, jostling small commuters. We are in a large city that is rich with cultural diversions and amusements. There are galleries and arenas and museums. They could be going to a concert or a ferry that will take them to an island playground. Often they are called to attention and marshalled into a semblance of discipline as the subway approaches Museum Station. The energy of their now restrained anticipation increases palpably as the train slows down.

When the weather or my growing curiosity kept me indoors, I would discover in *The Book of Knowledge* a world that seemed to have no boundaries in time or space — a world unknown, it seemed, even to the teachers and the authors of our textbooks. I learned of civilizations and great cultures that predated, and were maybe more refined than, the American and British and even Roman empires, which we heard about from time to time. Inventions as fundamental as the written word predated the monumental English language and happened in a place we never heard about: Mesopotamia. Who knew?

The subway train is silent now, the energy somehow depleted. In my imagination I am with them, carrying my Book of Knowledge,

exploring the evidence of achievement asserted in those pages, but on display at the museum. The printed word demands credulity, a leap of faith in the authority of scholars and historians. The museum offers proof. The tawny lion, rampant, strides across his medium of glazed blue brick, jaws wide in a territorial roar, and we are linked by his reality to a civilization that flourished two and a half millennia ago: the Babylon of Nebuchadnezzar II. What, I want to ask these now stationary awestruck children, will we achieve in our time that will deserve to be admired two thousand years from now? The striding lion and his assertion of immortality, and the boundless possibilities in human creativity, leave us silent, contemplative, perhaps inspired.

It doesn't take much. A discovered book or a mandatory tour will have the same effect — transcending the limitations of the moment or the place, offering admission to the vastness of our options, our potential to leave a mark that is indelible.

The school is long gone. But, like the museum, its purpose survives in the outcome of time spent there, the imprint of discoveries that are often inadvertent — nourishment for the rambunctious mind, stilled for a moment by the hunger of curiosity.

BLACK OPAL RING

Katherine Dunnell,
Mineralogy
Technician

I n 2000, a long-time ROM supporter donated three significant pieces, including two brooches: a large tanzanite and diamond piece and a yellow sapphire set in yellow gold (both on display in the Gallery of Gems and Gold). But the jewel in the crown, as it were, was a dazzling black opal ring. Black is the most sought after of all the opal colours, and the "play of colour" of this stone is incredible. Its uniform harlequin pattern and constant orange flash are benchmarks rarely seen on the market. Estimated at ten carats by gauge, it is set in platinum and surrounded by graded marquis-cut diamonds acquired from Henry Birks and Sons Ltd. in 1970.

> The opal's uniform harlequin pattern and constant orange flash are benchmarks rarely seen on the market.

The ring was made for Birks by Peter Kochuta, one of Canada's preeminent goldsmiths and the first to master platinum. A challenge to work with, platinum was his metal of choice; it gives strength to the setting, and to the goldsmith the ability to create delicate, almost invisible mounts. One of Kochuta's many apprentices has been quoted as saying, "Every wealthy household in Canada had a woman who wore a Peter Kochuta ring, whether she knew it or not." Kochuta did not enter competitions, preferring to stay behind the scenes. However, his work was often cited for excellence by high-quality jewellers and jewellery designers, appraisers, and auction houses.

In 2000, the Canadian Cultural Property Export Review Board certified this ring as a Canadian Cultural Property — deemed a significant piece of our national heritage.

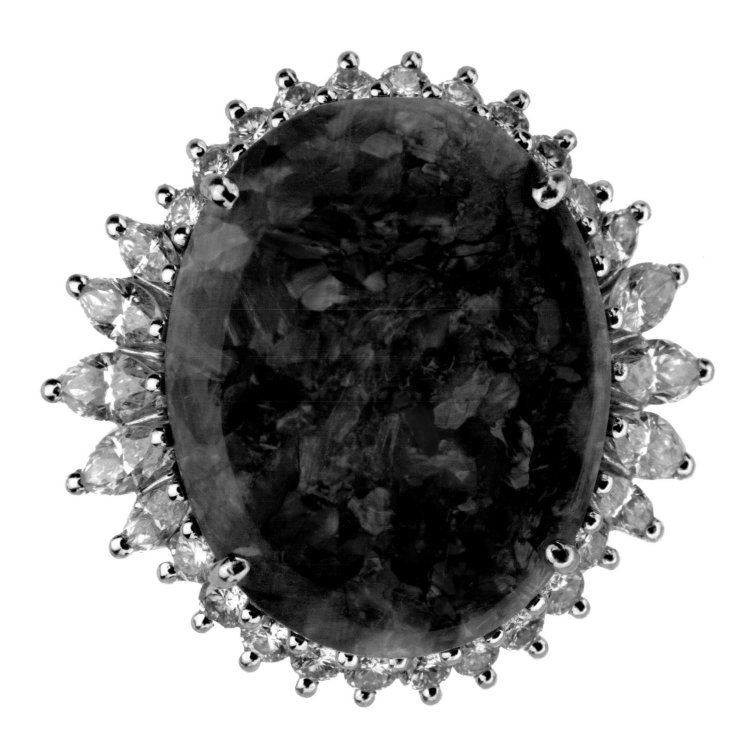

MARGARET MACMILLAN

Photography by Julia Campisi

The name is businesslike — black opal ring — and does not begin to prepare you for the thing itself. Go deep into the Royal Ontario Museum's minerals section, past the arrays of extraordinary rocks, and you will find it sitting in its display case. You may be surprised at its size — the stone itself is easily as wide as a quarter — and you will be impressed by the elegance of its diamond setting. But it is the opal itself that will draw you in.

It is not black at all, but contains the colours of the rainbow. Take some time to look at it (move slightly as you do), and you will see reds, greens, oranges, blues, purples, glints of gold — all shifting and glimmering. Opals, I have learned, are not minerals. Unlike diamonds, say, or rubies, you cannot see into them. But it is easy to imagine, as many have through the centuries, that opals are looking out at the world and possess magical properties.

During the Middle Ages, they were considered lucky, perhaps even capable of making the wearer invisible. More recently, they have been associated with tears and death, although if your birthstone is the opal — happy those of you who are born in October — they bring good fortune.

Aborigines in Australia regard opals as marks from the time when the creator's foot touched the earth and all the stones started sparkling with colours, or as signs that ancestors have left behind. Yet the scientific explanation for opals has its own magic: Many millions of years ago, when the planet was still settling down, water was pushed at high pressure through sandstone and other rocks, picking up bits and pieces of debris along the way. The flowing blobs of silica — think of them having the consistency of hair gel — solidified, transforming into a source of beauty that

refracts the colours of the spectrum. In the same display as the black opal ring, a lump of stone from Mexico is studded with orange opals, looking for all the world like a hard piece of fruitcake. And opals, hard stones though they are, still contain water. You have to be careful not to let them get too hot or dried out.

I have loved the ROM since I was a child. One of the reasons is that it always contains surprises. I should know it pretty well after sixty years of visits, but with each trip I discover another treasure — whether a Chinese snuff bottle shaped like a bean or a delightful early Canadian table. The black opal ring is my most recent surprise. My initial reaction was, simply, Oh, how beautiful it is. How could the donor ever have borne to give it away? (Of course, I couldn't help but wonder how it would look on my own hand.) But then, because I am a historian, I started to wonder about its journey to its case. How did the stone get to Canada? Who chose it, mounted it? And who bought it, only to give it away again?

While the black opal's exact path to Canada remains unknown, it can only have come from one place: the outback in South Australia and, most probably, from Lightning Ridge, which describes itself online as a wonderfully crazy place to visit. Indeed, it probably is, with summer temperatures well over 40°. Although Aboriginals have treasured black opals for centuries, the rest of the world only discovered them in the first great wave of globalization, in the nineteenth century. Railways and steamships and telegraphs linked nations ever more closely, and trade, investment, people, and ideas moved back and forth across the globe — as did precious stones. Tanzanite from Africa, sapphires from Madagascar, green garnets from the Urals, and opals from Australia all found their way onto the jewellery of the world's well-to-do.

At some point after World War II, the black opal made its way to one of Canada's leading jewellery designers. Like the gemstone, Peter Kochuta had travelled a long way — in his case from Czechoslovakia as part of the wave of migrants who enriched Canada with their skills. He arrived in 1939 but did not escape the war, volunteering instead with Canadian forces in Europe, where he was wounded. Although he started his career as a jeweller who worked on routine pieces for big companies, he became a specialized designer for the famous firm Birks (and other luxury retailers across the country).

Kochuta was a sublime craftsman who made some of Canada's most distinguished jewellery and trained the next generations of designers. He was a modest man and rarely bothered to mark his creations, although his peers could instantly recognize their artistry. The ROM's ring is mounted in platinum, one of Kochuta's favourite metals and as rare as a black opal. And so, another tiny link was made between Australia and Canada — because some of the world's major platinum deposits are here, including one near Sudbury, Ontario.

The ring was finished in 1970, when Pierre Elliott Trudeau was prime minister and the country faced the October Crisis in Quebec. It went on sale at Birks, in London, Ontario; then a family business, Birks was the quintessence of solid, sober Canadian prosperity. It was where young men bought engagement rings and where husbands chose jewels to celebrate the birth of a child or a birthday. (When I was at the University of Toronto in the '60s, some young women still kept hope chests, with the linens and furnishings they would take to their new homes as young brides. We all imagined our engagement rings would come from Birks, where we would also choose our silver patterns.) Kochuta's black opal ring was purchased for Beryl Ivey, the matriarch of a prominent London family. And in time — perhaps because she had other rings she loved more, or because she wanted others to marvel at it — she gave it to the museum.

And marvel I do. I think of the different histories embodied in the ring, starting with the early stages of our planet; followed by the millennia its black opal was buried in rock; and then, suddenly like a camera speeding up, its quite recent discovery in Australia, its journey to Birks, its meeting with the skilled Peter Kochuta, and its arrival on Ivey's hand. Let us hope that time slows down, and that the black opal will stay with us at the ROM for the next few centuries.

Katherine Dunnell Responds

The beauty of any gemstone is not just in its inherent aesthetics, but also in the fact that it was formed by unique geological processes, was later discovered, and then travelled a considerable distance to its owner. In very few cases, the conditions align to produce a transparent, beautifully coloured gem rough that can be faceted into a gemstone. Gemstones are a marriage of science and culture; they tell stories. Mogul courts traded and fought for gems, the European aristocracy traded them back and forth as they conquered new lands and uncovered their riches. MacMillan's thoughtful piece encompasses the fascination of how something as marvellous as a black opal comes to be, and ponders who and how the unique stone arrived in Canada. As an urban culture, we are somewhat disconnected from where things originate, and we often assume that they will always there. But the Australian opal fields are a wild and rugged place, and extraction of anything so exotic and mysterious is a dirty, dusty endeavour.

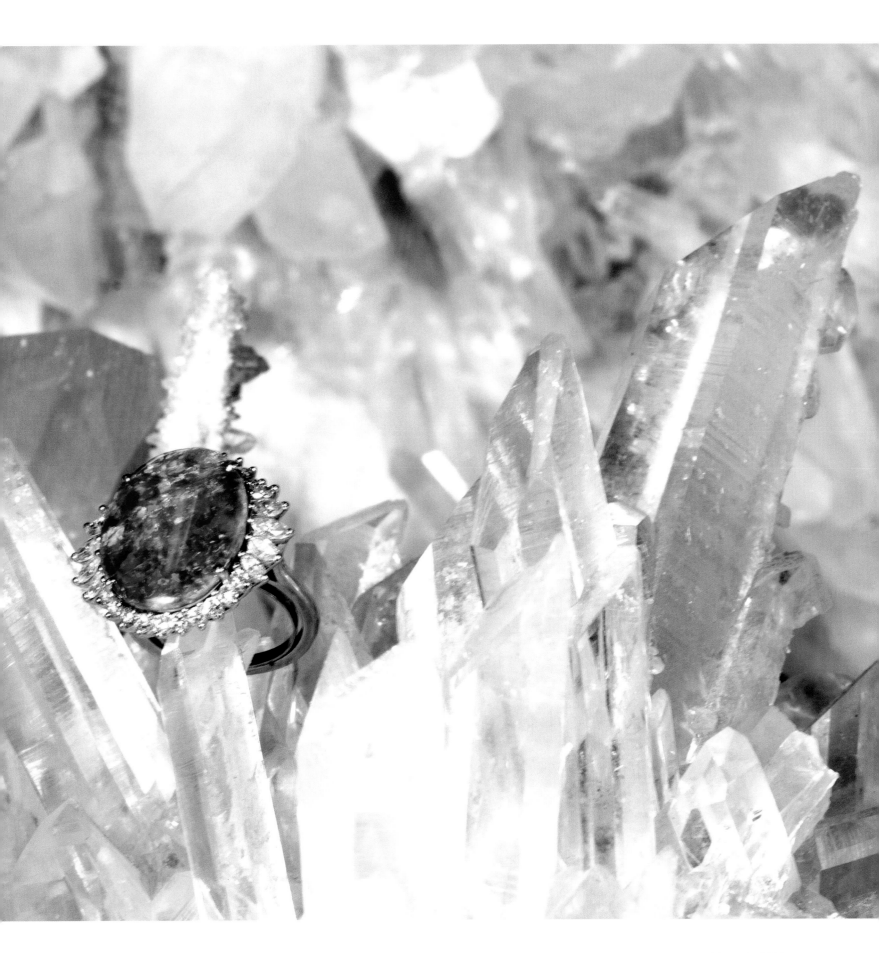

SHIVA NATARAJA

Deepali Dewan,
Senior Curator
of South Asian
Visual Culture

Artists from the South Asian subcontinent often give physical form to abstract concepts, in order to facilitate understanding by people of differing languages, regions, and creeds. Their works become vehicles through which divinity can be accessed. This sculpture represents the Hindu god Shiva in his manifestation as Lord of Dance (Nataraja). With his raised leg and his steadfast gaze, Shiva is presented as seductive and powerful. The figure conveys the story of his divine dance (sometimes called the dance of bliss): in an era of corruption, Shiva destroys the world through the force of his dance, so that it can be born anew.

Traditional symbols are present in the sculpture, each with its own story: the crescent moon, the skull, the double-sided drum, the snake, the earth goddess as a small figure perched in his hair, the demon of ignorance who gets trampled underfoot. Multiple arms, a human feature represented in superhuman form, convey Shiva's divinity. The passion and rapidity of his movement are suggested by locks of hair that spring from his head, and by a halo of fire. Yet the metal out of which the sculpture is fabricated — cool, solid, immobile — grounds the work as a product of human creation. The tension in the sculpture, between motion and stillness, creation and destruction, reality and metaphor, is supposed to reflect the devotee's state of mind as he or she stands in front of it, striving for liberation from the cycle of rebirth through a union with the divine — a state of bliss.

The artist who created this work lived almost 1,000 years ago in a powerful kingdom ruled by the Chola dynasty, in present-day South India. He would have been part of a community that had mastered the lost wax method of metal sculpture. Shiva Nataraja was the preferred god of the Chola emperors and an apt symbol for the victorious military campaigns they celebrated as divinely ordained. On festival days, the sculpture would have emerged from a darkened temple interior, decorated in sumptuous fabrics and fragrant garlands, and carried on poles threaded through holes at its base. Over the past 100 years, however, a new chapter has been written in the history of Shiva Nataraja, darling of the art market. Involving great profit and, at times, great scandal, the commercial trade in such statues has brought bliss and heartbreak to international viewers, collectors, and practitioners alike.

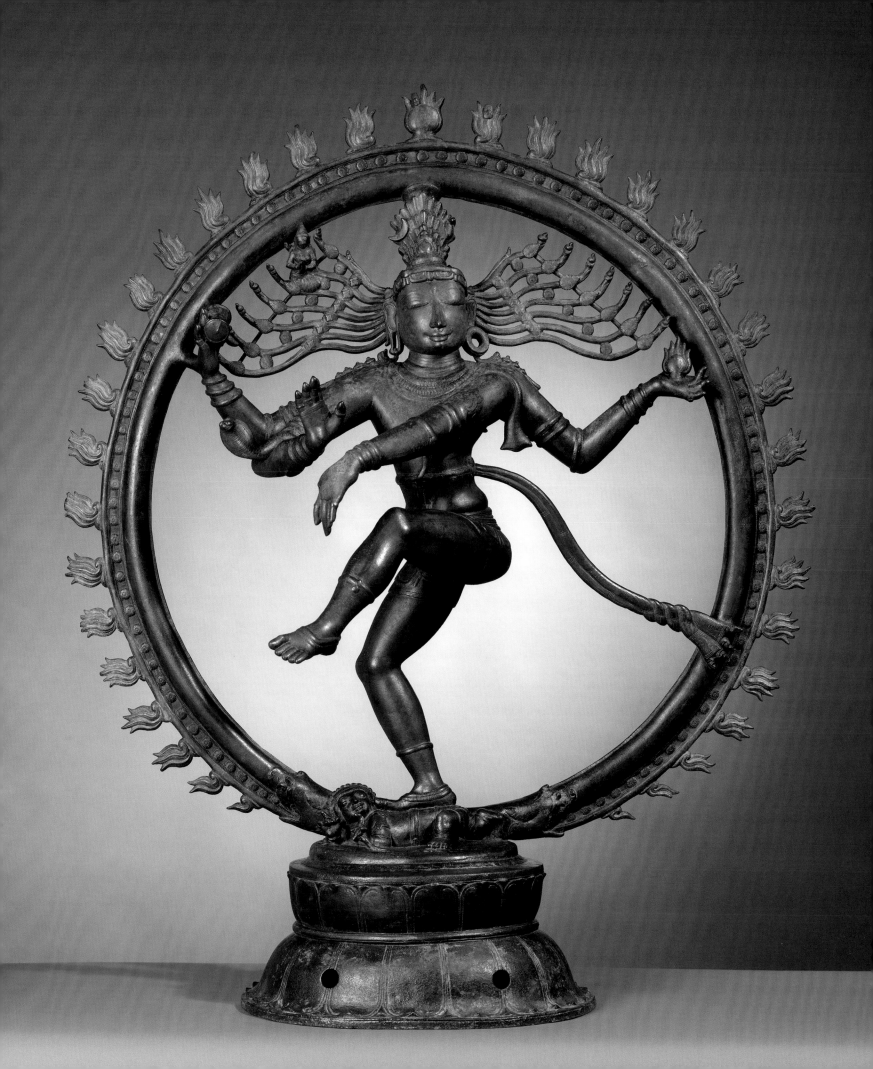

DEEPA MEHTA

Photography by Joe Bulawan

I think I was about six years old when, half asleep, I walked in on my parents' rather formal dinner party and declared with complete certitude that the god Shiva had woken me up, played his *damru* (an hourglass-shaped drum), and danced for me. Amongst murmurings of "how sweet," my mother led me unceremoniously back to bed, where she found and duly admonished the cause of my overactive imagination — my placid, plump amah, Lakshmi. My nursemaid had been with us for two years; she was from Nepal, a long trek from dusty Amritsar in Northern India. An unabashed Shaivite, she belonged to a sect that worshipped Shiva as the Supreme Being, a rarity in our Sikh-dominated city. Shiva, according to the members of the sect, was the head honcho of the Hindu Trinity, which consisted of Brahma the Creator, Vishnu the Preserver, and Shiva the Destroyer.

We woke up daily to her chanting — "*Om namah* Shivaya. Shiva is the supreme reality" — accompanied by the tinkling of a brass bell and the fragrance from an incense stick, which invariably gave my kid brother asthma, or perhaps an excuse for not attending kindergarten.

Lakshmi's early morning prayers were our alarm clock. Freshly bathed, she always wore crisp saffron-coloured saris, the colour of renunciation. Her forehead was inevitably covered with *vibhuti*, a sacred ash. This she would mix with water and, carefully using her forefinger, middle finger, and ring finger, apply it as three horizontal lines. This symbol immediately identified her to those in the know as a Shaivite.

Looking at my scrubbed face, while she braided my hair in preparation for school, she would shake her head, expressing sorrow at my unadorned forehead. "You poor thing. You know what the Veda say? They say an empty forehead is like a cemetery." Terrified, I would beg her to smear my forehead with the sacred ash, in

case crucifixes, like the ones in our local Christian cemetery, started sprouting on my forehead. The request was denied each time. Sahib would fire her, she said, and besides how could I attend my Christian school, the Sacred Heart Convent of Jesus and Mary, with Shiva's symbol on my forehead? The nuns, she said, with all their Hail Marys, would make Shiva furious. And what if that resulted in him doing the *tandava*, his dance of destruction? Surely, I didn't want those sweet white women, so far from home, to be turned into puddles of ash? A tough question, as Sister Francis was an ogre, and to see her obliterated by Shiva wasn't too bad a thought.

To avoid my imminently disastrous fate — a mushroom of crosses on my forehead — I became acquainted with worship. Shiva, I proclaimed to whomsoever would listen, is my favourite of all Indian gods. And strangely, I started to quite enjoy this role I had picked for myself — that of the pious little girl. While my parents were amused and my brother thought I had gone insane, my ash smeared Lakshmi felt for the first time that there was hope for me.

As I grew older, hitherto unknown aspects of Lord Shiva kept revealing themselves. I remember at around nine trying to dance to Chubby Checker's "Let's Twist Again" with my older cousin Ritu. The music emanated from our newly acquired Grundig gramophone,

but no amount of instruction on how to move my hips helped. I was a lousy dancer, Ritu declared with complete frustration. Mom, feeling sorry for me, left the living room and came back with a small bronze figure of Shiva as Nataraja, doing his dance of bliss. She plonked the perfect figure on the Grundig and said, "Perhaps Shiva, the greatest dancer of all time, can inspire you." I never did learn to twist, but my curiosity about "the greatest dancer of all time" was definitely aroused. And I never doubted that if he was so inclined, Shiva could teach Chubby Checker a thing or two about moving his pelvis.

Once something subliminal floats into our conscious mind, we start seeing it everywhere. It's as if we were always surrounded by it but didn't pay it any attention. Wherever I looked, I began to see the image of the Nataraja. Painted behind buses hauling timber across the plains of Northern India. On calendars hung on walls with peeling whitewash. In plastic reproductions of the dancing god, enveloped by incense smoke in sari stores. Hanging from the tridents of dreadlocked, ash-smeared sadhus smoking ganjas on the roadside. Embedded in a gold pendant nestling between the gargantuan breasts of a society lady. He was everywhere. In popular art, in piety, in poverty.

My first lesson in the significance of the Nataraja and art history came when I was fifteen. My cousin Ritu came back from the United States, having completed a master's in museology. (The study of museums had turned her into a full-fledged groupie of Ananda K. Coomaraswamy, a brilliant art historian and museologist.) Ritu pointed to our worn figure of the Nataraja, now standing on a reel-to-reel tape recorder, and said with complete authority, "Do you know if a single icon or image had to be chosen to represent our incredibly rich and complex culture and heritage, the Shiva Nataraja would be the obvious candidate?" Then she made me write it down. Ten times. My cousin was older and not averse to banning me from the contents of her wardrobe if I argued with her. Somehow, all the stories I had been told about Shiva, all the comic books I had read illustrating his adventures, became embodied by that one image. Nataraja seemed to contain all the attributes my favourite god stood for: creation, destruction, the triumph over ignorance, the control over the elements, the musician, the dancer, the supreme lover, the breaker of rules, and so forth.

The twelfth-century bronze Nataraja from the Chola dynasty in Southern India became, for me, the most recognizable and culturally significant form within the modern world — not unlike Michelangelo's *David* within its cultural and religious context.

A quick run-through of what each symbol and gesture in the Nataraja stands for: The ring of fire represents purification through destruction. His left foot rests upon the demon of ignorance; Shiva is subduing him. The *damru* in his upper hand represents the eternal rhythm of time. The fire in his other upper hand is the flame of

My mother plonked the perfect figure on the Grundig gramophone and said, "Perhaps Shiva, the greatest dancer of all time, can inspire you."

extinction. His lower hand makes the gesture of reassurance, while with the other he makes the gesture of deliverance. The paradox of creation through destruction sits at the heart of the figure, its thematic relevance, if you will. The dance is understood as a metaphor for the Hindu spiritual journey, the goal of which is a release from the cycle of birth and death.

Years later, at Delhi University, I studied not only the different schools of Hindu philosophy but also the whole pantheon of Hindu gods, including the myths and metaphors surrounding them. After

graduation, I became — no surprise — an agnostic. But beliefs, or non-beliefs, have nothing to do with the gift of imagination that my amah gave me all those years ago. As she put me to bed, ash-smeared Lakshmi, worshipper of Shiva, would whisper in my ear, "Belief in Shiva will release you from the endless cycle of birth and rebirth. But if you want him to dance for you, you must go to sleep. Right now."

RUHLMANN CABINET

Robert Little,
Mona Campbell Chair of
Decorative Arts

After his studies and a brief period working with architect Pierre Patout, Jacques-Émile Ruhlmann succeeded to his father's decorating business — one that purveyed wallpaper, painted finishes, and mirrors to the luxury market of Paris. He gradually expanded the business to accommodate all the decorative furnishings and accessories a classic French interior required.

Ruhlmann did not train as a cabinetmaker, but he was nonetheless interested in furniture design. He drew upon the great French cabinetmaking tradition of the eighteenth century, with its use of exotic and precious materials and exacting craftsmanship, which he recast in a more contemporary idiom. This small two-door cabinet exemplifies his interpretation of this tradition; known as a chiffonier, it is derived from eighteenth-century precedents (though back then it would have been called a *petite armoire*). Like so much of the fine cabinetwork of the Louis XV period (1715–74), its gently swelling surfaces are veneered with exotic woods, in this instance Macassar ebony inlaid in a lozenge pattern with ivory on a mahogany carcass. Where an eighteenth-century cabinetmaker would have fitted bronze mounts on the feet, swelling corners, and handles, Ruhlmann chose ivory. The interior is fitted with shelves and a removable unit of three small drawers.

Referred to as the Cabanel model, no. 1527, the ROM's cabinet was initially designed between 1920 and 1921. Its namesake, the couturière Fernande Cabanel, was probably the first client to have one. Other examples, with slight variations in detail and dimensions, were built; the Brooklyn Museum of Art has a veneered model in amaranth wood, made in 1923.

Until 1925, much of the furniture associated with Ruhlmann was produced by the best independent cabinetmakers in Paris; he later established his own furniture workrooms at 14, rue d'Ouessant. The museum's example bears the stamp the Chanaux & Pelletier workrooms. Adolphe Chanaux later collaborated with another outstanding designer, Jean-Michel Frank (1895–1941).

Ruhlmann's furniture and interior designs epitomize the finest of art deco style. He achieved great success with the furniture and interiors he completed for the International Exposition of Modern Industrial and Decorative Arts, held in Paris in 1925. After he died in 1933, his nephew Alfred Porteneuve fulfilled existing orders of Ruhlmann & Laurent, and subsequently established a business under his own name in 1934.

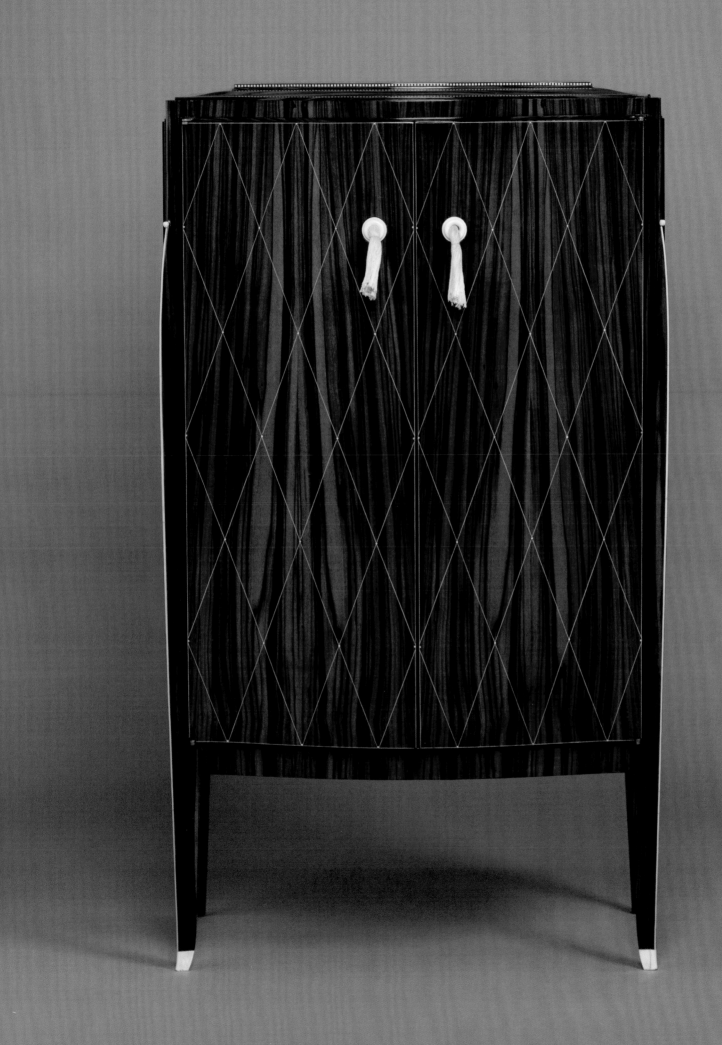

LYNDA REEVES

Photography by Evan Griffiths

When I was fifteen years old, I spent the summer with my grandparents in Beirut, roaming around and exploring their house. I was particularly drawn to the big rolltop desk that sat in the corner of their living room. I loved to run my hands over its contours, admiring its deep mahogany colour. I knew nothing about it, except that it made me feel as if I were living in a different time and in a place far grander than my surroundings. Although the house was large and well furnished, this desk had a refinement and formality about it that captured my youthful imagination.

Furniture has always spoken to me in ways that painting, photography, and sculpture do not. Great pieces can evoke feelings that are as powerful as those stirred by music or literature. A beautiful chair, sitting in the corner of a room, can feel almost alive, carrying with it the story of its time and creator.

The cabinet by the celebrated art deco designer Jacques-Émile Ruhlmann was conceived during the modern era's greatest period of furniture design and craftsmanship. Not since the eighteenth century, when fine cabinetmaking was considered the most important of the decorative arts, had a designer compared to the finest furniture makers to the court of Louis XV.

Ruhlmann brought the same artistry and craftsmanship to his pieces that had made France the centre of the decorative arts 150 years earlier, but he did it in a language of modernism that employed clean lines, glamorous materials, exotic woods, ivory, and gleaming metals. He was a designer, not a cabinetmaker, so he assembled the best craftsmen and eventually established his own shop. Collaboration was essential to his work.

Ruhlmann brought the same artistry and craftsmanship to his pieces that had made France the centre of the decorative arts 150 years earlier. He did it in a language of modernism that employed clean lines and glamorous materials.

Seeing the cabinet for the first time at the Royal Ontario Museum, I was struck by its small scale and delicate lines. It is fine in the way that the most beautifully made things are; the perfection of the graining and depth of the patina are remarkable. It stands out among the other art deco pieces in the Samuel European Galleries. Robert Little, the decorative arts curator, pointed out the exquisite detailing: the graceful subtle curves, the ivory embellishments, and the tassels that were an unusual choice during this period. He explained that when it was made, it would have cost as much as or more than a small house.

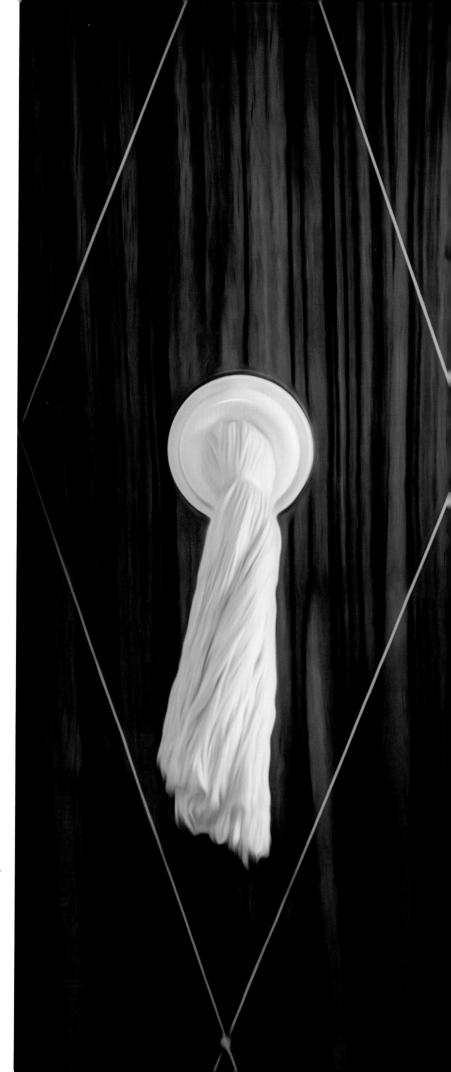

Some of the surrounding pieces were clearly influenced by this one, but they don't sing in the way the Ruhlmann cabinet does. It is akin to seeing a couture gown beside its ready-to-wear counterpart; they're similar but hardly the same. This cabinet transcends its purpose and becomes, for me, more than just an object. When I gaze at it, I am reminded of a muscular, barrel-chested man standing firmly on his two legs, dressed in a perfectly tailored suit. Refined yet athletic.

I can recall the few times when I have been similarly struck by the perfection of design and the importance of collaboration between designer and craftsman. The last time was at the 2010 Yves Saint Laurent retrospective, at the Petit Palais in Paris. The clothes were so beautiful that I could have wept, but the room where the collections' fabric boards were displayed was the highlight of the show. Each swatch was dyed a depth and intensity of colour that I had never seen before. My partner, Michel Zelnik, knew Saint Laurent at the height of his fame and explained that one man, Gustav Zumsteg of Zurich, produced all the bold silks that became Saint Laurent's signature — a master of his art. The designer and the fabric maker became lifelong friends and true collaborators.

It's sad that such craftsmanship is a rarity these days. Sometimes, I think about what we have traded for closets bulging with clothes that we discard after one season, or sofas that won't last long enough to be recovered but don't cost enough to worry about. We've opted to buy inexpensive things that look remarkably good, and may stand up just as long as our interest in them. We're not fussed when they don't. We've traded quality for quantity, and that means most of us will never know how it feels to have a piece of furniture that is too magnificent to ever part with — that elevates every scheme and thrills every person who sees it, because it doesn't take an educated eye to respond to fine work. Today, we claim there is a revival underway, a newfound appreciation of fine furniture, but what we now consider "fine" is a far cry from the artistry of Ruhlmann and his cabinetmakers.

When my grandmother in Beirut died, I was asked what I wanted to inherit. Everyone expected a girl say jewellery, but I wanted the rolltop desk. Eyebrows raised, but it turns out the desk was made by a noted cabinetmaker to the court of Louis XVI. It was, and is, a fine example from the Directoire period. Bringing it to Canada required an appraisal by Sotheby's for insurance purposes, not to mention the cost of shipping. Yet I wanted it badly enough that my parents were willing to jump through the hoops. It now lives with me in Toronto, a wonderful reminder of all the things I love about great furniture: fine craftsmanship, enduring design, and a rich history, which in this case stretches from the court of Louis XVI to my house. And, of course, it was the beginning of a love affair that is still going strong.

PARASAUROLOPHUS

David C. Evans,
Curator of Vertebrate
Palaeontology

The almost-complete skeleton of the duck-billed hadrosaur *Parasaurolophus walkeri* is one of the ROM's crown jewels. It was the first specimen of this bizarre, tube-crested herbivorous dinosaur ever found, and it remains the best-preserved and most complete.

It was discovered in the Alberta badlands, on a 1920 expedition led by Levi Sternberg; most of the museum's dinosaur collection is attributable to him. The youngest of Charles Hazelius Sternberg's three sons, Levi is one of the most celebrated fossil collectors in history, along with his father and two brothers. This specimen was found in what is now the core area of Dinosaur Provincial Park. The species was introduced to the world two years later by palaeontology curator William Arthur Parks, who initiated and led the dinosaur collecting program in 1918. He named *Parasaurolophus walkeri* in honour of Sir Byron Edmund Walker, the first chairman of the board of directors. (Parks himself is honoured by a bronze plaque outside the museum.)

Parasaurolophus is one of the strangest and most iconic dinosaurs, owing to the long, tubular crest that projects over a metre beyond the back of its head. Bizarrely, the crest is actually hollow; it is composed of a series of thin bones that surround an elongated nasal passage. When the animal inhaled through its nose, the air would travel up and over the eyes, loop around behind the skull, and pass forward before entering the throat on its way to the lungs. The latest research on these crests suggests that *Parasaurolophus* and closely related dinosaurs used their crests to make low, bellowing calls to communicate with each other — as well as visually show off.

The ROM's *Parasaurolophus walkeri* skeleton has been illustrated in countless books on dinosaurs, featured on coins and stamps, and made into toys. Exact replicas, cast from the original fossil, are on display in more than twenty of the world's major museums, including the American Museum of Natural History in New York and the Natural History Museum in London. This makes it, at least in my mind, our most-famous single object — a globally recognized symbol of the Royal Ontario Museum.

> *Parasaurolophus walkeri* is one of the strangest and most iconic dinosaurs, owing to its long, tubular crest.

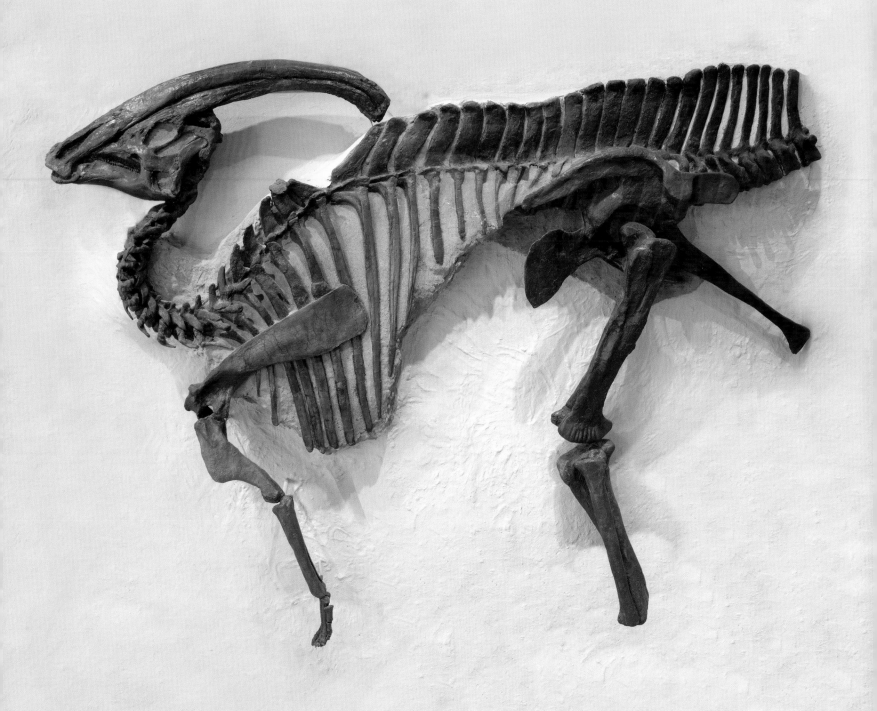

GUY VANDERHAEGHE

Photography by Laura Domnar

Why is it that the image of *Parasaurolophus walkeri* stirs something akin to nostalgia in me? As far as I can recall, the '50s and early '60s, the years of my childhood, were pretty much free from the dinosaur obsession that causes today's kids to vibrate like tuning forks. A quick visit to the Internet provides evidence that there was some ancient reptile–creep in pop culture during those decades: the first plastic mass-produced dinosaur toys appeared; Godzilla was wreaking cinematic mayhem in Japan; *The Flintstones* was a hit on ABC in 1960; and, apparently, gleeful children were digging dinosaur toys out of cereal boxes. Maybe life in the rural gulag of Esterhazy, Saskatchewan, quarantined me from lizard fever; my own excavations in the arid rubble of breakfast cereal boxes unearthed nothing but baking soda–powered frogmen and submarines, and plastic GIs. No dinosaurs.

In elementary school, nothing much was said about primeval reptiles. I have a vague recollection of teachers dismissing them as lumbering dolts that had lost the evolutionary race to more nimble and quick-witted mammals, which, it was implied, had reached their apotheosis in us, a bunch of crewcutted, pigtailed nose-pickers to whom a fabulous future awaited, as long as we knuckled down, studied hard, and got more mammalian so we could leave those reptilian Russkis in the dust.

The tone of '50s pedagogy was frantically sanguine. Sure, the first half of the century had experienced some setbacks: two world wars, the Holocaust, and now the threat of nuclear annihilation hanging over our heads, but, hey, look at these neat artists' renderings of what's just around the corner: Towering skyscrapers looped and spiralled by superhighways that hurtle you to your destination in

That droopy canopy of ribs, that curve of neck that seems too fragile to support that big head and bizarre cranial crest are oddly touching.

automobiles that don't require human guidance. Vehicles that allow the man in the grey flannel suit to sit back, relax, and enjoy a martini on his way home to the nuclear family, without risk of a drunken death. And, see, here's a magnificent city under a glass dome with a perfectly controlled climate, and in that metropolis nutritionally balanced meals are available in convenient pills that gyroscope-commuters can pop on their way to work.

The never-stated but clear implication of all this was that dinosaurs were losers, and losers were what none of us should ever be.

This hectoring, aggressive competition-fuelled optimism continued into high school, peaking during Canada's centennial year, perhaps the most aggressively upbeat year in the history of the country, a time when Bobby Gimby's bouncy tune became the insidious earworm of an entire nation (*CA-NA-DA, One little two little three Canadians*). That same year, the federal program Young Voyageurs dispersed teenagers all over CA-NA-DA so that we little Canadians could get to know and appreciate one another better. High school students from Saskatchewan got shipped to Toronto, and I was one of them.

It was on this junket that I first encountered the Royal Ontario Museum, and I was gobsmacked. I can't claim to have been uniquely impressed with the dinosaurs (I was pretty much impressed with everything inside the building), but I remember the weird fossils and skeletal reconstructions emanating a ghostly presence that no artist's cheesy renderings could ever match. I must have encountered *P. walkeri* then, although I have no memory of it, probably because an adolescent male was more likely fascinated by *Tyrannosaurus rex*, whose potent demeanour and wicked-toothed grin better meshed with never-to-be-realized adolescent fantasies of total physical awesomeness — just as soon as he lost the pimples and packed some beef on his own skeletal frame.

Now, however, I find *P. walkeri* far more compelling than T. Rex. Probably, this is a function of age. At sixty-three, television and newspapers have fed me so much vicarious carnage that I have come to develop a more favourable opinion of herbivores. And *P. walkeri* has a particularly gentle and vulnerable look to it. That droopy canopy of ribs, that curve of neck that seems too fragile to support that big head and bizarre cranial crest are oddly touching. It's hard to see *P. walkeri* as anything but a memento mori with a 77-million-year provenance, a reminder that both winners and losers end up as just one more deposit in another sedimentary layer of our spinning earth.

Frankly, these ruminations are afterthoughts. To come clean, my first reaction to this image was, *Man, this is one goofy looking dino.* And a nanosecond later, *God, he reminds me of Daffy Duck!* I admit this is a big stretch. A shared duckbill and a generically goofy appearance are weak links between a cartoon character and a long-dead saurian, but the longer I gazed at *P. walkeri* the stronger my conviction grew that somewhere, sometime I had seen something that was prompting me to stuff them into the same mental envelope.

I confess a childhood attachment to Daffy. His inflated ego, his loud-mouthed bluster and expostulation, his haplessness, his put-upon air were far more simpatico to me than Bugs Bunny's smooth, streetwise mammalian savvy, which allowed the wascally wabbit to overcome every obstacle. Then, an impulsive trawl of the Internet to renew an acquaintance with my favourite duck turned up something intriguing — a 1939 Merrie Melodies called *Daffy and the Dinosaur*. Watching it, I had a powerful sense of déjà vu. If that feeling was justified, I must have previously seen the cartoon on TV or possibly at the local movie house, which might have acquired some outdated, discount product to foist upon gullible little children.

In this early incarnation, Daffy is more *P. walkeri*–like than in subsequent versions, his neck frailer and more serpentine. And although never achieving the same Porsche 930 turbo spoiler look of *P. walkeri*'s cranial crest, the 1939 Daffy's most prominent head feathers swept outwards from the back of his skull, rather than

assuming the more familiar tufty, feather-foliage silhouette that later jauntily rode atop. The Wikipedia entry for *P. walkeri* suggests several possible functions for its signature cranial crest: thermoregulation (a little brain cooling would have been in order for hot-headed Daffy); sound amplification (none needed in the stentorian duck's case); and visual display for identifying species and sex (in Daffy's case, the less said about this the better).

Here, then, was the explanation for my fond feelings for *P. walkeri*: Daffy and Mr. P were brothers in loserdom. Dinosaur and duck were everything my teachers had warned me against (and that I secretly identified with), which naturally created an affection that I haven't been able to shake, a fondness for the gloriously maladapted, the misfits, the also-rans of our blue, blue planet.

SIXTH-CENTURY TUNIC

Anu Liivandi,
Assistant Curator of
Fashion and Textiles

This early Byzantine tunic is a tribute to founding director Charles Trick Currelly and to Dorothy K. Burnham, founding curator of the textile department. Currelly acquired it while he was still working as an archaeologist, actively collecting in the field and laying the foundations for the ROM; Burnham elucidated its construction and technique in her seminal publications *Cut My Cote* and *Warp and Weft*. The artifact represents three of the museum's important collection areas: Egyptian (since it was made there); Greek and Roman (since it is in the Greco-Roman style of the early Byzantine period); and textiles and costume (since it gives equal importance to both areas of study). It salutes the new Centre of Ancient Cultures, too.

Although such tunics were worn throughout the Romano-Byzantine Empire, most extant examples come from burial sites in Egypt, preserved thanks to the extremely dry and stable environmental conditions. Decoration of tunics usually consisted of longitudinal bands (*clavi*) from shoulder to hem, roundels (*orbiculi*) or squares (*tabulae*) at shoulder and knee, and double longitudinal bands on the sleeve. Fancier tunics could also have transverse bands at the neck and hem. The complexity of the ornamental scheme varied according to the taste and economic status of the wearer, as well as the intended use of the garment.

This style of tunic was woven to shape — sewn into a garment with minimal effort and wastage. It was woven sideways on a wide vertical loom, starting with a sleeve, progressing to the full front and back length, leaving a vertical slit in the centre for the head, and ending with the other sleeve. The finished textile was removed from the loom, folded in half across the shoulders, and sewn together at the sides. As is often the case, this ankle-length tunic was shortened by sewing a tuck at the waist. Adding a belt or sash would have allowed the wearer to control its extreme width and, in periods of physical activity, to further shorten it by pulling part of the skirt up and over the girdle.

Typically, the undyed linen ground of the tunic was done in warp-faced tabby weave. The in-woven tapestry decoration is mostly in deep purple wool (a colour associated with power and luxury), with orange and yellow wool accents. Eccentric wefts are used freely to delineate such details as facial features; these are largely in undyed linen, but there is some use of orange wool to indicate hair.

The decoration of the tunic blends elements of several iconographic schemes: The neckband features Dionysian dancing revellers framed in an arcade. The women (maenads) either wear a long draped garment or animal skin, or are nude except for a long floating scarf. The men are nude, except

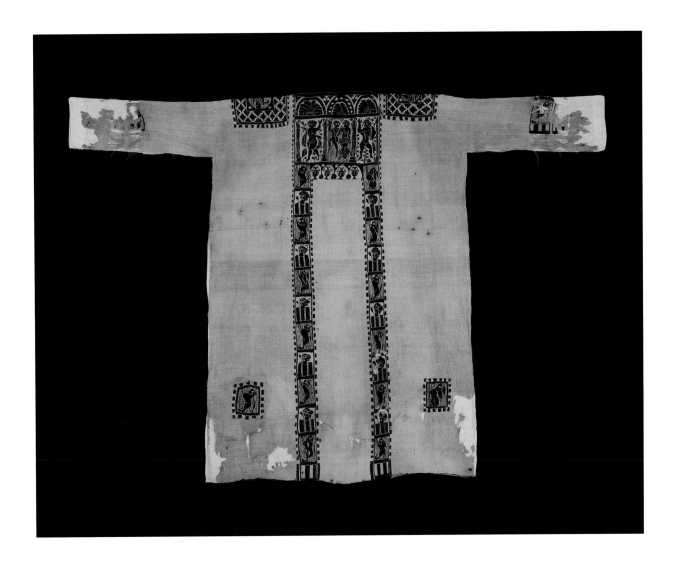

for a mantle thrown over the shoulder, and carry either a shield or a drum. The Dionysian context is reinforced by the row of wine containers (amphoras) below and the vine leaves or tendrils shown throughout. In contrast to the lively movement of the dancers, the human figures in the shoulder bands are all statically and frontally posed in the tradition of portrait busts, and yet are virtually identical except for slight differences in hairstyle and the colour of the shoulder bands of their own tunics. Between the busts are animals of the hunt, mostly lion and hare but also a single winged griffin and a less well-differentiated animal that may be a boar or bear. These animals occur in the square panels at the knee and in the sleeve bands, too, although much of the latter decoration has been lost. Each shoulder square has a running man wearing only a mantle, perhaps carrying a shield in one hand but clearly brandishing a stone in the other, in battle or the hunt.

ARITHA VAN HERK

Photography by Haley Wessel-Friesen

Nudists describe someone wearing clothes as a "textile" (especially on that apron beside water, the beach). And textiles we humans are, thinking nothing of the service of garments or the life of the clothes we wear.

Textiles haunt museums with their fragility, the text inside the fabric chalice for an idea unwrapped and worn. Curators display cloth objects with caution; skin oils and light degrade them equally. We patrons of the past grope for a way to read such articles, some words to interrupt apparel's silence, breath to a story. A field of linen, woven to shape, flat and passive, its value now limited to the gaze of assessing eyes.

Imagine the weaver, visible and invisible, producing this piece. How long that worker bent over the garment, his shuttle carrying the thread under the arm's stretch, with no medico to diagnose weaver's bottom — pain caused by prolonged sitting on hard surfaces, resulting in inflammation of the bursa separating the gluteus maximus muscle from the sit bones. In other words, sore bum syndrome. Surely how Bottom, that rude mechanical so central to *A Midsummer Night's Dream*, gains his name, for Bottom is a weaver by trade.

Ah, the stretch of time and suggestion, how a shaped cloth can merge the semiotic and the vulgar, the literal and the figurative.

It's not the cloth that bridges the past, not the panels or the bold stripe of decoration, but the body that wore this garment, the way her knees bent to take steps, the shift of a muscled buttock under the cloth's fleeting touch, the *clavi* riding the shoulders with the precision of comfort.

Why was the tunic first worn? For a celebration of the equinox? For a name day? Or simply because it was a new day and a new garment fit?

Imagine this tunic glowing with newness, the sheen of the loom. Was it a gift? How much did it cost? Why was it first worn? For a celebration of the equinox, the time of balance and harmony? For a name day or a wedding? Or simply because it was a new day and a new garment fit?

A man may have worn it. With money, apparently. The decoration affecting status, the purple costly. Yet tabby is the most common weave, plain, the filling threads and warp threads interlacing to form a checkerboard pattern with a large number of intersections, which makes cloth strong, warm. A daily outfit, then, but elegant enough.

A Byzantine tunic, that's all. A loose-fitting garment, sleeved or sleeveless, extending to the ankles and worn by men and women. Asexual, airy. Tunics were popular in the 1960s, refusing the tedium of buttons or the rigidity of zippers, structured armholes and facing. They combined the medieval with irrepressible hip, sly seduction. Escaping the suit, celebratory in the simple reach from shoulders to knees. Dashikis without colour. A retro peasant outfit now, *caftan* the word used in fashion blogs — with particular reference to Elizabeth Taylor and how the tunic's capaciousness managed her appetite. A uniform of hunger and rebellion.

Evolved from the chiton and the *exomis* — oh, how those words rotate the tongue! Who wore a tunic to sleep in? Who wore a tunic to dance in? King David, possibly, dancing and exposed, decent or indecent. Vikings wore tunics made of bone. Can that be corroborated? Leather, but surely not bone. Tunics dance across the friezes of the Parthenon. The Phoenicians added broad borders to their tunics. Tolstoy certainly wore a tunic thrashing wheat (that was his conceit, pretending to be a peasant, ostentatiously humble). Uriah Heep. No tunics in Dickens, whose characters wore rags tight fitting and threadbare. Certain clergy and religious orders still wear versions of tunic: the cassock and the alb.

A tunic seems benign, but it recalls the robe of Nessus, the poisoned shirt that killed the playful Hercules, metaphor for garments that trap humans in their folds. Symbolically a fatal present, it inflicts inescapable misfortune. The robe of Nessus condemns the wearer to a life of torment. Robertson Davies' Dunstan Ramsay, wearing the silk shirt that he cannot afford, is burned by his "guilty luxury." This is the article that can never be doffed, its burden insufferable.

Theories claim that an obsessive concern with clothing reflects an obsessive concern with morality. But if all anxieties, all forms of daily

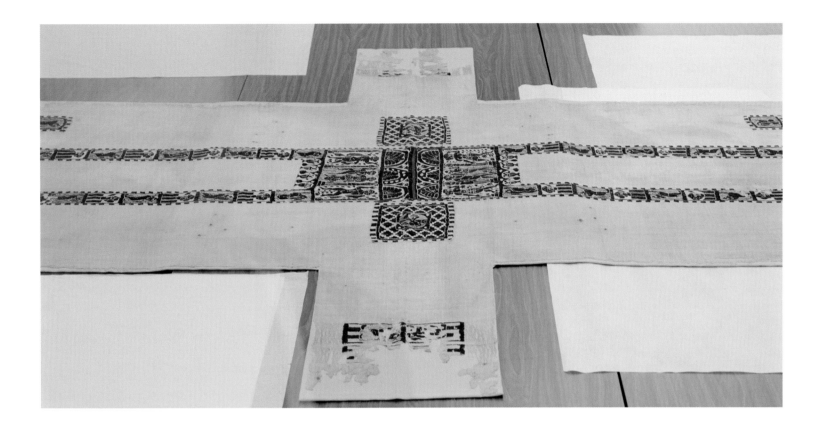

ritual are eventually transformed into art, then what can a Byzantine tunic communicate? That bare shoulders under a tunic marble with wickedness, that a tunic ascribes body more than other garments, signalling unfaithfulness? Ah, clothing is always more revealing than nudity.

But the bridge between time and religion melts intention, and on this tunic's chest panel figures dance together in a Dionysian *thiasus*, rapture and ecstasy. If this was a Christian's garment, explain please the nostalgia for celebration, festivity, disorder.

Like many sixteenth-century groups, the Copts were a punishing sort, their unbroken chain of patriarchs determined to erase all trace of women and heathens. At the temple of Isis, in the Nile River on the island of Philae, the friezes and sculptures bear the vengeful marks of chisels: men standing on ladders and chipping away at the noses and ears of the carvings of Isis, meticulous mutilation adamant as hatred. Those physical censors were doubtless wearing tunics. The hours and hours of labour evidenced there bespeak a zealotry that cannot efface the goddess's intricate story, her power over magic and nature. As a habitué of museums, I have seen the rebuilt temple on Agilkia Island, but I wish I could have been a tourist in the early 1900s, when, after

the old Aswan Low Dam was built, tourists used rowboats to glide among the submerged columns and peer down into the temple from the river's watery surface.

Neither marble nor monument, the survival of the ROM's tunic is strange and miraculous. Stretched now over the scrim of history, mute witness to the stark passage of stars and the deep bloom of sun, it comes to this preserved moment having last served as a shroud. What else to wear to one's own demise? Its curve comfort enough, its cloth familiar, wrapping the body. That is the provenance of a garment, whether hanging in a closet or waiting for discovery in the deep, cool vaults of a museum, its secret story gone mute, speaking from a frame of linen.

Imagine it when last worn, comforting a corpse, cloth no longer warmed by the heat of a moving, breathing body. Become swaddle for the dead, and with no notion of its preservation, stretched on a board inside a chill future, a vacant garment from which we awkward viewers try to imagine a gate back through time.

Coarse but durable, it can only lend itself to charity: "He who has two tunics, let him give to the one who has none" (Luke 3:11).

Dec 7/89	W. Meddowcraft		Toronto Ont
Dec 7/89	J. P. Playter		Toronto Ont
9	Bernard McEvoy		9
" 12	Jas Bassingthwaighte		Sault Ste Ma
	Clarence Bell		152 Cumberland St. Toronto
	G. D. Corrigan		Milton
	Miss Corrigan		"
	Thos Wallace		Toronto
	Dermot McEvoy		Laskay
	R. A. Malloy		Toronto
	A. Wallace		Toronto
	Wm Watt		
30/89	J. McPherson		"
" 31	A. J. Hunter		"
"	E. A. Henry		"
Jan 2	J. The Ripper ☠ ✗		London
"	J. McClain		"
"	Tom Rice		
	Bert Whole		
	Wil		

A WEALTH
OF ACQUISITION
How the Royal Ontario Museum Built Its Collection

Julia Matthews,
Former Head of
Libraries and Archives

The Royal Ontario Museum contains six million specimens and artifacts, give or take a few thousand, amassed over more than 100 hundred years — and the collection continues to grow.

At the turn of the twentieth century, the scattered foundations already existed: Well-developed collections in earth and life sciences had been gathered at the University of Toronto for instructional purposes; historic archaeological material, seldom visited, resided at the Ontario Provincial Museum in St. James Square (now part of the Ryerson University campus). And there were odds and ends elsewhere — including a mummy at Victoria College and a shrunken head in the University College museum. In 1905, a University of Toronto commission urged the creation of a single institution, one that was both academic and public, to gather these disparate materials.

Interest in a museum existed beyond the university. Travelling in Egypt in 1907, a group of wealthy Torontonians visited an archaeological dig by Victoria College graduate Charles Trick Currelly. He showed them a plaster cast of a mural depicting Queen Hatshepsut's voyage to Punt. He hoped to tint his mural with the original colours, and they gave him $1,500 to pay for the process. Currelly also wanted to broaden the university's collections. Convinced there were bargains to be had if artifacts were acquired immediately, he skilfully persuaded those backers to support his efforts then, and for the next forty years. If you stand on Philosopher's Walk today and look up at the grand windows of the highly decorated original wing, you will see that those travelling founders were driven by a capacious vision: inside was the whole world.

As blueprints were being drawn up for the building, protracted negotiations between the Ontario government and U of T resulted in the ROM Act in 1912.

When Prince Arthur, Duke of Connaught and Governor General of Canada, officially opened the museum on March 19, 1914, he praised its founders for making "popular education" the institution's mission, rather than appealing only "to the connoisseur and the expert." For the next hundred years, this combined ambition — popular and academic, nature and culture — would animate the ROM's activities.

Other museums have begun as encyclopedic collections, which have often been divided into independent institutions. That was what happened at the British Museum, which hived off natural history (the Natural History Museum) and the national library (the British Library), keeping archaeology as its core. The typical fate of university museums has been starvation or shutdown. But the ROM's dual mission and interdisciplinary focus endure, a rare balancing act.

To understand what the founders thought a collection should accomplish, it is necessary to travel back to a time when there were two main views. On the one hand, museums could instill in visitors the uplifting knowledge of linear development, from ancient civilizations to the great British Empire. On the other, for those with a scientific bent, the wealth of nature was available for personal study and for commercial development. These ideals, however, did not always reside amicably under one roof.

In 1914, the ROM was actually five museums, representing zoology, paleontology, mineralogy, geology, and art and archaeology — each with a prestigious director. They were later consolidated into three divisions, and finally became a single institution in 1955. Until 1968, for more than half its life, the museum was part of U of T, though it did have its own board of trustees. Today, curators continue to be cross-appointed to universities.

Sir Byron Edmund Walker, the first chairman of the board of trustees, embodied the spirit that created the institution. A lifelong collector, he started with fossils as a child, roaming the fields around his rural home near Hamilton, Ontario. At twelve, he went to work in his uncle's bank, where one of his tasks was to detect counterfeit bills — a job that may have ignited his interest in art prints. In 1868, Walker joined the new Canadian Bank of Commerce. Thirteen years later, the bank sent him to New York as a junior agent, where he began to purchase fashionable and inexpensive European etchings. At the time, American robber barons were buying European masterpieces, which Walker saw in the new Metropolitan Museum of Art. He returned to Ontario a cosmopolitan, convinced that Canada needed worthy galleries and museums. He said, "We are rich enough to bear the cost with

(continued on page 166)

Above: As items arrived at the museum, "draughtsmen" (all female) recorded them in accessions logs, known as Yellow Books because of the colour of their bindings. The fabrics described here have since been reassigned and renumbered.

Right: Edmund Walker at home with his etchings. The museum stored materials in the basement of his St. George Street house prior to the opening of the first wing in 1914.

Page 158: Tourists from Canada and the United States signed the provincial museum's visitor book (1889–90), as did a sinister-sounding guest from London.

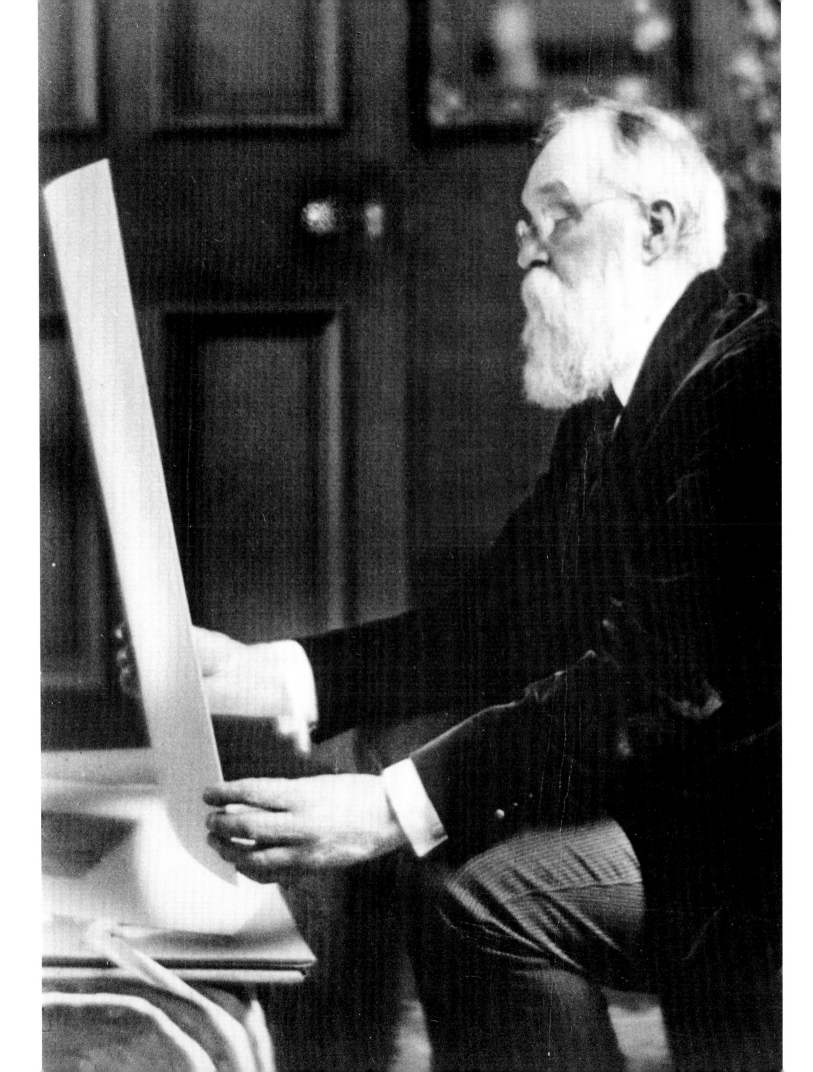

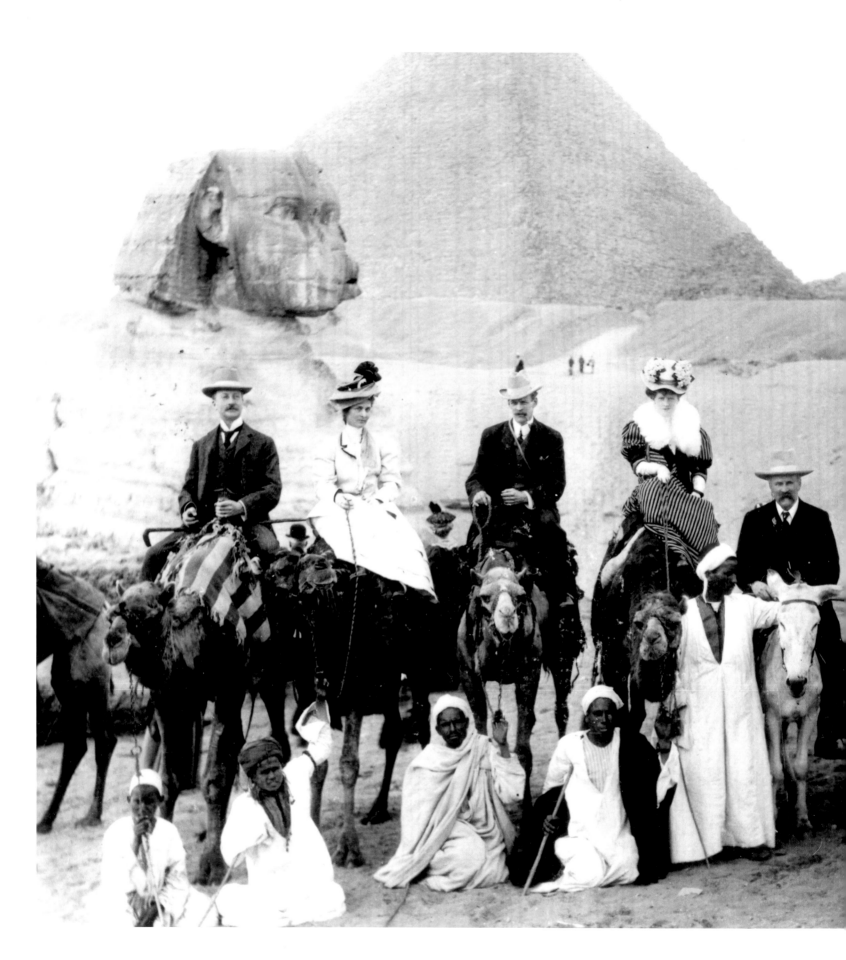

SIR ROBERT MOND

One of the ROM's influential benefactors in the United Kingdom was Sir Robert Ludwig Mond, who worked to foster the cultural development of the British Empire. Many of the Egyptian artifacts that Charles Currelly amassed were from excavations funded by Mond, who joined the Twenty Friends of the Arts, the ROM's first donor group, in 1917. Mond donated his own artifacts from Egypt, Persia, China, and Europe, and was one of four purchasers of the 40,000-volume H.H. Mu Library in the early '30s. With Sigmund Samuel, he funded a two-storey addition to house it, which opened in 1937.

SIR EDMUND OSLER

Sir Edmund Boyd Osler was passionate about arts and travel. He visited Charles Currelly in Egypt, and then advocated for government funds to create and operate the Royal Ontario Museum. He personally pledged $50,000 a year for five years and donated a large collection of Paul Kane paintings, which are among the museum's greatest treasures. Osler's family continues the tradition; his great-grandson Wilmot Matthews and his wife, Judy, are honoured in the Matthews Family Court of Chinese Sculpture, which is entered through the Sir Edmund Osler Gate.

SIGMUND SAMUEL

The philanthropic businessman Sigmund Samuel was involved with the ROM from its beginning, contributing some of the finest pieces in the ancient Greek collection. But his passion was Canadian history, and he donated wonderful holdings of prints, paintings, maps, books, and other artifacts. He also bequeathed a trust for the development of Canadiana, and in 1951 helped fund a separate building in which to display it. (Along with Sir Robert Mond, he had previously funded the H.H. Mu Library addition.) After Samuel's death, his grandson Ernest and his wife, Elizabeth, continued to support the museum, serving as members of the board of trustees — Elizabeth as chair. They funded the refurbishment of the rotunda, which is dedicated in their honour.

SARAH WARREN

Sarah Warren was a major benefactor of the ROM. In 1909, she took over the running of her late husband's business, the Dominion Rubber Company, and for more than forty years was the only woman on the Board of Trustees, frequently settling the debts Charles Currelly incurred on the museum's behalf.

Left: Mr. and Mrs. H.D. Warren (left); Mr. and Mrs. Gordon Osler; Charles Cockshutt; Edmund Osler; and their guides. The group called themselves the COW Expedition, using the initials of their surnames.

CHARLES TRICK CURRELLY

Charles Trick "Carlo" Currelly had a fund of good stories, many related to his astonishing luck with finds and sponsors. His friend Pelham Edgar said that ROM got its start because Currelly needed to blow his nose in London. While he was having some coins identified by a Greek and Roman specialist named Grueber, a small shabti figure he had purchased near the British Museum fell out of his pocket, wrapped in a handkerchief. The coins had been entrusted to Currelly by William Hunt, the "Great Farini," who was his neighbour in Port Hope, Ontario, and had crossed the brink of Niagara Falls on sixteen-foot ash stilts (Currelly stories are never simple). Seeing the figurine, Grueber asked Currelly if he was interested in Egypt. It turned out that Flinders Petrie, the famous English Egyptologist, happened to be in town that day, and Grueber sent Currelly off with a note of introduction. Before long, Currelly was staying with Petrie — preparing an exhibition of material from the Egyptian Exploration Fund's latest digs and being tutored in the arts of packing and handling fragile material. When the chancellor of Victoria College (who wanted his alumnus to collect and teach biblical archaeology) travelled to London, he paid Petrie and Currelly a visit. And that, according to Currelly, was the genesis of the ROM.

As a director, Currelly was constantly lecturing, teaching, and interacting with visitors. His catholic interests meant that the collection's scope was broad from the start. He bought Chinese and African material in Cairo; he donated a serene stone head from India, in memory of his mother. Whenever stress threatened to overwhelm him, he went on speaking tours and travels to recover, which is how the museum acquired its wonderful tribal pottery from the American Southwest, not to mention the crest poles from the West Coast.

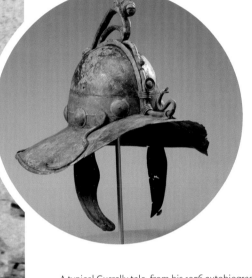

A typical Currelly tale, from his 1956 autobiography: "One day when I went into Fenton's I was shown a gladiator's helmet, in good condition except that one cheek piece was missing. An Italian had brought it to London and had told this story. About 1840–1850 some men were digging near the Colosseum when one of them came on a cheek piece and then the other found the whole helmet; neither would sell to the other. An Italian count bought the helmet but would not pay the extravagant price that the owner of the cheek piece demanded. I realized that in the last sixty-odd years a great part of Rome in the poorer quarter had been torn down and rebuilt, and that the chances of that cheek piece being still in existence were practically nil....After a little over a year, during which time the helmet was at Sir Lawrence Alma Tadema's studio, where he had insured it for a thousand pounds, it went to Toronto and I had a case made for it. Not long after...Fenton sent me a parcel of Roman odds and ends he had picked up for a few shillings, with a letter to say that he knew I was keen on Roman material and as these cost nearly nothing he was sending them without asking me. When I unpacked them, here was our cheek piece — another bit of luck that has followed the museum from the beginning."

Above inset: The Roman gladiator's helmet Currelly described as lucky in his 1956 autobiography.

Left: The only known photograph of Currelly in the field, taken in Egypt in 1906.

"We bought the dumps," Edmund Walker explained, "the interesting odds and ends neglected by the average buyer. We have bought priceless things for a bagatelle by watching and waiting and getting hold of the right people. We were always poor."

ease, but we are not intelligent enough to see our own interest in spending the money."

Together with George Reid, president of the Ontario Society of Artists, Walker lobbied for murals in the new legislative buildings and in city hall that depicted the province's history. Later, in 1900, the two helped establish the Art Museum of Toronto, which became the Art Gallery of Ontario. Walker persuaded the widow Harriet Boulton Smith to bequeath her home, the Grange, to house the gallery, and then he bought land and paid for an ornamental fence so that there would be an public space surrounding it. Shortly afterward, he wrote to Currelly, who had been sending glowing letters of Egyptian discoveries to Walker's son: "I should certainly like to invest a little money in Egyptian antiquities, especially in glass, mosaic bead, and scarabs." On a visit back to Toronto, Currelly brought Walker a jewel for his cravat and showed him other finds so inexpensive that Walker persuaded U of T to authorize him as a collector.

As Walker told an interviewer years later, "We bought the dumps, the interesting odds and ends neglected by the average buyer. We have bought priceless things for a bagatelle by watching and waiting and getting hold of the right people. We were always poor." And during the celebrations honouring his long association with the Canadian Bank of Commerce, Walker delivered a speech that was more personal than most of his orations: "I know the value of money, but I shall rather have created one of the institutions of my country than to possess millions." In fact, the list of institutions he "created" is illustrious and long. The ROM was so personal to him that he stored artifacts in his home on St. George Street until the first building was ready.

By 1909, the "little junta" of Walker's friends persuaded the Ontario government to partner with U of T in building an appropriate home for the antiquities and the natural science collections already on campus. Among these was Walker's own collection of fossils and the wonderful paleontological library

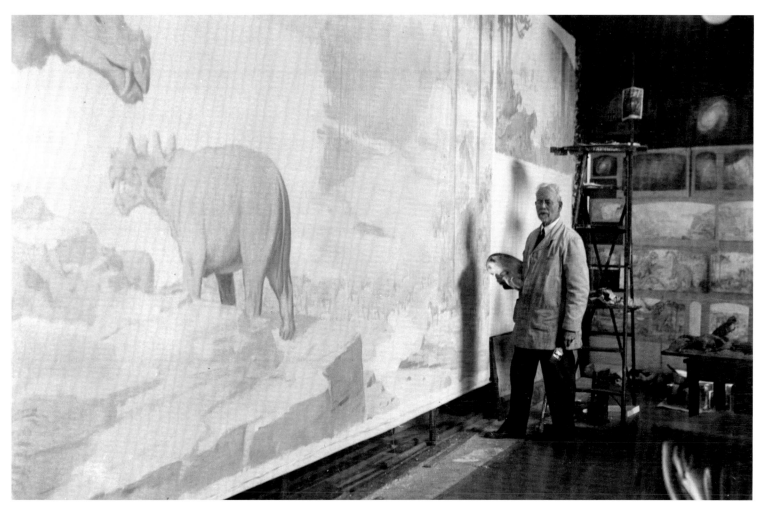

Above: G. A. Reid worked with Arthur Parks to paint scientifically accurate murals in the Vertebrate Palaeontology Gallery.

Left: The Vertebrate Palaeontology Gallery later became the museum's first library space (note the murals above the bookshelves).

The ROM buildings have grown to 820,000 square feet, of which less than half is open to the public.

Below left: Toshusai Sharaku, portrait of Kabuki actor Ichikawa Ebizo playing the part of Sadanoshin (c. 1795).

Below right: Nishimura Shigenaga, *Utsutsu no asobi* or *Playing Games with the World of Sense Impressions* (triptych of hanging scrolls, c. 1750).

Opposite: W. A. Parks uncovering dinosaur bones in Alberta in 1918, and as director of the ROM of Palaeontology.

he had amassed. This was the ROM's first private donation. His scientific soul supported fossil expeditions in Alberta, and he lived long enough to witness the museum name its holotype dinosaur specimen *Parasaurolophus walkeri* in his honour (see page 146). Following his death in 1924, his family donated more than 1,000 Japanese woodblock prints that he had acquired on his travels. Sir Byron Edmund Walker had the authority and the *gravitas*, plus the lust of the eye that marks all collectors. He was the perfect patron for nature and culture.

Over the course of 100 years, the ROM buildings have grown to 820,000 square feet, of which less than half is open to the public. No sooner has each expansion been completed than planning for the next phase has begun. In 1914, nearly everything was on display, and the staff numbered twenty, including skilled carpenters who created the cases for storage and display. By the late '20s, the provincial government was asking the directors to stop encouraging visitors to write their MPPs with complaints of overcrowding. During the Depression, a new wing was approved as a job-creation project, opening in 1933. In 1982, two huge additions were built: the Queen Elizabeth II Terrace Galleries provided display space facing Bloor Street, and the Louise Hawley Stone Curatorial Centre on the south housed collections and staff. One prime motive for the latest iteration — Daniel Libeskind's

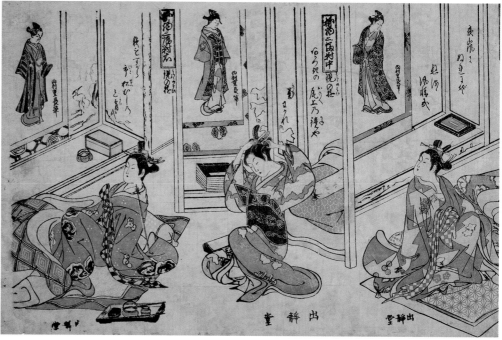

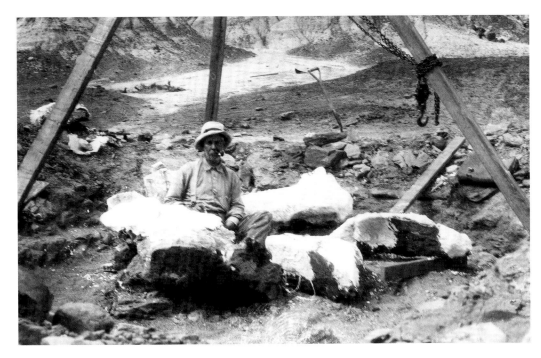

Michael Lee-Chin Crystal — was more gallery and exhibition space, especially for large shows. Whereas once every pot and stuffed animal was out, nowadays there are star objects. Galleries contain a variety of densities in cases, on the walls, or on the floor, but only a fraction of the overall collection is on view.

What made collecting possible in the museum's early years was money from public and private donors. There was a protective circle around Charles Currelly, who incurred debt in the ROM's name and would place prized artifacts on top of packing cases, letting donors decide what to pay for. Government funds were also essential in continuing scientific surveys. He didn't object to being called the founding director, but his fellow directors would push back when he acted as if the whole museum was his and that the public only cared to visit the ROM of Archaeology.

One of the special exhibits in 1914 was of typical gems from an Indian bazaar, given to Thomas Walker, the director of the ROM of Mineralogy, who had connections with the Geological Survey of India. In 1929, crowds flocked to see the sugar cube–sized Errington diamond, whose popularity spurred further donations from mining companies and individuals. Walker cultivated other museums by exchanging specimens, but his novel strategy was to run the ROM of Mineralogy as a business. Since it received no funds for acquisition from U of T, it created its own. As part

of this strategy, the museum hired miners in Cobalt, northeast of Sudbury, Ontario, to collect ore samples, which it then sold to scientific supply houses and other collectors.

As an example of how once obscure specimens can enter the spotlight, consider meteorites. In 1914, the ROM of Mineralogy had two, whereas now there are more than 500, including some of the rarest specimens. The study and display of meteorites offers a glimpse into the history of our planet and its place in the solar system over the past 4.5 billion years.

Halted by World War I, fieldwork resumed after 1918, especially in Ontario and Alberta, with trainloads of dinosaur bones arriving at Queen's Park. Then, as now, they were a big draw, and they needed space for public display. Crest poles sent from the West Coast lay behind the building, wrapped in floor wax and burlap waiting to be installed. The magnificent stone lions arrived from China. Twenty years after the opening, the promise of a new wing gave the staff hope that it would be possible to bring galleries and amenities in line with current best practices: Other prominent museums had armour courts; the plans for the original building called for a huge central space, complete with tournament wall paintings that featured staff caricatures. Scenic settings and human mannequins were also in

(continued on page 173)

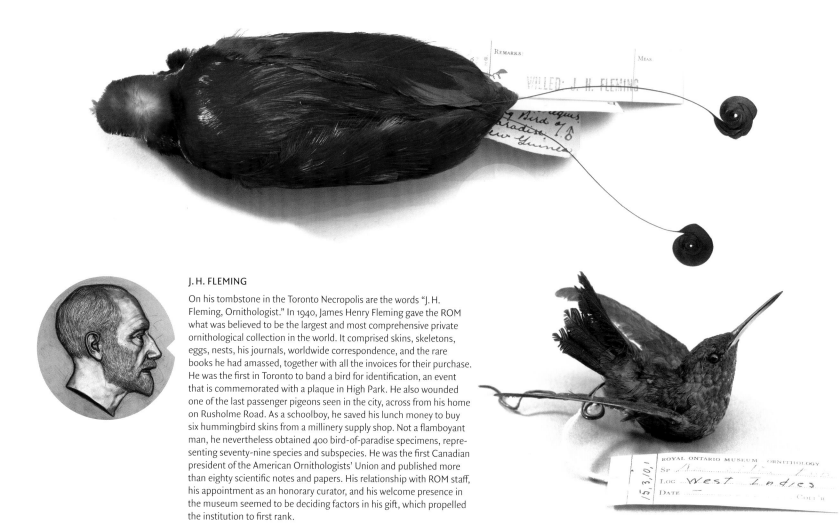

J.H. FLEMING

On his tombstone in the Toronto Necropolis are the words "J. H. Fleming, Ornithologist." In 1940, James Henry Fleming gave the ROM what was believed to be the largest and most comprehensive private ornithological collection in the world. It comprised skins, skeletons, eggs, nests, his journals, worldwide correspondence, and the rare books he had amassed, together with all the invoices for their purchase. He was the first in Toronto to band a bird for identification, an event that is commemorated with a plaque in High Park. He also wounded one of the last passenger pigeons seen in the city, across from his home on Rusholme Road. As a schoolboy, he saved his lunch money to buy six hummingbird skins from a millinery supply shop. Not a flamboyant man, he nevertheless obtained 400 bird-of-paradise specimens, representing seventy-nine species and subspecies. He was the first Canadian president of the American Ornithologists' Union and published more than eighty scientific notes and papers. His relationship with ROM staff, his appointment as an honorary curator, and his welcome presence in the museum seemed to be deciding factors in his gift, which propelled the institution to first rank.

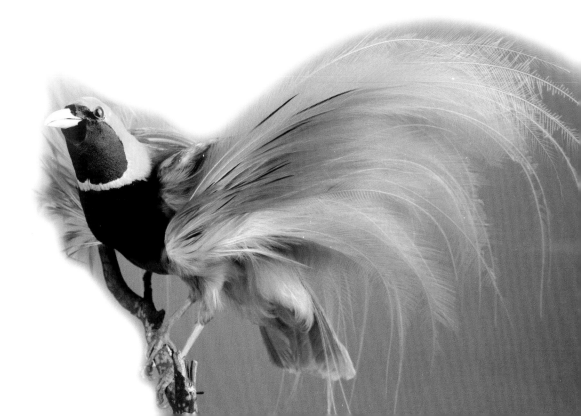

Top: A bird of paradise specimen (note J.H. Fleming's handwriting on the lower tag).

Middle: One of the six hummingbirds that started Fleming's collection.

Right: Another mounted bird of paradise.

EVELYN H. C. JOHNSON

Stating in 1923, Evelyn H. C. Johnson donated the Chiefswood collection — over 200 Six Nations and family artifacts. In a letter to Charles Currelly in 1916, she wrote: "I cannot tell you how I love these relics of the former grandeur of our people and wish and hope they may still be saved to our own museums." The fact that the ROM housed its collection in a fireproof building influenced her donation.

ORONHYATEKHA

The collection of Oronhyatekha, a Mohawk physician, arrived in 1911 and was dispersed among many departments. It is an eclectic assemblage of objects and natural history specimens from around the world, and represents the important roles that First Nations of the Great Lakes have played in Canadian history. Over the years, a number of items have left the ROM. Three medals that had been loaned to the museum of the International Order of Foresters (founded by Oronhyatekha) were returned to their original owners in 1929, for example.

Oron-hy-a-teh-ha.
A Mohawk.

Top: Six Nations artist Betsy Turkey's cornhusk doll, in nineteenth-century Iroquoian dress with cradleboard (1840).

Above: Oronhyatekha's ceremonial headdress featured non-traditional ostrich feathers. He used a similar image as his *carte de visite*.

Left: Letter to "Prof Currelly" from Evelyn H. C. Johnson (1930). Her eyes were troubling her, for which she apologized.

What made collecting possible in the early years was money from public and private donors.

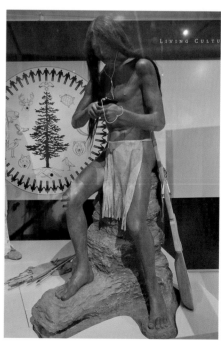

vogue. The ROM hired taxidermists and artists to create dioramas. Mannequins for the new displays of Native North Americans were commissioned by Edmund Walker and paid for by the Canadian National Exhibition; they were divided into culture groups while awaiting gallery space.

In 1914, the ROM of Zoology held herbarium specimens that had been assembled before 1865, but the first curator of botany was only appointed in 1978. The last collection to be transferred from U of T was of non-vascular plants and fungi in 2000. Today, botanists and mycologists work to foster an understanding of biodiversity and are active in the Canadian interdisciplinary centre.

When John R. Dymond was appointed director of the ROM of Zoology in 1934, he set about increasing the size and scope of all the natural history sections through his connections with other bodies and his own fieldwork. It is institutional lore that Randolph Peterson began his career studying moose but switched to bats because he could obtain more specimens. Today, the bat collection is among the world's best, and researchers continue to bring back small mammals from Mexico, Central and South America, Vietnam, and China. The museum is a also valued participant in DNA bar-coding projects. In entomology, it is regarded as a world leader in the study of black flies — an Ontario subject, certainly. Now, as in the past, scientists and technicians forge beneficial relationships with both amateurs, such as fishers and birders, and government ministries and agencies.

Until recently, collection and departmental names had the flavour of Victorian nomenclature. Front-line staff needed to know if a species had a backbone when deciding whether to refer a visitor or caller to vertebrate or invertebrate paleontology. In the same way, what is now called ROM Ancient Cultures subsumes several old-fashioned names for the human occupation of Asia, Europe, and the Americas starting 250,000 years ago. Among the former "West Asian" materials, are significant artifacts acquired through ROM excavations in Iran and Yemen. Because many Middle Eastern countries now prohibit digs (or are war torn and out of bounds), the materials are an important source for scientific analysis and publication projects for scholars around the world.

Archaeology and ethnology are areas of collecting that have radically changed over the past century. Not only has the ROM repatriated human remains, it has altered its displays and enhanced levels of consultation. Current best practices now include ceremonial burning of sweetgrass or tobacco with First Nations participating. And new curatorial interests and exhibitions have led to the purchase and donation of South Asian, Meso-American, and African materials.

(*continued on page 177*)

Top: Ornithology curator L. L. Snyder (left) shows F. A. Urquhart, director of the ROM of Zoology, a young eagle in 1952.

Bottom: Preparation of the "new" dinosaur gallery that opened in 1969 took three years. The innovative display included leaf castings, which placed the animals in ecological context.

Opposite top: Sylvia Hahn painted four murals in 1939. Staff members served as models for her tournament spectators (detail).

Opposite bottom: The new Mohawk family group was installed in 1935. Parts have since been repurposed in the Daphne Cockwell Gallery of Canada: First Peoples.

GEORGE CROFTS

Because Crofts had shipped the Luohan to S. M. Franck, the original dealer, he was curious about how it had arrived in Toronto. Currelly later said that meeting Crofts was the second-most important event in his life (the first was meeting Flinders Petrie); the result was more than $10 million of material, which made the ROM a world leader in Chinese art and archaeology. But the opportunity was almost missed. When Currelly, who was showing the president of the University of Manitoba around the galleries, was brought a card that read "George Crofts, Esq.," he assumed the man was a dealer and sent word that he had no money and could do no business. Crofts expressed sorrow, and mentioned an emerald-velvet carpet that had been in front of the Jehol Palace throne for 500 years. Hearing this, Currelly surmised that this was the mystery man who had been supplying Franck with the finest oriental pieces. He checked all the hotels in town and, with an hour to spare, tracked Crofts to his room where they made a deal. Currelly explained that he was not allowed to go into debt, but that he would "tear the money out of Toronto in ten-cent pieces" before letting the opportunity slip away.

In both aesthetic and scholarly terms, Crofts' legacy is among the world's richest. He collected, as Currelly instructed, objects that illustrate ancient daily life and customs, and he left his personal collections of carved crystals, snuff boxes, carved ivories, and porcelain to the ROM. Tragically, a dock strike in 1924 brought him to bankruptcy, and he died soon thereafter — but not before the University of Toronto awarded him an honorary doctorate in 1922.

HERMAN HERZOG LEVY

Herman Herzog Levy was born in Hamilton, Ontario, in 1902. As a young man, he travelled to Amsterdam to learn the diamond business, and would often visit the Rijksmuseum after work. He knew that Rembrandt's *The Night Watch* was considered a masterpiece, but he didn't like it at first. He studied it for weeks and came to understand it on an intellectual level, but he still didn't like it. In later life, he paid his dues to the museums that had educated him by serving on boards and by making donations of both objects and money, benefiting in particular the McMaster Museum of Art in Hamilton and the ROM. His $15 million bequest came with specific instructions: he wanted volunteers and professionals to work together to purchase certain categories of Chinese ceramics, bronzes, stone and wood sculpture, tomb figures, and jade. Moreover, the ROM was to spend all the money in five years. This was done — a unique moment in the collection's history.

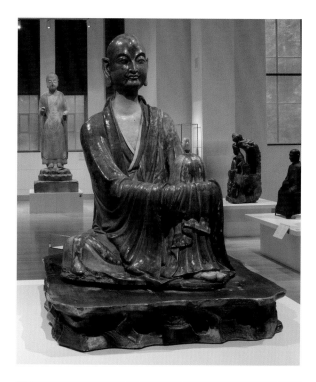

Top: Sarah Warren purchased this rare Luohan in London, UK, in 1914 — an acquisition that paved the way for the most extensive collection of Chinese art and archaeology outside of China.

Bottom: A wood and antler tomb guardian, Eastern Zhou-Chou Kingdom, China, fifth to fourth century BCE.

REV. JAMES M. MENZIES

Rev. James M. Menzies worked as a missionary in China from 1909 to 1934. He acquired many oracle bones (an ancient example of Chinese script), as well as bronzes, pottery, jade, and rare materials from the Shang and other dynasties. His son, Arthur, who had a distinguished diplomatic career, endowed a fellowship in 2009 to promote research using the ROM's Chinese collections.

BISHOP WILLIAM CHARLES WHITE

Drawn by the strength of the ROM's collections, William Charles White, the Anglican bishop of Henan, presented himself to Charles Currelly in 1925, carrying a fourteenth-century painting he wished to donate. The museum made him its agent, and through his contacts it acquired rare bronzes, including tools and horse fittings. When China instituted firmer controls over excavations, desperate monks rescued the fresco of the huge future Buddha Maitreya from certain destruction by wrapping slices of wall in reeds and cotton wool. Dealers offered the paintings to the bishop for a reasonable price. After a hazardous journey, the cargo was shipped to Toronto only a few years before the sluice gates that were flooding the Western market with China's patrimony were sealed. The mural was kept hidden, until it was installed on a special wall to mark the new wing's opening in 1933. It was paid for by Sir Joseph Flavelle, whose foundation provided two contemporary companion pieces, Daoist in origin. At retirement, Bishop White was appointed keeper of the East Asian collection and associate professor of Chinese archaeology, making the University of Toronto the only university in Canada at the time where students could pursue Chinese studies.

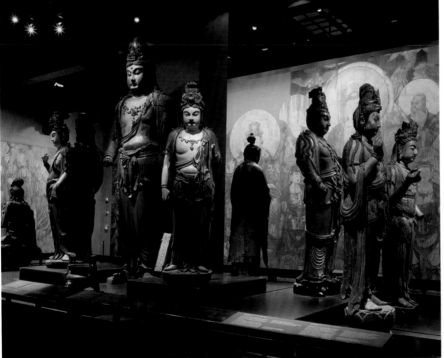

Top: A Shang Dynasty oracle bone from China, 1400–1050 BCE.

Left: The Bishop White Gallery, 1983–2006.

Prescience inspired the founders. Currelly bought Chinese ceramics in Cairo before it was fashionable to collect them, and today the museum's Asian materials are among its most beloved and renowned.

Although Currelly eschewed masterpieces in favour of the more mundane, fine art complements many of the collections. For instance, Sigmund Samuel amassed 4,000 paintings, prints, drawings, engravings, and maps that he hoped would illustrate Canadian history. The Canadian furniture collection is matchless. There are exquisite examples of decorative arts, including sculpture, glass, and ceramics, in the European and Middle Eastern galleries. The textile and costume collections, which can be displayed only for short periods because of conservation considerations, range from ancient cloth, carpets, and folk embroidery to haute couture.

On this whirlwind and idiosyncratic tour, it is important to highlight the prescience that inspired the founders to include pieces from China, India, and Africa. Currelly bought Chinese ceramics in Cairo before it was fashionable to collect them, and today the museum's Asian materials are among its most beloved and renowned.

By the time the ROM turned fifty, museums had created subdisciplines. Conservators had to be chemists; exhibit planners

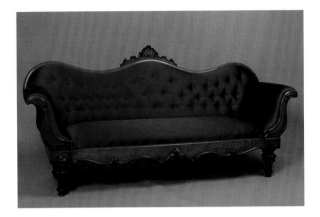

Above: The Sigmund Samuel Gallery of Canada features historical and contemporary furniture, including a nineteenth-century upholstered maple sofa from York County, Upper Canada, and a modern Karim Rashid design.

Opposite: The ROM commissioned this haute couture Dior gown by John Galliano in 2011, with the support of the Louise Hawley Stone Charitable Trust.

Above: Six Nations artist David M. General created this vision helmet, which the museum acquired in 1993. It was included in Things That Fly, a ROM exhibition at Toronto Pearson International Airport to mark the opening of Terminal 1.

Opposite: El Anatsui, *Straying Continents*. The Institute for Contemporary Culture commissioned this wall sculpture, made of discarded metal, for a travelling retrospective of the Ghanaian artist's work that opened in 2010.

were communication theorists. No longer did guards have to dust the cases before starting their rounds — and, besides, they were now called security officers. And case designers began to account for microclimates and accessibility. One consequence of these changes was to increase the specialized spaces for back-of-house work, which now include loading bays; preparation, decontamination, and cold rooms; meeting spaces; and computer facilities. For curators, there are laboratories and specialized equipment. Everyone needs classroom space, desks for interns, and library facilities. Administration has expanded. Volunteers require gathering places to plan their indispensable activities.

When staff moved into the nine-storey Stone Curatorial Centre in 1982, they occupied purpose-built work and storage spaces, sometimes for the first time. Geology's rocks went three floors underground, and anthropology's kayaks to an unbuilt elevator shaft. The largest department was exhibit design, with a mandate to fill the empty galleries. Within a decade, the hunt for more space had resumed, and today the ROM maintains a large storage facility on the outskirts of the city. With the advent of social media, and an ever-expanding digital world, more and more visitors can go behind the scenes virtually.

The curatorial staff recently undertook a massive study of the collection. The data they have gathered will help prioritize digitization and public access project; define staffing requirements and primary research areas; and plan storage needs and even fundraising. It will also enable the museum to refine its approach to storytelling.

As for the future, it is crucial to continue collecting contemporary objects to document social, political, spiritual, economic, artistic, and technological changes. There is no end in sight, because the museum intends "to sustain and improve the breadth of our collections, aided by private individuals and public bodies." And it now has ROM Contemporary Culture, a centre to mount challenging exhibitions on issues of the day.

Although Currelly would have hated it, the modern ROM has a formal acquisition process. Whim and opportunity are no longer sufficient — whether for donations or purchases. Criteria include storage and conservation considerations; whether the source and ownership can be traced; and what the new specimens and artifacts will contribute to display, research, and teaching. And for the first time in its history, the acquisition budget is a known quantity, thanks to a $50 million charitable trust bequeathed by Louise Hawley Stone in 1997. A peer group considers curators' acquisition applications annually (some recent purchases appear in this book), and donors continue to come forward with

(*continued on page 181*)

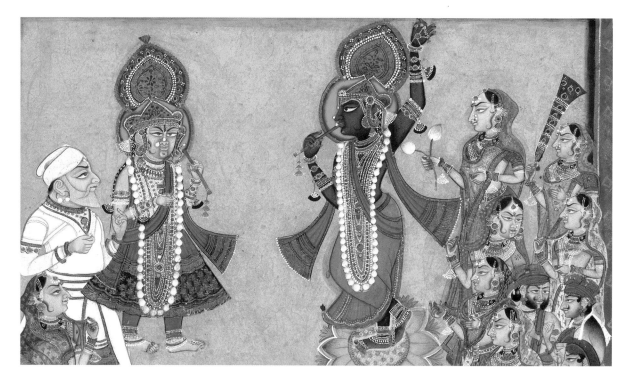

Right: An early nineteenth-century painting of Krishna fluting, by an unknown artist. The Louise Hawley Stone Charitable Trust Fund supported its acquisition.

Below: Chinese artisans carved this sculpture, which the Tanenbaums donated in honour of former director and CEO William Thorsell, from a large specimen of the mineral serpentine. Its inscription reads, "Fortune changes when the time comes," and visitors can touch it for luck.

LOUISE HAWLEY STONE

Louise Hawley Stone, who studied under Bishop William Charles White and wrote her master's thesis on a single chair, had a fifty-year attachment to the museum. As its first volunteer, she arranged a study room for the Far Eastern department in 1948, and founded the Bishop White Committee in 1960 to raise funds and public awareness for Asian studies. She also served on the board of trustees and was a frequent donor: Japanese country textiles, English embroidery, and a Chinese imperial court costume were among the 1,000 pieces she donated to the textile and costume collections alone. Stone fully endowed the museum's first curatorial chair, the Louise Hawley Stone Chair of East Asian Art, and lived to meet its first incumbent. The terms of her will established a charitable trust of $50 million, giving the ROM a steady income to purchase objects for the collection and to fund related publications.

JOEY AND TOBY TANENBAUM

When Joey Tanenbaum's mother brought him to the ROM in 1934, he wanted to take home a mummy. Thirty years later, he bought his first painting for $100. In 1997, he and his wife, Toby, gave the museum 300 artifacts of rare Byzantine art, making the collection the biggest in Canada. Then, in 2000, they donated more than 1,800 antiquities from China, West Asia, and Europe — the single largest gift the ROM has received.

Above: Frozen tissues used for ornithological DNA analysis.

astonishing and precious things. New areas have also become important; frozen blood and tissue samples used for molecular research in natural history are the museum's fastest-growing collection.

Thanks to the men and women who built the Royal Ontario Museum, it now conducts cultural conversations with the citizens of the city, the province, and beyond — all the while expanding and extending its collections, exhibitions, and programs. Imagine those early Torontonians standing outside the current Bloor Street West entrance: In 1914, they started a museum based on what they thought people should see. A hundred years later, they would be amazed at the vital role visitors play in determining the ROM's mission.

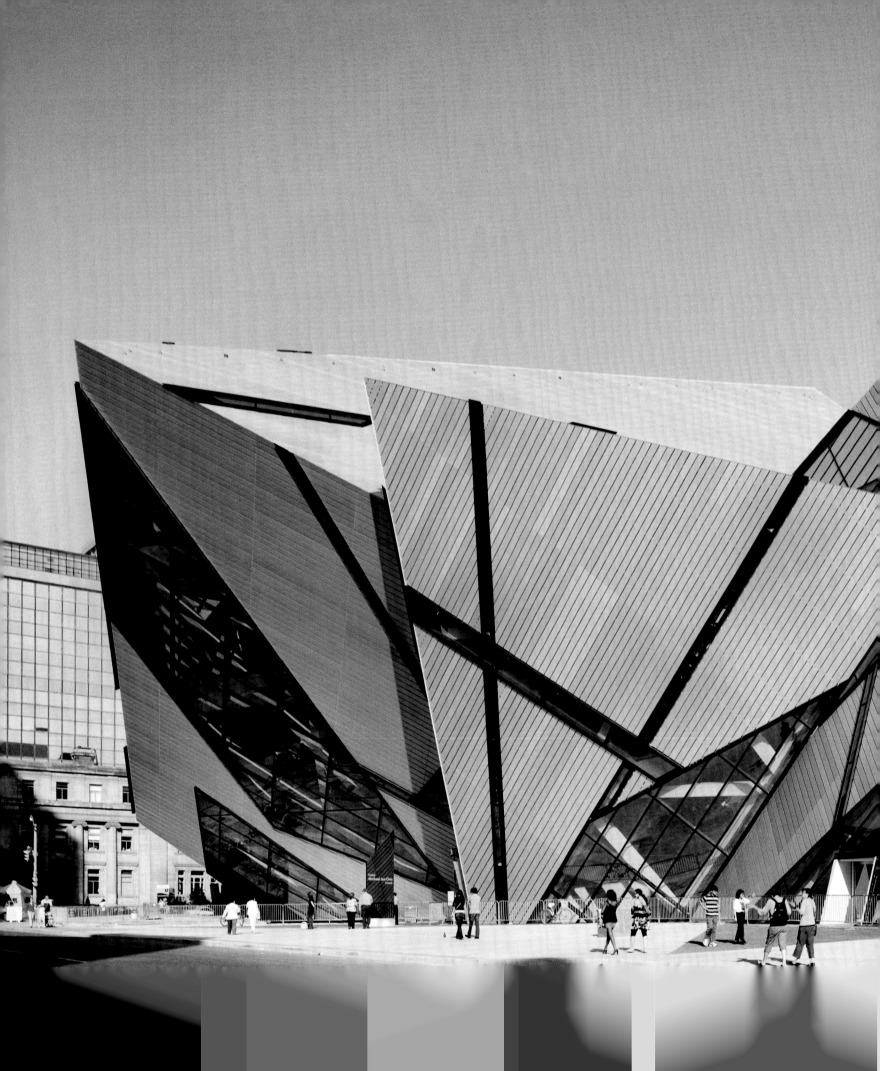

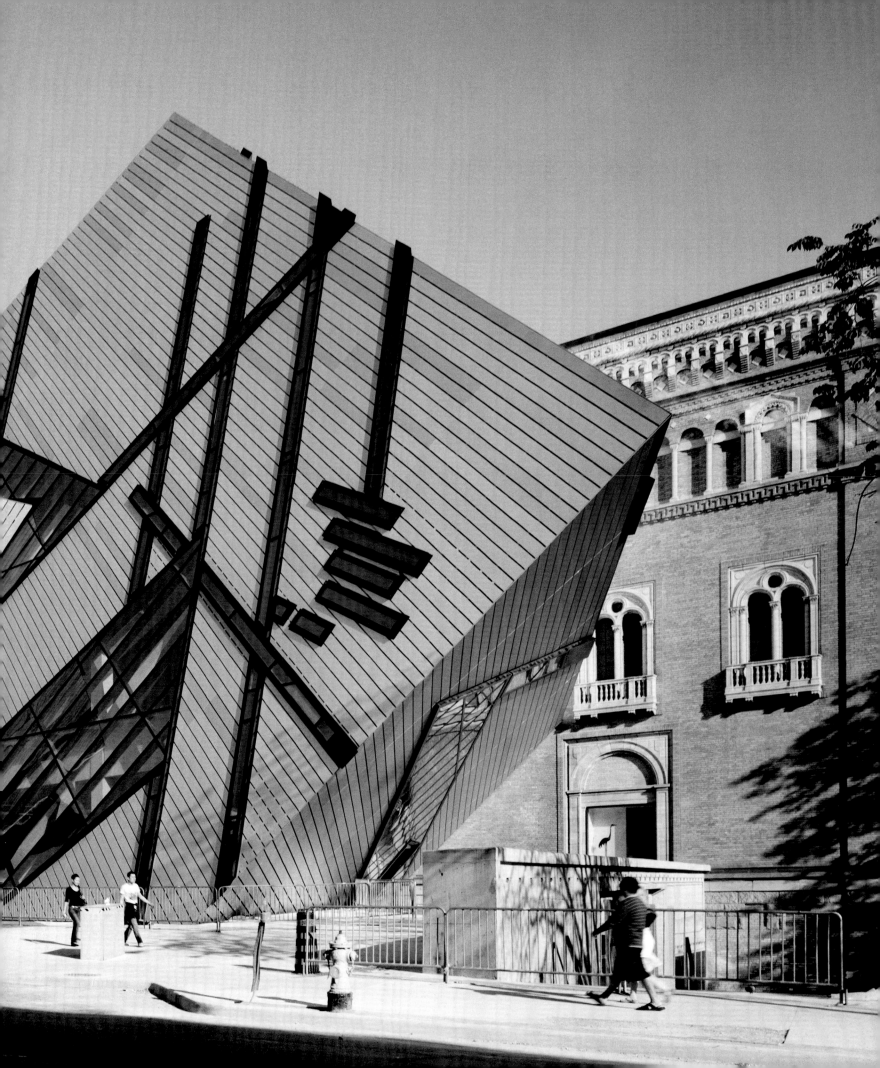

OBJECT LIST

Kunti, from the series In Response to...
Navjot Altaf (1949–)
Mumbai, India; 1999
Metal, indigo, acrylic paint on teak
This purchase was made possible with
the generous support of the South Asia
Research and Acquisitions Fund and Talwar
Gallery, New York
ROM 2007.31.1.1-2

Passenger pigeon mounts
Ectopistes migratorius
Collected 1878
30 × 30 × 50 cm
ROM 30.3.14.1; ROM 34.1.5.1

Blackfoot robe
Great Plains; nineteenth century
De-furred elk(?) skin
213 × 196 cm
Gift of the Louise Hawley Stone Charitable
Trust. Purchased with the assistance of a
Movable Cultural Property grant accorded
by the Department of Canadian Heritage
under the terms of the Cultural Property
Export and Import Act
ROM 2006.79.1

Gem-quality molluscs
Conus gloriamaris (Glory-of-the-Sea)
Collected off the coast of the Philippines
Specimens range 7.92–11.74 cm
Purchased with thanks to Mal de Mer
Enterprises, Mesmer Collection, and
Weiner Collection
ROM IZ M11138–ROM IZ M11141

The Paradise of Maitreya
Mural by Zhu Haogu and Zhang Boyuan
Yuan Dynasty, China; 1298
Ink and colour on plaster
5.22 × 11.11 m
Gift of the Flavelle Foundation in memory
of Sir Joseph Flavelle
ROM 933.6.1

Hudson Strait kayak
Inuit of southern Baffin Island or northern
Quebec; 1910–14
Wood, depilated sealskin, sinew
668.4 × 65.8 × 46 cm
Robert J. Flaherty collection; gift of
Sir William Mackenzie
ROM 915.40.11.1

Ikem headdress
Calabar, Cross River Region, Nigeria; late
nineteenth to early twentieth century
Wood, antelope skin, pigment, bone
Collected in 1929
ROM 935.10.1

"Gordo" the *Barosaurus*
Barosaurus lentus
Late Jurassic; c. 150 million years
27 m long
ROM 03670

Traill scrapbook herbarium
Catharine Parr Traill (1802–99)
Compiled 1898; acquired 1972
33 × 25.4 cm
Donated to the Vascualar Plant Herbarium
by Katherine Parr Strickland Heddle, when
the herbarium was still part of the Universi-
ty of Toronto Department of Botany
ROM 251

Springwater pallasite
Springwater, Saskatchewan
20 14 × 1.4 cm; 1850 grams
Found in 1931; accessioned 1931
Purchased from Ward's Scientific
Establishment
ROM M16970

Edo plaque representing a young warrior
Benin City, Nigeria; sixteenth century
Bronze
45 × 39.5 × 9 cm
ROM 908.66.1

Ice crawlers
Grylloblatta campodeiformis
Holotype specimen
5 × 20 mm
Collected from Sulphur Mountain, Banff,
Alberta (elevation 1,980 m); 1913
ROM 84082

Fishing by Torch Light
Paul Kane (1810–71)
Oil on canvas
Depicting Menominee Nation, Fox River,
Wisconsin; 1849–56
45.7 × 73.6 cm
The Honourable George William Allan
Collection
Gift of Sir Edmund Osler
ROM 912.1.10

"Bull" the white rhino
Ceratotherium simum
Born 1963 in South Africa; acquired 2009
from the Toronto Zoo
ROM 119469

Anomalocaris canadensis
Middle Cambrian; c. 505 million years
20 × 13 cm
ROM 51211

Black opal and diamond ring
Peter Kochuta (1925–)
Made by Henry Birks & Sons; c. 1970
Gift of Beryl Ivey; certified by Canadian
Cultural Properties Review Board
ROM M47968

Striding lion (glazed brick wall, relief)
Neo-Babylonian Iraq; 604–562 BCE
Polychrome glazed; fired bricks
122 × 8 × 183 cm
Excavated by a German expedition to
Babylon, 1899–1917
ROM 937.14.1

Figure of Shiva Nataraja
Chola Dynasty, India; twelfth century
Lost-wax bronze cast
101.6 × 27.0 × 87.6 cm
ROM 938.44

Two-door cabinet, "Cabanel" model
Jacques-Émile Ruhlmann (1879–1933)
Paris, France
Designed c. 1921; this example produced
c. 1925 by Chanaux & Pelletier
Macassar ebony, ivory, silk, mahogany
132.5 × 81 × 45 cm
The Bernard and Sylvia Ostry Collection,
purchased with funds from the Louise
Hawley Stone Charitable Trust; certified
by the Canadian Cultural Property Export
Review Board under the terms of the
Cultural Property Export and Import Act
ROM 998.135.7.1.8

Parasaurolophus walkeri
Holotype specimen
Late Cretaceous; c. 76 million years
Collected 1920
370 × 40 × 283 cm
ROM 00768

Sixth-century tunic
Early Byzantine Egypt
Linen tabby with woven wool tapestry
126 × 182 cm
Acquired by Charles Trick Currelly in Egypt,
1907–09
The Walter Massey Collection
ROM 910.1.11

CONTRIBUTORS

Marvin Luvualu Antonio is a multidisciplinary artist in Toronto.

Anita Rau Badami is a critically acclaimed and bestselling author of fiction and non-fiction, including *Tell It to the Trees* and *The Hero's Walk*.

Allan Baker is senior curator of ornithology and head of the Department of Natural History. He runs a DNA laboratory and teaches molecular evolution in the Department of Ecology and Evolution at the University of Toronto.

Robert Bateman, an acclaimed wildlife artist and naturalist, exhibits work around the world. He has received twelve honorary doctorates and was made an Officer of the Order of Canada in 1984.

Sebastián Benitez, a Venezuelan artist based in Toronto, explores issues of memory and identity through photography.

Genevieve Blais is a fourth-year student at OCAD University in Toronto.

Joseph Boyden, a celebrated writer, has been translated into seventeen languages. He won the 2008 Scotiabank Giller Prize for his second novel, *Through Black Spruce*, and has received the Queen Elizabeth II Diamond Jubilee Medal and four honorary degrees. He divides his time between northern Ontario and New Orleans.

Brian Boyle has been the ROM's photographer since 1974. He is a former president of the Professional Photographers of Ontario and former vice-chair of the Professional Photographers of Canada.

Arni Brownstone is assistant curator of ethnology, overseeing collections from Latin America and the Great Plains, Plateau, Great Basin, and Southwest regions of North America. His research focuses on the visual culture of the northern Plains Indians, with a special interest in pictographic painting.

Joe Bulawan, a fashion and portrait photographer from Toronto, attends Sheridan College in Oakville, Ontario.

Dale R. Calder is curator emeritus of invertebrate zoology in the Department of Natural History and a research associate of the Bermuda Aquarium, Museum, and Zoo. He retired in 2003, but continues studying the museum's collection of hydroids and jellyfish.

Julia Campisi studied political science at McMaster University in Hamilton, Ontario, and is now pursuing a bachelor of fine arts at Ryerson University in Toronto.

Jean-Bernard Caron is curator of invertebrate paleontology, working with fossils from the Burgess Shale collection. In 2011, he launched the museum's *Burgess Shale* website, a collaboration with Parks Canada.

Wayson Choy has published two companion novels and two memoirs, and has taught writing at Humber College in Toronto. He is a Member of the Order of Canada and a recipient of the Queen Elizabeth II Diamond Jubilee Medal.

David Clark has exhibited work in Toronto, New York, and Florence, as well as in Zlin, Czech Republic.

Austin Clarke won the Scotiabank Giller Prize and the Commonwealth Writers' Prize for Best Book with his 2002 novel, *The Polished Hoe*. His first work of poetry, *Where the Sun Shines Best*, was shortlisted for the Governor General's Literary Award in 2013.

Douglas Currie is senior curator of entomology and associate professor in the Department of Ecology and Evolutionary Biology at the University of Toronto. His research focuses on the diversity and biogeography of Holarctic black flies.

Wade Davis has written seventeen books and won the 2012 Samuel Johnson Prize for Non-fiction for *Into the Silence: The Great War, Mallory, and the Conquest of Everest*. He holds degrees in anthropology and biology, as well as a doctorate in ethnobotany, from Harvard University.

Deepali Dewan is senior curator of South Asian Visual Culture and teaches in the Department of Art at the University of Toronto. She specializes in nineteenth- and twentieth-century visual culture of South Asia and the South Asian Diaspora.

Laura Domnar is a third-year photography student at Sheridan College in Oakville, Ontario.

Katherine Dunnell is a mineralogy technician in the Department of Natural History. She helped develop the Teck Suite of Galleries: Earth's Treasures, and the blockbuster 2008 exhibition The Nature of Diamonds.

Uzoma Esonwanne is an associate professor of English and comparative literature at the University of Toronto. He specializes in psychoanalysis and race, the Nigerian poet Christopher Okigbo, and repetition in African and Diasporic literatures.

David C. Evans is a curator of vertebrate paleontology, overseeing dinosaur research, and an assistant professor in the Department of Ecology and Evolutionary Biology at the University of Toronto. He is developing a systematic survey of Alberta's Milk River region, and pursuing field exploration of the Sahara Desert in Sudan.

Takumi Furuichi studied graphic arts in Tokyo before enrolling in Humber College's photography program in Oakville, Ontario.

Sheree Fitch is an educator; literacy advocate; and the author of poetry, picture books, non-fiction, plays, and novels for all ages. She received the Vicky Metcalf Award for Children's Literature in 2000. She is writer-in-residence with the Pictou-Antigonish Regional Library in Nova Scotia, and is co-editing a treasury of Atlantic poetry for children.

Silvia Forni is curator of anthropology in the Department of World Cultures, and assistant professor of anthropology at the University of Toronto. She oversees permanent and rotating displays of African artworks in the Shreyas and Mina Ajmera Gallery of Africa, the Americas, and Asia Pacific.

Beau Gomez studies photography at Ryerson University in Toronto.

Tess Goris is a third-year photography student at Sheridan College in Oakville, Ontario.

Charlotte Gray has published nine bestsellers, including *The Massey Murder* and *Sisters in the Wilderness* (about Catharine Parr Traill and Susanna Moodie). She is a Member of the Order of Canada and a Fellow of the Royal Society of Canada.

Evan Griffiths, an Alberta native, studied creative photography at Humber College in Toronto.

Chris Hadfield is an astronaut and former commander of the International Space Station. Among other honours, he was

appointed to the Order of Ontario in 1996 and earned the NASA Exceptional Service Medal in 2002.

Lawrence Hill has written nine books. In 2013, he delivered the CBC Massey Lectures based on his book *Blood: The Stuff of Life*. He is finishing a new novel and has co-written the adaptation for a television miniseries of *The Book of Negroes*.

Alex Hutchinson is a science journalist and frequent contributor to *The Walrus*. He earned a Lowell Thomas Travel Journalism Award in 2012 for his *New York Times* story about hiking remote routes in the Himalayas.

Ross King has published six titles on Canadian, French, and Italian art and history. His book *Leonardo and "The Last Supper"* won the 2012 Governor General's Award for Non-fiction.

Anu Liivandi is assistant curator of fashion and textiles, and a member of the Directing Council of the Centre International d'Etude des Textiles Anciens. Her interests include Late Antique and medieval textiles of the Mediterranean, and documentation standards and thesaurus development in the area of textiles and costume.

Burton Lim is assistant curator of mammalogy. He has conducted fieldwork in eighteen countries, paying particular attention to the evolution of bats and the biodiversity of mammals. He also participates in the international

Barcode of Life project, helping to create a genetic reference system for species identification and discovery of mammals.

Kenneth Lister is assistant curator of ethnology, and oversees the Arctic, Subarctic, and Northwest Coast collections of North America; the Native watercraft collection of canoes and kayaks; and the Paul Kane collection of sketches and oil paintings.

Robert Little is the Mona Campbell Chair of European Decorative Arts. He is developing the permanent exhibition for the future Gallery of Twentieth-Century Design, and writing a book on the homes and collections of Montreal financier J. W. McConnell.

David Macfarlane is an author, novelist, and magazine writer. His 1999 novel, *Summer Gone*, was shortlisted for the Giller Prize; his latest novel, *The Figures of Beauty*, was published by HarperCollins Canada in 2013.

Joe MacInnis, a physician and scientist, studies leadership in high-risk environments. He has logged more than 5,000 hours beneath the Atlantic, Pacific, and Arctic Oceans, and is working on a leadership video for the Canadian special forces. His book *Deep Leadership* came out in 2012.

Linden MacIntyre, a novelist and broadcast journalist, has co-hosted CBC's *The Fifth Estate* since 1990. He has won nine

Gemini Awards, as well as the 2009 Scotiabank Giller Prize for *The Bishop's Man*. He will publish his fourth novel, *Punishment*, in 2015.

Margaret MacMillan, a Fellow of the Royal Society of Literature and an Officer of the Order of Canada, is the warden of St. Antony's College, Oxford University, and a history professor at the University of Toronto. Her latest book is *The War That Ended Peace: The Road to 1914*.

Julia Matthews joined the ROM in 1982 as the head of Libraries and Archives. She retired in 2005 but returned in 2013 to assist with several projects related to the museum's centennial.

Christine McLean studied fine art at Bishop's University, in Sherbrooke, Quebec. She now attends OCAD University in Toronto.

Deepa Mehta is an award-winning director and screenwriter. Her film *Water* was nominated for an Academy Award for the Best Foreign Language Film in 2007; more recently, she adapted Salman Rushdie's award-winning novel *Midnight's Children*.

Deborah Metsger, assistant curator of botany, is responsible for Catharine Parr Traill's Green Fern album. Her research examines the systematics of maples, the documentation of the vascular flora of Ontario, and plants as the intersection of science and culture.

Hassan Mohamed studies photography at Sheridan College in Oakville, Ontario.

Ian Nicklin is an earth science technician in the Department of Natural History.

Arianna Perricone is a mixed-media artist. She is completing a bachelor of fine arts at Ryerson University in Toronto, with a specialization in photography.

John-Charles Pinheiro, an artist based in Toronto, documents subcultures within the realms of sport and aviation.

Lynda Reeves is publisher of *Canadian House & Home* magazine and the host of *House & Home TV*.

Clemens Reichel is associate curator for ancient Near Eastern archeology, and assistant professor of Mesopotamian archaeology in the Department of Near and Middle Eastern Civilizations at the University of Toronto. His research concentrates on complex societies and the evolution of urbanism.

Jody L. Rimmer has studied art history, architecture, and photography at the University of Toronto and Humber College in Toronto.

Raymond Salaber studied photography at OCAD University in Toronto. He has exhibited work in Canada, Czech Republic, India, and South Korea, and has an upcoming show in China.

Lisa Takkinen studies photography at Sheridan College in Oakville, Ontario.

Jessica Toczko, an Ottawa native, studies photography at Sheridan College in Oakville, Ontario.

Ka Bo Tsang was previously curator of Chinese pictorial art, and continues her study of the Chinese collection as a research associate.

Guy Vanderhaeghe won the 1982 Governor General's Award for fiction with his short story collection *Man Descending*, and again in 1996 for *The Englishman's Boy*, a novel.

Aritha van Herk has written five novels; four works of non-fiction; and hundreds of articles, reviews, and essays. She recently collaborated with photographer George Webber on two books of place writing, *In This Place* and *Prairie Gothic*. She teaches creative writing and Canadian literature at the University of Calgary.

Haley Wessel-Friesen is a mixed-media artist and a photography student at Ryerson University in Toronto.